LetterScapes

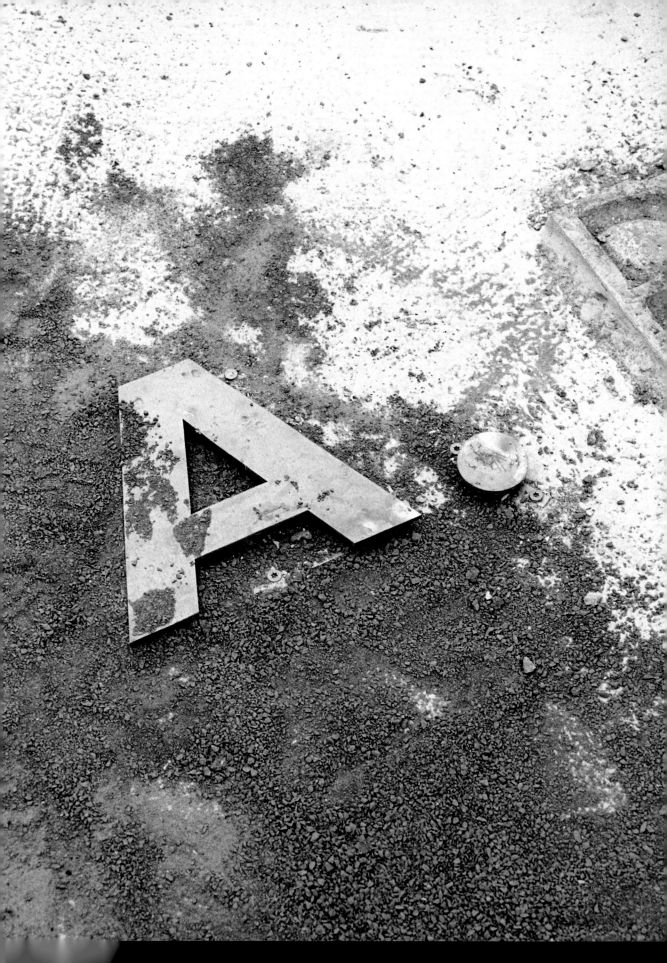

Anna Saccani

LetterScapes
A Global Survey
of Typographic Installations

365 illustrations, 290 in color

 Thames & Hudson

Page 2: A letter from *A Flock of Words* by Gordon Young
with Why Not Associates (see page 296).

LetterScapes. By Anna Saccani
Copyright © 2013 SHS Publishing, Rome
www.shspublishing.com

Design by Anna Saccani
Texts by Anna Saccani, unless otherwise credited

Photo editing by Ruben Cruz
Proofreading by John Z. Komurki

First published in 2013 in hardcover in the United
States of America by Thames & Hudson Inc.,
500 Fifth Avenue, New York, New York 10110

thamesandhudsonusa.com

Library of Congress Catalog Card Number 2012942985

ISBN 978-0-500-24143-1

Printed in China

Contents

Reading by the Sea

Foreword by Leonardo Sonnoli

Leonardo Sonnoli is an award-winning Italian designer and lecturer. After graduating in 1962 from the High Institute of Industrial Arts in Urbino he went on to Tassinari/Vetta Studio in Trieste, where he is now a partner. Between 1990 and 2001 he was Creative Director at Dolcini Associati Studio, working on visual identities, cultural event communication, signage systems and exhibition graphics. In 2002, along with Paolo Tassinari and Pierpaolo Vetta, he founded CODEsign.

Today, the use of writing in public spaces has moved away from the old social and descriptive functions of public lettering, which were linked with expressions of power and its architecture. Instead, this writing commemorates events or people, designates a spatial or commercial identity, or is a form of artistic expression, often becoming an installation in its own right and an integral part of architecture.

This book, the result of research carried out for a doctoral thesis at Venice's IUAV university, is intended as a modest contribution to the current literature on the subject of public lettering. Given the broad nature of the topic, it was inevitable that limits would need to be imposed on the research. This, however, is what makes the book unique.

The starting point is the definition of 'public lettering' given by Armando Petrucci as: 'Any type of writing designed to be used in open spaces – but also in confined spaces – to allow multiple readings (group or mass readings) and at a distance, of a text written on an exposed surface; a necessary condition is that the display writing be sufficiently large, and present the message (verbal and/or visual) in a sufficiently discernible and clear way.'[1]

The public nature of the projects in this book – that is, their location in places accessible to all – was an essential criterion in the selection, and this means that they were chosen on the basis of their social value, in addition to their permanent character in the spaces they occupy.

Almost all the projects featured employ the Latin alphabet. Western culture has a history of figurative representation and of speech very different from those of other alphabetic cultures. Where language plays a public role of stating, remembering and celebrating, it has long been translated visually through a semantically appropriate rendition of the letters, using repeated forms, even if calligraphic in style, and sometimes specifically designed for the occasion.

The selection in this volume is obviously not exhaustive, and is only representative of the contemporary scene. While many examples have been omitted, those featured are sufficient to highlight the changes in the use of lettering that have taken place over time – both in the epigraphic tradition that has represented public institutions since the Roman Empire, and in the commercial use of writing, which invaded cities from the late nineteenth century onwards.

In recent years, cities have increasingly shifted the management of public spaces from public to private interests. This is one of several reasons behind the change in the role of words and letters in such spaces. The expansion of graphic design beyond the confines of the page has also made an important contribution to a change in approach; this was undoubtedly the result of artistic experimentation in the post-war period, using language as visual material and, above all, translating concepts into typography.

However, even with a carefully chosen font, the emotion that comes from reading a text by Katherine Mansfield half-submerged in the salt-scented sea, with the slanting light of the setting sun over Wellington, is difficult to describe in words. Because reading is not just a matter of seeing.

[1] Armando Petrucci, *La scrittura: Ideologia e rappresentazione*, Piccola Biblioteca Einaudi, Turin, 1986.

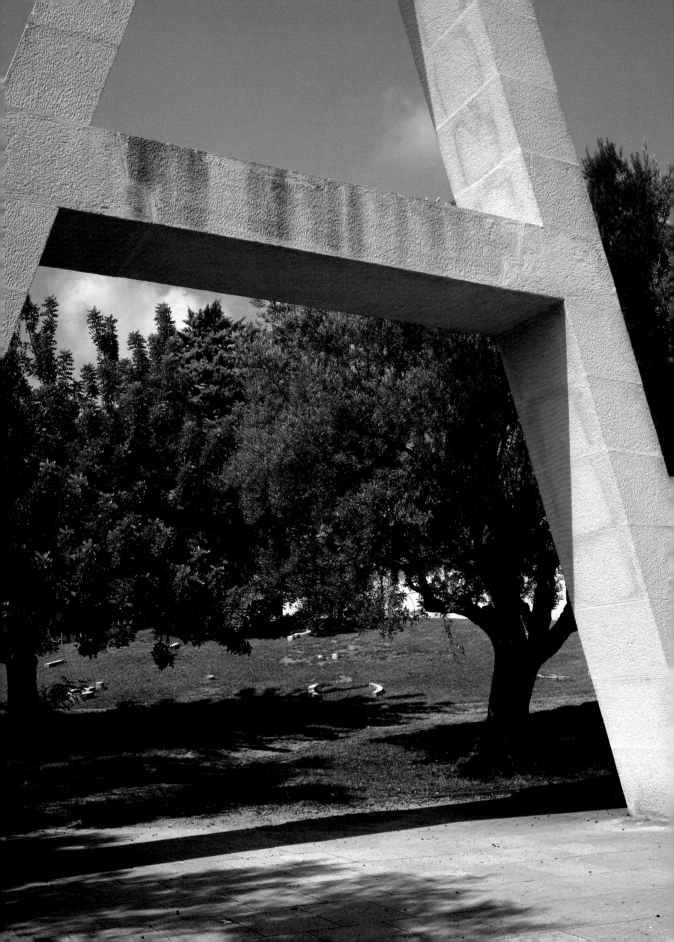

Introduction

More than ever, public lettering can be seen everywhere we look in the contemporary world. Road signs, shop names, advertisements and graffiti cover the walls of our cities. These messages penetrate into our minds, informing, appealing, persuading or inciting. Painted, drawn, sculpted or cast, assembled in metal, plastic or stone, the words become tangible physical entities in the landscape, contributing to its personality and unique identity.

Often the messages are too many and too confusing. They blend into a background noise, with no individual voice emerging from the general hum. But there are times when, suddenly, something will attract our attention. Intent on our daily chores, heads down, we find our eyes turn to seize this new message. A word, phrase or sometimes just a letter becomes familiar and part of our landscape.

A public lettering is made unique by the relationships it sets up with what is around it: not a blank page, but the sky, the streets, the sunlight with the shadows it creates, the rain making the colours brighter, combined with slow erosion from the passage of time. To this we can add people, moving, gazing, more or less attentively, their curiosity driving them to find something new and different in an everyday landscape. In the words of Jock Kinneir, a major figure in the study of this discipline: 'If public lettering was just a larger size of type there would be little to interest us. Yet, quite apart from the question of the extra dimension, there are obviously a host of different relationships to be explored. Buildings and people, rather than pages, are the frame of reference, and sometimes even the sky and open fields.'[1]

This volume is an exploration of typographical installations created between the mid-twentieth century and the present day, selected from the most important works throughout the world. All the works discussed are sited in public or semi-public places and were intended as permanent fixtures, and so this book can also be used as a guide. It aims to highlight the graphic element in the installations, along with the communicative power of the arts of typography and lettering, demonstrating that these works deserve as much attention and appreciation as do architectural and artistic creations.

Opposite: Joan Brossa,
Transitable Visual Poem,
Barcelona.

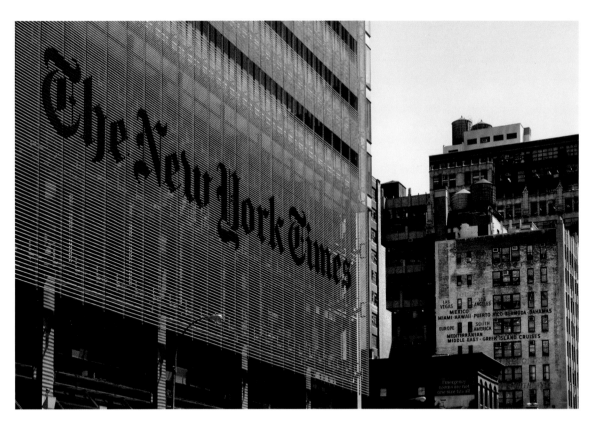

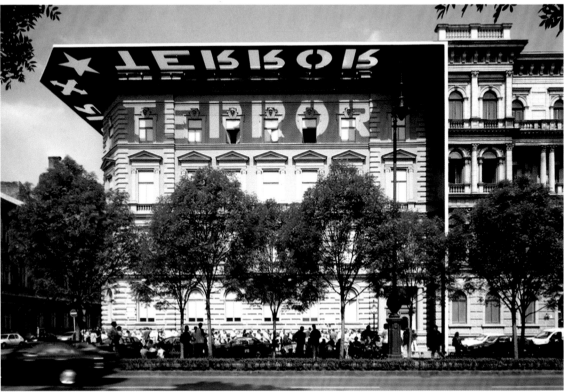

The Installations

Permanence was one of the main criteria in deciding which works to include in this collection – a decision that led to many ephemeral typographical installations, such as exhibition pavilions and staging, being excluded. The permanence of an installation underlines the commitment of the institutions and the community towards that particular work. However, even permanent installations may become altered as a result of damage from vandalism, or show signs of aging over time. Robert Indiana's sculpture *LOVE*, for example, has had to be re-fenced and repainted from time to time. One of the letters in Maarten de Reus's *G.R.O.E.N.* had to be replaced after a car ran off the road and destroyed it (although it saved the driver's life). And of the four original Bankside typographic fences designed by Caruso St John, only two have survived: one has been vandalized and another replaced by a new installation.

Siting an installation in a public or easily accessible location encourages spontaneous and unexpected interactions between the work and the visitor, particularly where many people pass through an area, bringing it to life. The word 'public' derives from the Latin *publicus*, meaning 'of the people'. This implies that a 'public space' is a space belonging to all – a part of a city, such as a street, square, park, railway station, town hall, library or theatre. Historically, it can be compared to the ancient Greek *agora*, the Roman *forum* and the great consular roads, medieval squares and more recent major urban works, such as the Parisian boulevards designed by Baron Hausmann in the mid-nineteenth century. Spaces are not merely physical entities; they are also symbolic of the civil liberty of democracy.

The landscapes in which these installations are showcased are many and varied, ranging from urban to natural. Some are sited in the centres of major cities (in New York, Rudolph de Harak's digital clock and Michael Bierut / Pentagram's signage for the *New York Times* building; in London, Caruso St John's Bankside Signage System; in Madrid, Estudio Sic & Buj+Colón's Monument to the Victims of 11 March 2004). Others are found in smaller towns (in a busy, partly pedestrianized district of Amsterdam, Lawrence Weiner's *A Translation from One Language to Another*; in the piazza of the small Emilian town of Carpi, Italy, BBPR's Museum-Monument to the Deportee for Political and Racial Reasons). Yet others are sited in urban suburbs (in Pantin, northeast of Paris, Pierre di Sciullo's installation for the National Dance Centre; in Ede, in the Netherlands, Karel Martens's facade for the Veenman printers). They might also be found in rural locations (in the Pentland Hills, in the countryside near Edinburgh, Ian Hamilton Finlay's Little Sparta).

The installations discussed here are almost always 'site specific', a term generally used in contemporary artistic and creative fields to describe a project designed for a particular location. Close links with the environment in which it stands are central to the development of a site-specific work, taking in not only space but also the history, architecture and culture of the place. This can be seen in the installations of designers such as Attila F. Kovács, whose work on the House of Terror Museum in Budapest uses materials and words to emphasize the facade of the very building in which opponents of the Nazi and Communist regimes were tortured to death; Lawrence Weiner, whose series of manhole covers for the city of New York poetically evokes the grid plan typical of large US cities; Caruso St John, whose signage system uses different forms and materials to represent the diversity of the people living in the regenerated Southwark area of London; Ashton Raggatt McDougall, who, for the Marion Cultural Centre, used the word as one element in the generation of a sense of community identity; and Gordon Young and Why Not Associates, who in all their works create relationships that are different each time, the product of their sensitivity to context.

Opposite top: Michael Bierut / Pentagram, signage for the *New York Times* building, New York City.

Opposite bottom: Attila F. Kovács, House of Terror Museum, Budapest.

In addition to these site-specific works, there are others that were not designed for the context in which they are located but nevertheless succeed in establishing an important dialogue with it. The most striking example is probably Robert Indiana's sculpture *LOVE*. Copies of this work can be found in many different cities, on a variety of sites including museums and private and public areas. The version in Philadelphia was particularly well received; the city has embraced the sculpture with such enthusiasm that the name of the square where it is sited has been changed from JFK Plaza to, inevitably, Love Park.

This book also examines a number of works in locations that are not strictly public, but are nevertheless easily accessed. One such is Little Sparta, the private garden of Ian Hamilton Finlay's house that establishes so close a relationship with the southern Scottish landscape that it seems to become an organic part of it. Also included are a number of typographical installations connected with museums, which, without being museum exhibits, form a structural component of the building itself. Sometimes the installation determines the physical layout of the museum space, as in the case of Smith-Miller+Hawkinson, Barbara Kruger, Quennell Rothschild and Guy Nordenson's *Imperfect Utopia*. Visible from an aeroplane and even from a satellite, the large letters forming the words '*PICTURE THIS*' generate a variety of spaces for the North Carolina Museum of Art in Raleigh, North Carolina. In other cases, it is the museum itself that becomes writing, taking its existence from it, as at the Museum-Monument to the Deportee for Political and Racial Reasons in Carpi, for which BBPR designed a commemorative space with rooms whose walls are covered in phrases and the names of victims of concentration camps, and, in the outside courtyard, steles bearing the names of the camps.

Finally, there are installations that, although they belong to buildings or other structures that are privately owned, are sited so that they can be seen by anyone passing by – for example, Ahn Sang-soo's Hangul Gate, which stands before the entrance to his house; the facade of the *New York Times* building designed by Michael Bierut / Pentagram; or Rudolph de Harak's digital clock displayed on a private building, presently owned by the Rockrose Development Corporation, but designed with the specific intention of providing a service to people using John Street in Manhattan.

Interaction with People

The first contact between installation and visitor is visual. The study of lettering is a discipline that is based above all on observation, as Phil Baines and Catherine Dixon point out in their book *Signs*: 'It is about seeing the letters which surround us in our public spaces; about seeing that which all too often we don't see: the directional signs for road networks passed by in cars at speed; the inscriptions or names on familiar buildings; even the characters found on the most mundane functional objects of our physical environment such as access grills for public utilities.'[2]

Some installations do require particularly careful observation. One example is Ilya Kabakov's *Antenna*. The text, composed of thin metal wire, is barely visible against its background of sky. Fundamental to this work – the secondary title of which is *Looking up, Reading the Words* – is the ability to look carefully. In Josep Maria Subirachs's installation for the new Barcelona town hall, the lettering that spells out the city's name is so closely integrated with the modular design of the facade that it is practically invisible. It is said that even Subirachs himself was unable to read it the first time he saw it. It becomes a kind of game to puzzle out the inscription, just as with Joan Brossa's *Visual Poem for a Facade*, where we need to understand the relationships between the letters arranged on the wall. We slowly perceive that the fifty letters making up the multi-coloured horizontal sign are repeated and arranged above the name of the building in five columns, in alphabetical order, using the same allocation of colours.

Opposite top:
Smith-Miller+Hawkinson,
Barbara Kruger, Quennell
Rothschild and Guy Nordenson,
Imperfect Utopia, Raleigh,
North Carolina.

Opposite bottom: Ilya Kabakov,
Antenna, Münster, Germany.

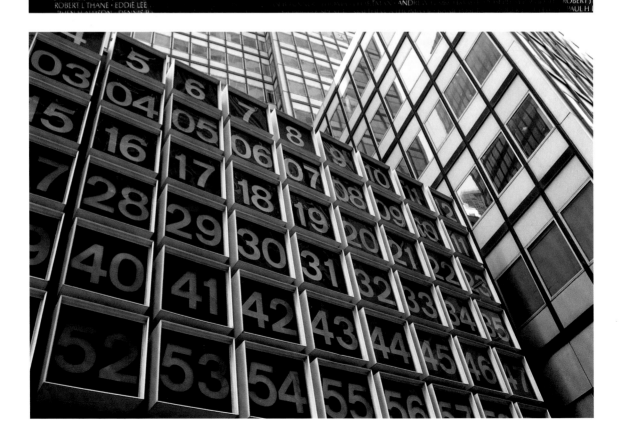

Another kind of typographical installation links our perception of the letters with movement. Examples are the works by Maarten de Reus in Carnisselande and Caruso St John in London. Maarten de Reus's installation consists of five enormous letters set up in the centre of a roundabout. As Baines and Dixon say, 'G.R.O.E.N. cannot be read from any one point but is a "drive-by art piece" which upon first acquaintance needs to be spelt out letter by letter as a child would read.'[3] Reading depends here on the driver's progress around the roundabout. One of the typographic fences designed by Caruso St John bears the word 'Bankside' painted on metal mesh. Peter St John explains, 'The holes in the fencing are so big that you can only read the letters clearly when you look at the sign obliquely, so that it seems to disappear as you walk past it.'[4]

In other cases, the relationship with the installation is based on touch, as with the Vietnam Veterans Memorial in Washington DC, designed by architect Maya Lin. Many people touch the inscribed name of a relative who died in the war as if to stay in contact with the actual person. This experience may prompt visitors to record the sensation more permanently: a sheet of paper and a pencil are all that is needed to take a rubbing of the loved one's name. It is not known whether this practice was suggested by the architect herself, by the foundation that looks after the memorial or if it came about spontaneously. What is clear is that today sheets of paper supplied by the Veterans Memorial Fund are handed out to visitors so that they can make rubbings. If anyone is unable to do it themselves, the Fund will make a rubbing and send it to them. Another example of an installation that refers to touch is Anton Parsons's *Invisible City*, in which the artist uses Braille, enlarged and therefore unreadable, as an invitation to an exploration extending beyond vision. Sometimes the local citizens become so attached to a work that they put pressure on the local authorities to ensure its future. This was the case with Robert Indiana's sculpture *LOVE*, now returned to Philadelphia thanks to the campaign organized by its citizens. Another example with a happy ending is that of FA+'s *Citat*, initially conceived as a temporary inscription painted on the asphalt of a Stockholm street, but which became so popular that the people the city asked to have it made permanent.

An installation can also court negative reactions, as in the case of *The Cursing Stone and Reiver Pavement* designed by Gordon Young with Why Not Associates, which gave rise to something of a furore. Inscribed with a famous curse, the stone has been seen by some as bringing bad luck on the inhabitants of the area. Attempts were even made to have it destroyed but, despite protests, the stone remains in its original position.

The Authors

The designers of the installations considered here differ greatly in their disciplines and professional backgrounds. They include graphic designers, artists, architects and stone-carvers. Different areas often overlap, leading to fruitful collaborations. There are two important examples of this: *Imperfect Utopia*, which came from a collaboration between architects Smith-Miller+Hawkinson, artist Barbara Kruger, landscape architects Quennell Rothschild and structural engineer Guy Nordenson; and the installations executed by the artist Gordon Young with the Why Not Associates group of graphic designers.

There are other professionals whose training does not preclude an interest in and knowledge of other disciplines. One of these is letter-carver Richard Kindersley: 'I work closely with architects developing lettering schemes and was awarded an Honorary Fellowship of the Royal Institute of British Architecture for my work in this area. I also undertake work in the graphic design field, and I have collaborated with people like Alan Fletcher and others,' he says.[5]

The architects of Caruso St John collaborate with graphic designers and outside artists. As Peter St John says, 'We sometimes use graphic designers, although we didn't

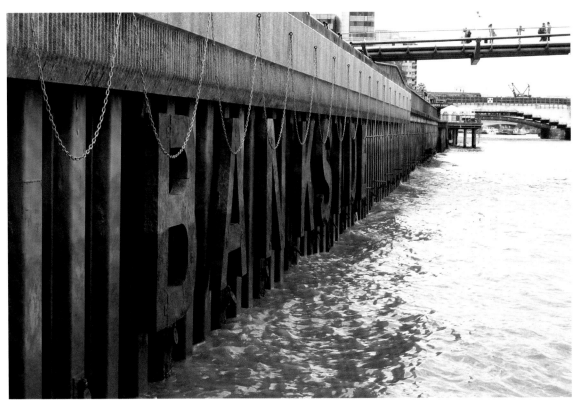

on this project [Bankside Signage System]. Here the graphic part was an integral part of our design. We worked with an artist (Roy Voss) at first, to develop the concept. We tend to do this a lot.'[6]

Three-dimensional Graphics and Manufacturing Techniques

In typographic installations, as opposed to printed works, letters do not lie on the static space of a page. They inhabit a dynamic space where people live and life flows. Letters thus acquire new characteristics, such as texture and volume, in a way that is much more obvious than in printed letters.

There are many ways in which typographic installations can integrate letters with space, ranging from a more or less two-dimensional letter on a surface to one that is fully three-dimensional and free-standing like a statue. Expressive inspiration, construction techniques and a variety of materials each have a role to play. Examples of installations exploiting two-dimensionality include Estudio SIC & Buj+Colón's Monument to the Victims of 11 March 2004, with its letters printed on a thin and almost invisible ETFE membrane suspended within the glass dome; Karel Martens's work for Veenman printers, in which a poem is reproduced on the external glass panes using a screen-printing technique; and Paula Scher / Pentagram's work for the New Jersey Performing Arts Center / Lucent Technologies Center for Arts Education (NJPAC), in which repeated words on the external walls are simply painted on. It has always been the case that the most widespread and immediate method for writing on a building is by painting, despite the need for periodic restoration to keep it in good condition. The great virtue of painted letters lies in their readability. According to Peter St John, 'A painted word always has a better chance of being legible from an acute angle than most constructed or modelled characters. Nineteenth-century sign painters got the best of both worlds by giving their letters pretend returns and shadows, so that they were enriched without loss of legibility.'[6]

But there are also cases where the letters begin to take on a perceptible thickness, revealing not only a frontal dimension but also a side dimension. An example is Lawrence Weiner's *NYC Manhole Covers*, in which the cast design stands out in light relief. This makes it possible both to step on them and to read them. As letter thickness increases, we need to take into consideration the letter's section and the shadow it casts. One material that lends itself to imprinting with a stamp is concrete, a technique of which Catherine Griffiths made extensive use in her Wellington Writers Walk, and that was also used by BBPR for the steles in the courtyard of the Museum-Monument to the Deportee for Political and Racial Reasons. As the letters become thicker, the role of light in augmenting the appearance of volume becomes increasingly important. This is the case with Joan Brossa's *Visual Poem for a Facade*, where the plastic letters are placed so as to stand away from the building and create a shadow that emphasizes their three-dimensional appearance. Pierre di Sciullo's external installation for the National Dance Centre is another three-dimensional piece of lettering; erected on the roof of the building, at night it is transformed into neon writing.

Some works use letters, neither entirely two-dimensional nor three-dimensional, that become almost an integral part of the construction. One example is Cardozo Kindersley Workshop's British Library Gates, which consist of the repeated words 'British Library' extending to a height of 4 metres (13 feet); the depth of the letters is not immediately apparent.

Sometimes a typographical installation has no physical link with the building. Where there is a logical link with the architecture, there arises what has been described by Jock Kinneir as 'a state of happy coexistence in which two very different partners maintain their integrity'.[7] A good example is Chermayeff & Geismar's *9 West 57th Street*, where

Opposite top: Gordon Young with Why Not Associates, *Walk of Art*, Wakefield, West Yorkshire, UK.

Opposite bottom: Caruso St John, Bankside Signage System, London.

the enormous '9', the street number of the neighbouring skyscraper, can be explored from all sides. *M,* designed by Roberto Behar & Rosario Marquardt / R & R Studios, stands alone in front of the entrance to the Metro station on the Miami Riverwalk. Its link with the station is established by fact that *M* stands for Metro, and because travellers wishing to enter the station must pass through the legs of the *M*.

There are also installations in which the letters become entirely autonomous, existing without reference to any surrounding architecture. *Bàrcino* is a work by Joan Brossa in Barcelona, in which the name of the ancient Roman city is rendered in seven different sculptures, one for each letter of the word. Maarten de Reus's *G.R.O.E.N.* is similarly an installation consisting of five different letters, while Robert Indiana's *LOVE* is a sculpture made up of a group of interlinked letters, composed in an arrangement that makes the sculpture unique.

In the examples seen so far, the three-dimensional appearance of the letters is achieved by adding material. But it can also be achieved by subtraction, for example, by carving or inscribing. Inscriptions can be characterized by the material used and the type of section chosen; the section can be V-sunk, as in most Roman inscriptions, though square sinkages are sometimes used for greater emphasis. Richard Kindersley's installation at Canning Town Underground Station in London is unusual as he has chosen to use concrete, a particularly difficult material to work with, for his carved inscriptions. In contrast, Maya Lin used an automated technique, photo-stencil gritblasting, to inscribe the names – more than 50,000 in number – on the Vietnam Veterans Memorial.

Another subtractive technique is to cut out the letters from the background material. An example is *Walk of Art*, designed by Gordon Young with Why Not Associates, where the names of donors are formed by piercing the metal plates that form the walkway. Similarly, in Attila F. Kovács's work for the House of Terror Museum, the letters of the word 'TERROR' are created by piercing the metal. These cast shadows on the facade, the pavement and the street, perhaps to suggest the immateriality of the spectre of fear.

Letters, Words and Texts

The installations discussed here all relate to the world of letters, but each in a different way. First, there are quantitative differences between them. Some works are composed of a single letter (Brossa's *Transitable Visual Poem* and René Knip's *ABC on the Hoofdweg*), others of a single word (Robert Indiana's *LOVE*, Maarten de Reus's *G.R.O.E.N.* and Pierre di Sciullo's National Dance Centre). Some feature lists of words (*Walk of Art* by Gordon Young with Why Not Associates and the Vietnam Veterans Memorial by Maya Lin), repeated words (Paula Scher / Pentagram's NJPAC and Cardozo Kindersley Workshop's British Library Gates) or whole texts (Karel Martens's exterior for Veenman printers and Catherine Griffiths's Wellington Writers Walk).

The choice to use one or more letters or words, and the judgement of the balance between content and form, text and image, depend on the message that the creator of the work wishes to communicate. Where a single letter or number is used, as in Chermayeff & Geismar's 9 *West 57th Street*, the installation becomes a sculpture in which our understanding of the sign seems almost secondary in importance. It is as if we could abstract the meaning of that particular installation to a point where, paradoxically (because very often these are the larger installations), its meaning resides not so much in what the letter signifies as in the composition as a whole.

Although all installations must address more or less explicitly the relationship between form and meaning, there are some that are particularly symbolic in approach. In the case of texts, it is usually important that they are legible as, for example, those

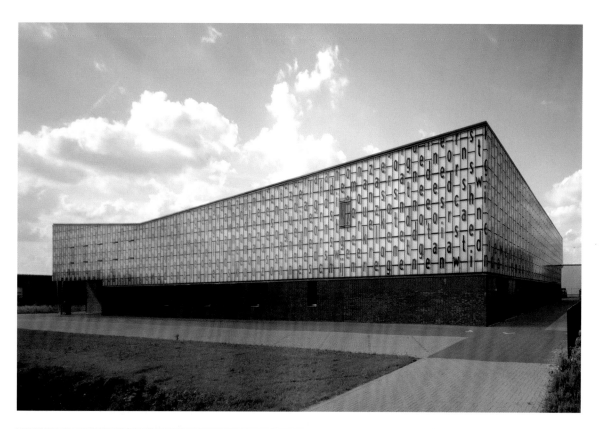

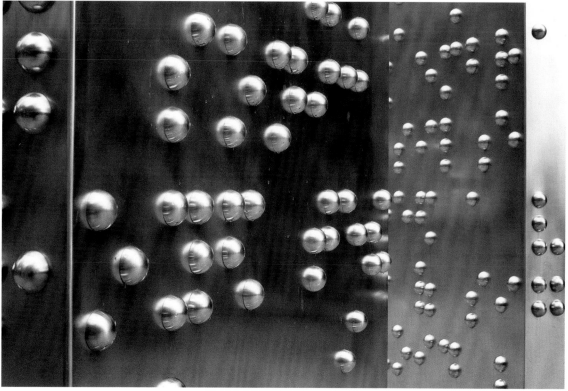

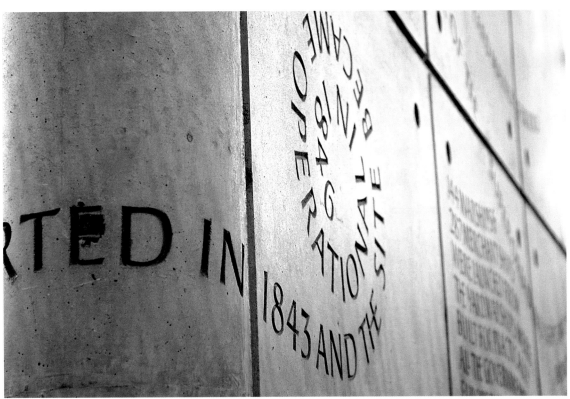

on the Wellington Writers Walk designed by Catherine Griffiths, which is covered with quotations from local authors. This means that the design of the letterform must also be legible in relation to the materials, techniques and colours chosen.

An interesting example is Karel Martens's work for the Veenman printers' building, where the letterforms are very legible but the text itself less so: K. Schippers's poem is broken down into letters arranged according to a geometric grill pattern on the facade, making it unreadable.

Where the text consists of a list – a situation typical of, but not limited to, memorials – it is the very repetition of words that can become the starting point for interesting and evocative compositions that are anything but boringly repetitive. Very often, the emphasis is placed on the number of names, giving visitors a sense of the extent of the tragedy and arousing their empathy. Maya Lin's Vietnam Veterans Memorial is a striking example, listing the names of 58,195 victims of the Vietnam War on a long black granite wall. Here it is possible both to find the precise position of an individual name and, at the same time, to be struck by the dramatic immensity of the whole. While at the Vietnam Veterans Memorial each name has its precise location on the installation, the architects of the Museum-Monument to the Deportee for Political and Racial Reasons, BBPR, have sought to create a more general effect. The interior of the last room of the museum is entirely covered by the names of the victims. In this case, however, the list is not exhaustive. Only some of the names are recorded, since the intention is not to focus on the individual but to overwhelm the visitor with an overall impression. The names appear everywhere: on walls, ceilings, vaults, columns and even doors and window surrounds. Some names stand for others, as in the case of Anne Frank, whose name symbolically represents all the children who lost their lives during the deportations. Hidden among the letters are acrostics, including 'Bruno Losi', the name of the mayor who strongly pushed for the building of the museum, and 'Cooperativa Muratori e Braccianti di Carpi', the name of the building company that carried out the work.

In *Walk of Art* by Gordon Young with Why Not Associates, a typographical walkway bears the incised names of supporters who campaigned to raise money for the Yorkshire Sculpture Park, both to thank the donors and to encourage others to give.

Type and Lettering

The installations use a wide variety of letterforms, chosen according to the type of work, the requirements of the commission, the characteristics of the materials used and, not least, the personalities of the creators who, through their professional training, will inevitably relate in different ways to the world of typography.

There is a crucial difference between type and lettering. As Baines and Dixon explain, 'Put very simply, type is an industrial product capable of duplication and automation, while lettering is a one-off, created for a specific purpose and capable of responding to the demands of scale, material and surroundings in quite a different way.'[8]

The following are only some of the very many examples of typographical letterforms used in these installations: Akzidenz Grotesk for Rudolph de Harak's digital clock and for Caruso St John's Bankside Signage System; Helvetica for *Citat* by FA+; Optima for Maya Lin's Vietnam Veterans Memorial; Helvetica with Optima for the Wellington Writers Walk by Catherine Griffiths; Univers for Joan Brossa's *Visual Poem for a Facade*; Agency Gothic for NJPAC by Paula Scher; and the letterforms designed by Eric Gill, favoured by Why Not Associates.

By contrast, Richard Kindersley's lettering for Canning Town Underground was designed especially for this project. Deriving from calligraphy, the letters are carved individually, with no two exactly the same. Maarten de Reus designed only the five

characters making up the word *G.R.O.E.N*, further letters being unnecessary. It is possible to see three different types of lettering at the Museum-Monument to the Deportee for Political and Racial Reasons. There is little information at the museum about the lettering, which does not seem to be based on any preexisting characters. It is probable that the lettering was done by the workers themselves without a systematic design but with sensitivity and a good sense of composition. Other designers have taken existing typographical characters and modified them. Lawrence Weiner, both for *A Translation from One Language to Another* and for *NYC Manhole Covers*, bases his letters on Franklin Gothic; Pierre di Sciullo's letters for the National Dance Centre are based on his own Minimum Sol; for *Nearamnew* Paul Carter reworks Meta; the letterforms of Robert Indiana's *LOVE* seem to have been inspired by Clarendon.

Type, Lettering and Art: The Debate

Many scholars, such as Nicolete Gray, Phil Baines and Walter Tracy, have discussed the use of types and lettering in public places, raising the question of the kind of training necessary to carry out these kinds of projects. In their view, the use of typefaces on buildings by professionals with little specific training often creates unpleasant results, which can debase the architecture itself and diminish its impact on the landscape. In their view, a public lettering is meant to be read. It must not, then, be ephemeral and it must be subject to rigorous study. Tracy sets out three critiques for the use of types in publicly displayed writing. The first concerns their two-dimensionality: types are designed to be printed, so they should be flat. The second relates to size: types are created to be printed to a certain size, definitely smaller than that of a sign. The third deals with their historical connotations: a typeface, particularly in its detail, inevitably reveals the period in which it was created and the techniques used. Tracy calls on architects to treat lettering with the same seriousness and rigour as other aspects of architecture. 'It is the architect, though, who in this, as in other contemporary matters, ought to take a positive line. His new factories, offices and flats are transforming so much the scenery that he ought to signify them in something more appropriate than printer's type; ought, in fact, to recognize with gratitude that original lettering may be a small but useful means of adding a visible touch of humanity to the growing rectangularities of the urban landscape.'[9]

Tracy continues: 'The better course is to find a designer with real ability in *creative* lettering (a few typographers may have it), give him a detailed view of the problem and demand a design which is original, distinctive, permanently attractive, and as true to that particular building as any other detail.'[10] It is these considerations that highlight the need for a specific professional training for those wishing to work in the area of public lettering. As Baines and Dixon argue, 'Ironically, while letters may surround us, nowhere is the subject of environmental lettering taught. Its broad nature means that it is spread too thinly across too many different courses, each with other teaching priorities. In the case of graphic design, a growing emphasis on the typography has meant that the teaching of the more fluid subject of lettering has all but been abandoned. This, and the ability of contemporary production methods to generate types at any size on virtually any substrate, tends to blind us to the important differences between lettering and type.'[11]

This debate, initiated in 1960 by Nicolete Gray, is still of great significance today, as it encourages us to take public lettering and its particular requirements seriously.

Notes

[1] Jock Kinneir, *Words and Buildings: The Art and Practice of Public Lettering,* The Architectural Press, London, 1980, p. 72.

[2] Phil Baines and Catherine Dixon, *Signs: Lettering in the Environment,* Laurence King, London, 2003, p. 7.

[3] Ibid., p. 160.

[4] Interview with Peter St John, 20 October 2011.

[5] Interview with Richard Kindersley, 21 October 2011.

[6] Interview with Peter St John, 20 October 2011.

[7] Jock Kinneir, *Words and Buildings*, p. 74.

[8] Baines and Dixon, *Signs*, p. 8.

[9] Walter Tracy, 'Typography on Buildings', *Motif*, no. 4, Shenval Press, London, 1960, p. 86.

[10] Ibid., pp. 84–85.

[11] Baines and Dixon, *Signs*, pp. 7–8.

Projects

Wrought-iron characters form a
unique typographical texture in
homage to Hangul script.

Ahn Sang-soo
Hangul Gate

Jongno-gu, Pyeongchang-dong, 131–21,
Seoul, South Korea

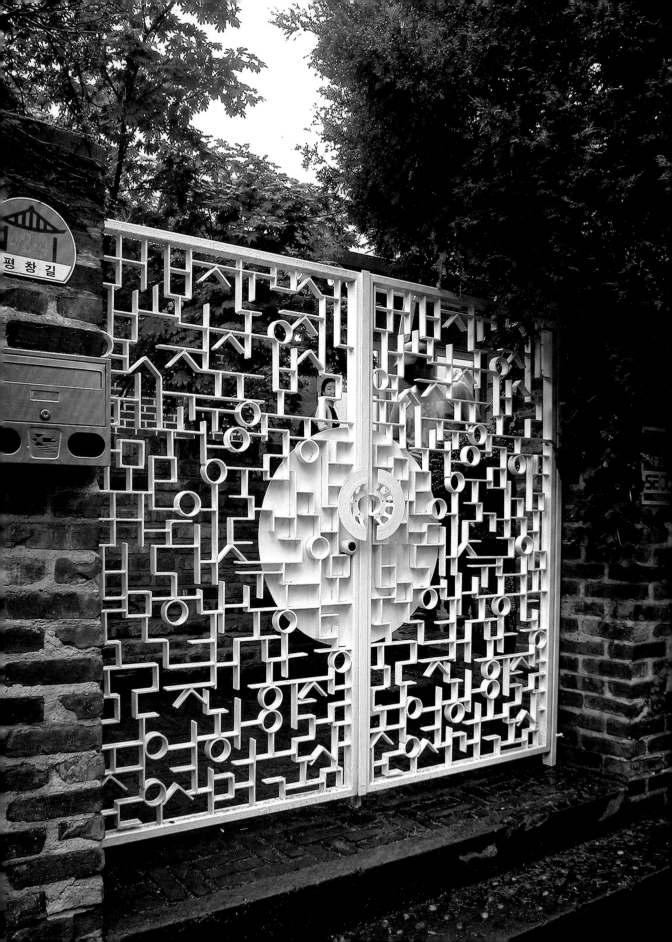

[1] Alain Le Quernec (introduction), *Ahn Sang-soo: Graphiste*, Collection Design&Designer no. 35, Pyramyd, Paris, 2005, p. 6.

[2] Ibid., p. 8.

In 2001, Ahn Sang-soo designed the gates for his house in Seoul using characters from the Korean Hangul alphabet, linked together to form a compact and regular texture. Made of wrought iron and painted white, the gates stand at the end of a cul-de-sac, so to see them one must turn into the road. It can be no chance happening that a graphics and type designer such as Ahn Sang-soo has chosen to enclose the private space around his house with Hangul script, which he has actively promoted through his studies and designs for many years.

Created according to a rational process, the Hangul script is unique in the world: it is the only form of writing of which we know the origin. Reproducing precisely the sounds of spoken Korean, Hangul was designed to be easily learned by ordinary people. It was officially promulgated in 1446 by the Korean king, Sejong the Great, in a small book with the title *Correct Sounds for Teaching the People*. This cultural reform, replacing the complex Chinese system that had been used for writing with one of only twenty-eight alphabetic symbols (later reduced to twenty-four), gave birth to a Korean script and has contributed much to a sense of national identity. As designer Alain Le Quernec has written, 'This original, rational and intelligent script is a major founding act in the history of Korean culture and identity.'[1] The letters in the Hangul alphabet are composed of no more than five formal elements: a point, a horizontal line, a vertical line, a diagonal line and a circle. The characters represent the form taken by the mouth, tongue, teeth, lips and glottis when pronouncing that particular sound. The vowels are represented by only three elements: a point, a horizontal line and a vertical line.

Hangul has yet to attain full national exposure. It was almost entirely suppressed during the period of Japanese occupation between 1910 and 1945 and, though it was reintroduced as the official writing system in 1945, its use today is precarious and inter-mittent. Ahn maintains that there are good reasons for continuing to use Hangul. First and foremost, it symbolizes Korean independence. Furthermore, with its ten vowels and fourteen consonants, it is capable of conveying almost any sound. It can be learned in a few hours and also contributes to the preservation of the minority languages spoken in Korea that would otherwise disappear without a trace.

Ahn has become a spokesperson for the campaign for the promotion of Hangul, arranging exhibitions, designing posters and logos for presentations and performances, giving lectures and speaking at conferences throughout the world. Like Chinese char-acters, Hangul characters are typically fitted within a square. Ahn has sought to free Hangul from this geometric straitjacket, placing the individual elements in separate positions.

According to Le Quernec, 'Ahn has sought to make signs legible through a process of refinement, as if ease of reading allows freedom of composition. Contrary to destruction, his work seems to be an admirable tribute to the Korean script, which he aims to endow with a possible new dimension; and it seems to be working.'[2]

Ahn's experimentation has led to the design of characters that allow the signs to be freely arranged using a computer. This project presents significant difficulties, given that the five simple elements can combine to make up more than 10,000 characters. In his work, the letters are combined in such a way as to give several meanings or no meaning at all. The characters he designs – sometimes almost impossible to read – are mainly used for titles and posters.

Opposite and following pages: Characters from Hangul script are linked together to form the gate.

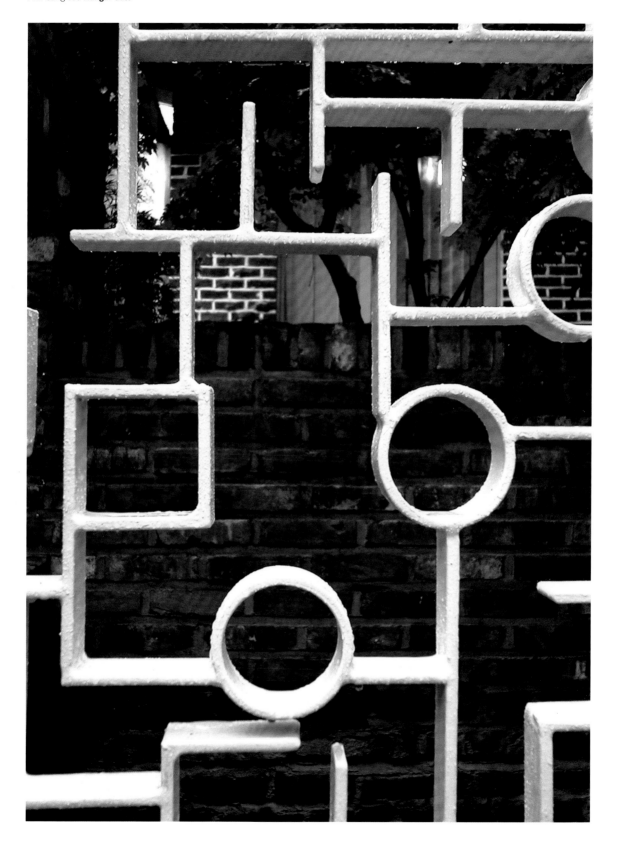

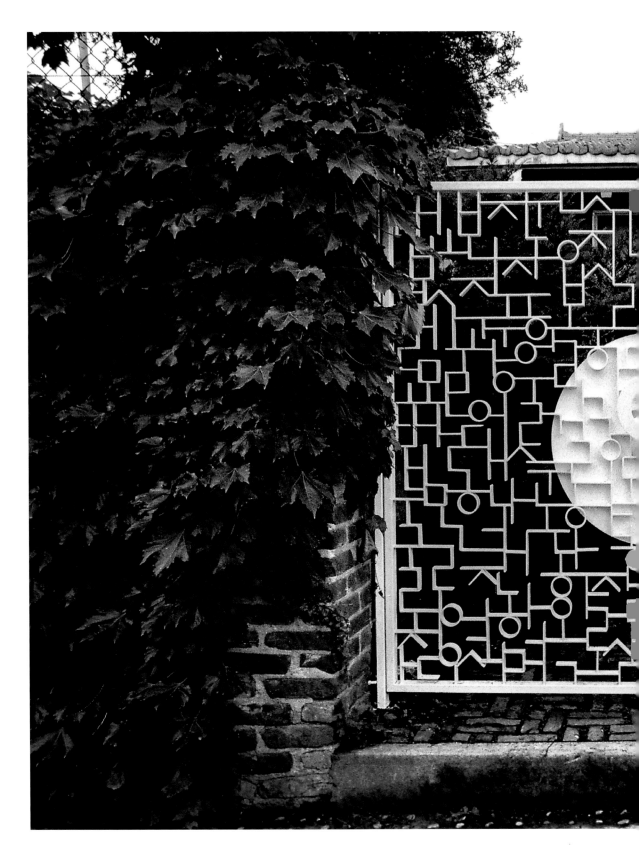

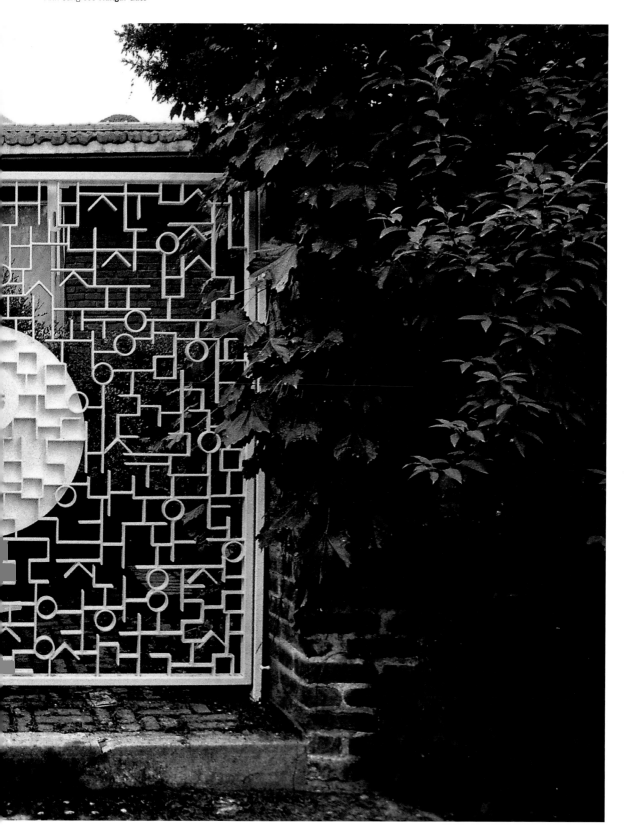

A symbolic integration of architecture
and lettering creates a landmark for a
growing community.

Ashton Raggatt McDougall
Marion Cultural Centre

287 Diagonal Road, Oaklands Park, Marion,
South Australia, Australia

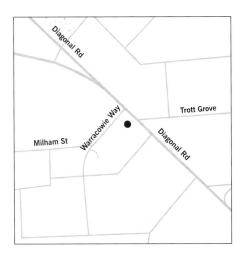

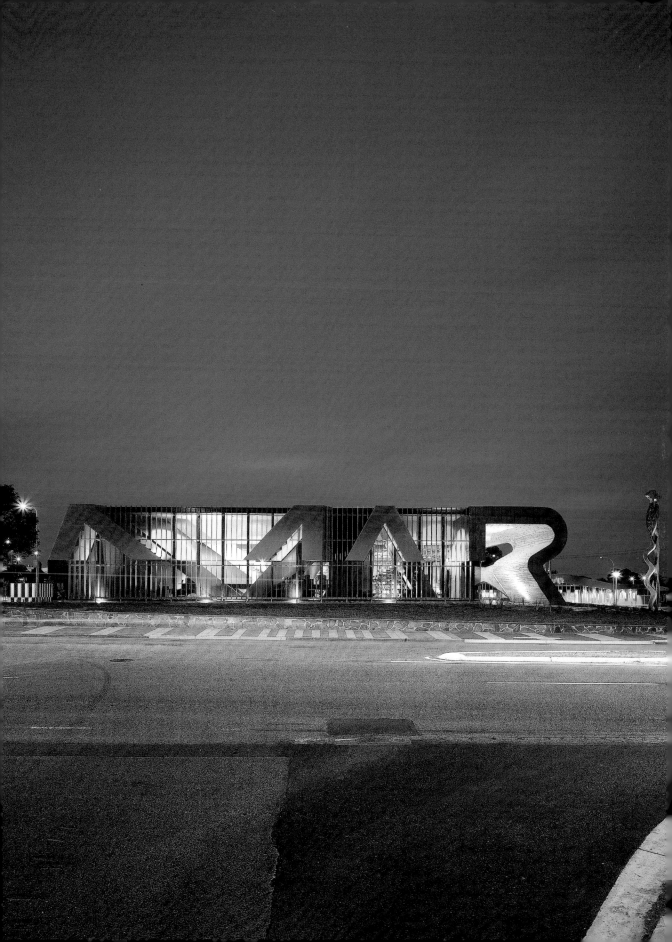

The Marion Cultural Centre was completed in 2001 by Ashton Raggatt McDougall (ARM) in collaboration with Phillips/Pilkington Architects for the city of Marion, South Australia, near to Adelaide.

Covering an area of 2,500 square metres, the Cultural Centre has, among other services, a library, an information centre, an exhibition area, a theatre, a refreshment bar and a car park. The word 'Marion', split up and rearranged so that is it not immediately recognizable, is used within the architecture of the Cultural Centre to create a space that provides a reference point for a community that has not yet developed its own architectural style. As Paolo Tombesi has said, 'The built history of Marion may not yet have allowed the community to recognize itself in the buildings that represent its evolution. Its name, however, does constitute a landmark in people's social experience of the place. Hence the decision to make the name of the architecture the architecture of the centre.'[1]

[1] Paolo Tombesi, 'Sign language', *Domus*, no. 848, 2002, p. 62.

Ashton Raggatt McDougall's decision to use letters in this case was inspired by nineteenth-century usage, when words were displayed on the main facade to give importance to public buildings such as town halls and libraries.

The Marion Cultural Centre deliberately emphasizes the horizontal in order to take up as much space as possible, thus increasing its visibility. The letters relate to the building in different ways: *M*, *A* and *R* are fully integrated within the architecture, while the other letters – *I*, *O* and *N* – are located in the surrounding landscape. In addition, *M*, *A* and *R* not only become part of the facade, but also have specific functions: *M* and *A* encase the reading room without isolating it from its surroundings, while *R* protrudes slightly from the building, acting as a veranda to shelter visitors from the rain.

The letter *I*, by contrast, is a piece of sculpture entitled *From the Horizon to the Horizon*, by local artist Greg Johns. The 8-metre (26-foot) double metallic column located near the main facade links the letters *M*, *A* and *R*, running along Diagonal Road, with the sculptures *O* and *N*, which stand along a smaller road, Warracowie Way. The letter *I* comprises a base of local ironstone, a central part with a shape similar to that of a river or a snake (in a reference to the local Sturt River) and a final section in the shape of a cloud.

The letters *O* and *N* are similarly independent of the main building: the *O* is composed of large stone blocks that mark the edge of a flower bed, while the *N* is a vertical trellis that acts as a support for climbing plants near the entrance to the area. The letters are also repeated, in dismembered or distorted forms, within the building. The letter *R*, for example, can be read as such only from the main facade. It is repeated in mirror image on the north facade. Similarly, the letter *M*, visible on the main facade, reappears on the rear elevation in red. A fragment of the bright orange *A* protrudes from the west corner, having cut through the entire building, determining the internal spaces of the foyer, bar and gallery. The word is only completely legible from the corner of Diagonal Road, on which the main facade stands, and Warracowie Way, where the three external elements are situated.

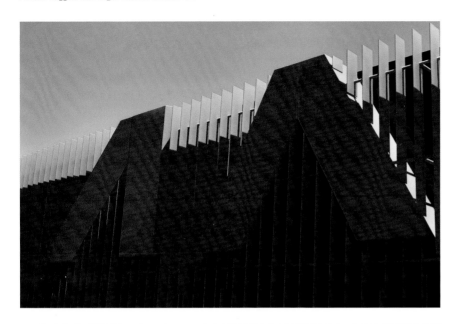

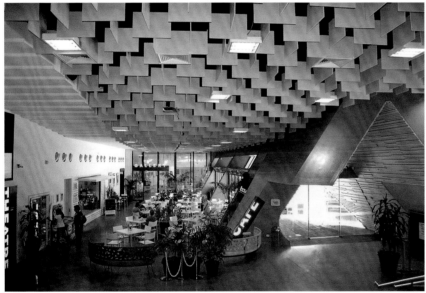

Top: A front view of the building showing the *M* and *A*.

Above: An internal view of the cafeteria, crossed by the *A*.

Following pages: The whole word, visible from the corner of Diagonal Road and Warracowie Way.

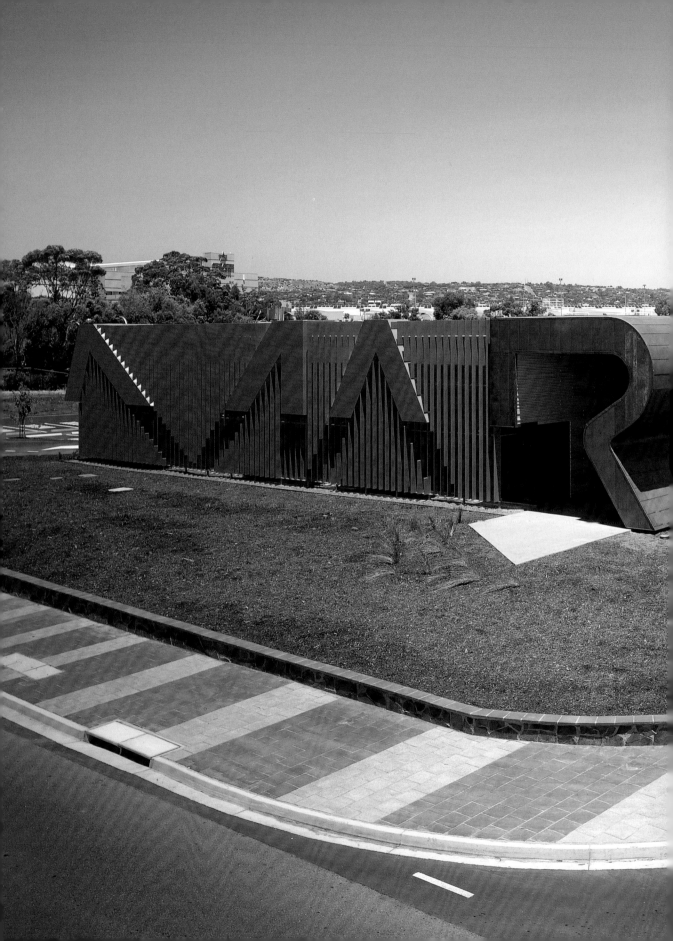

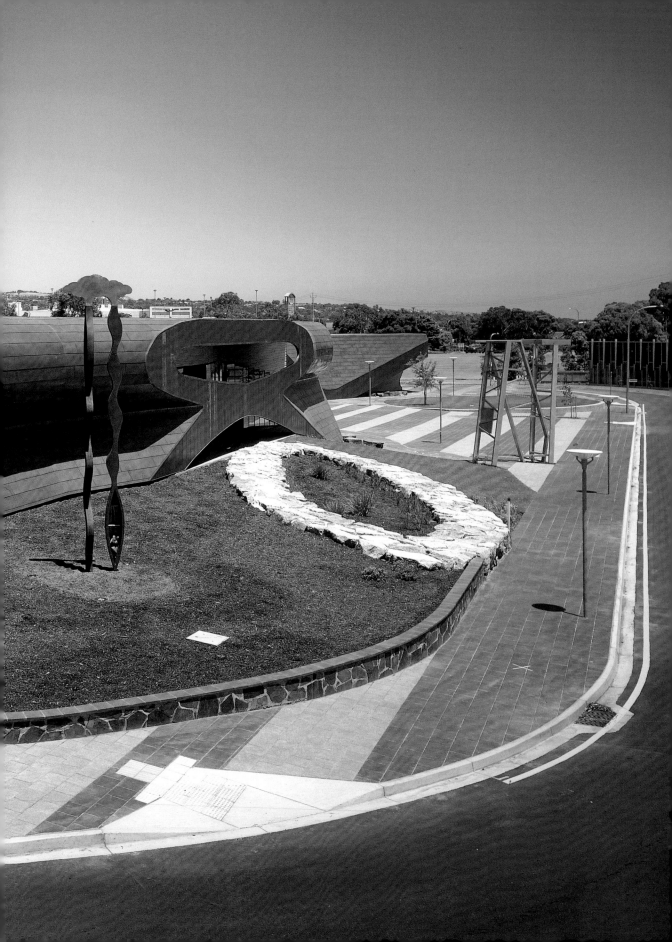

The letters *M*, *A* and *R* are fully integrated into the architecture.

Commemorating the drama
of deportation using
the power of words.

BBPR
Museum-Monument to the Deportee for Political and Racial Reasons

Piazza dei Martiri 68, Carpi, Modena, Italy

[1] Metella Montanari (ed.), *Architetture della memoria: Ideazione, progettazione, realizzazione del Museo monumento al deportato di Carpi*, Comune di Carpi, 2003, p. 70.

During the Second World War, a transit camp housing prisoners destined for concentration camps was established in Fossoli on the outskirts of Carpi (Modena). Bruno Losi, who was mayor of Carpi from 1945 to 1970, had the idea to institute a museum-monument dedicated to the deportees, in order to keep the memory alive and pay homage to those who had died. In 1963 a competition was held to restore Castello dei Pio and create an exhibition space in which architecture, painting, sculpture and graphics could be displayed together. The winners were BBPR (Belgiojoso, Banfi, Peressutti e Rogers) with the painter Renato Guttuso. Completed in 1973, the work was executed with both skill and commitment by the Cooperativa Muratori e Braccianti di Carpi (CMB), the same cooperative building group that had constructed the transit camp at Fossoli twenty years earlier.

The written word, immediate and explicative, was chosen to convey the trauma of deportation, which is the museum's main intent. The architecture becomes the medium that gives prominence to the words set on the walls.

The museum is organized so that the visitor walks through thirteen connected rooms within the castle, finally exiting to the courtyard. The first twelve rooms are bare and grey. On their walls are lines referring to the tragic history of the site, selected by the poet and film director Nelo Risi from the anthology *Lettere di condannati a morte della Resistenza europea*. Alongside these are wall paintings executed by artists including Picasso, Longoni, Léger, Cagli and Guttuso, as well as cabinets containing photographs and objects selected and arranged by Lica and Albe Steiner, who were in charge of the exhibition display. The last room is known as the Room of Names: its ceiling and walls are covered with the names of some 15,000 Italians who died in the Nazi concentration camps. Their names were selected at random by ANED (Associazione Nazionale Ex Deportati politici nei campi nazisti).

The visit ends outside, where sixteen reinforced concrete steles display the names of some of the concentration camps. The words inside the museum were reproduced on the walls using the *spolvero* technique, whereby an original, smaller-scale design is projected and traced onto large sheets of white paper, which are cut into vertical strips and applied onto the rough grey plaster, beneath which is another layer of black or red plaster. The outline on the paper is pierced with an awl and dusted (*spolverato*) with cement or chalk powder. The paper is then removed so that the direct inscribing, done with a flat-ended nail, can be carried out following the traces left by the powder. The difficulty with this procedure is that it is necessary to work very quickly, inscribing the words before the plaster dries. While this was relatively easy in the case of the quotations, for which an area of plaster the right size could be applied quickly and the plastering of the rest of the bare wall could be carried out later, it was much more difficult in the Room of Names where, as historian Metella Montanari explains, 'The number of names that could be inscribed before the plaster dried out had to be carefully calculated. These calculations became even more complicated when it was decided to use the vaulted ceilings as well. These curved surfaces were eventually covered with a further 3,000 names.'[1]

The names of the concentration camps on the outside steles are stamped into the reinforced concrete using trapezoidal cross-section wooden moulds. The letterform used throughout is an upper-case sans serif.

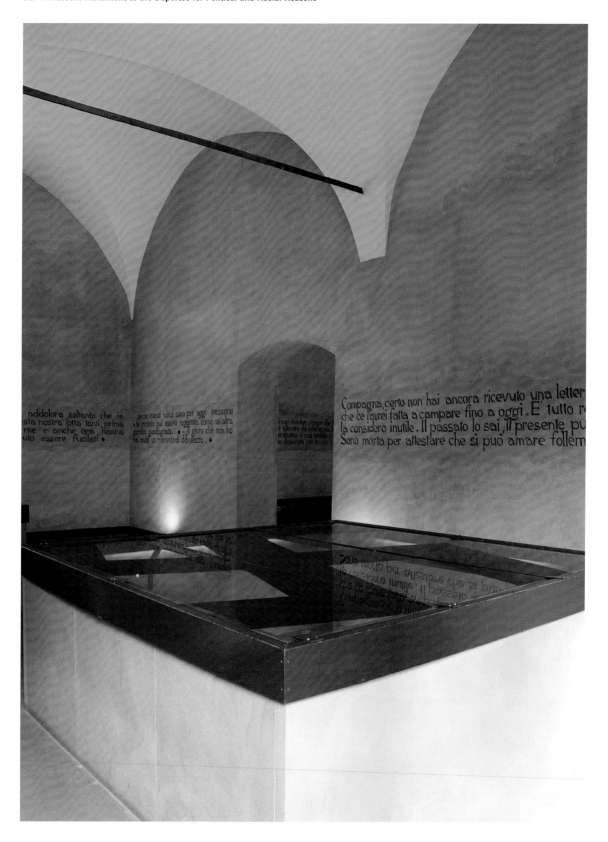

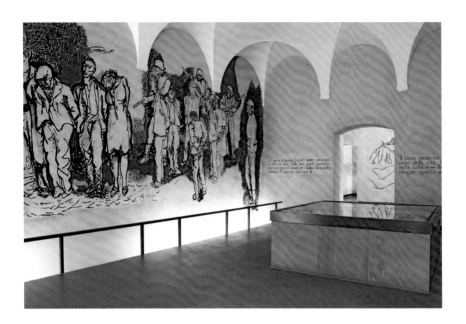

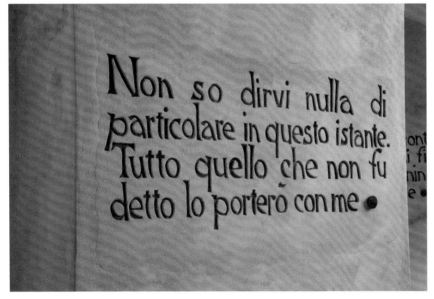

'I cannot say anything in
particular at this moment.

Everything that wasn't said
I will take with me.'

Preceding pages, top and
above: On the walls are short
texts selected by Nelo Risi from
*Lettere di condannati a morte
della Resistenza europea*.

Opposite: In the twelve rooms,
the letters were made using the
spolvero technique, which was
also used for the wall paintings
and the names in the last room.

ara mamma,

persone, ce

e uno dei ta

el popolo... in

RO NOT-

IGI GRAF

AZIO –

COEN –

CAIVANO

CE BONDI'

ESTINA BORGETT

ENRICA CALO' – GI

MIRELLA BEARD

CRISAN-

ADA TEDESCHI

ROSA SALMONI

PAOLA ROSATI

IDA PISA – JO

LE SED

A
RIN
IDA
GIAC
EMMA
INES PA

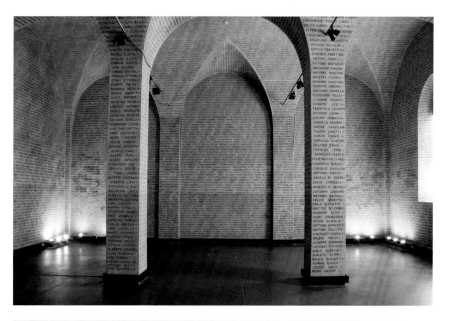

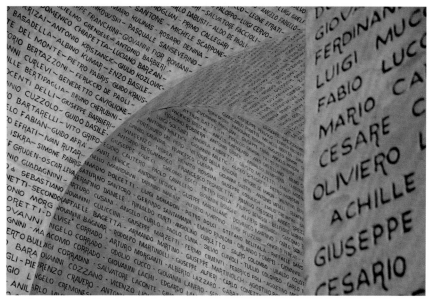

Opposite and top: Views of the last room of the museum, also known as the Room of Names. All the architectural elements – walls, ceiling, arches and columns – are covered with a dense letter texture.

Above: This alphabet's most distinctive letter is the *R*.

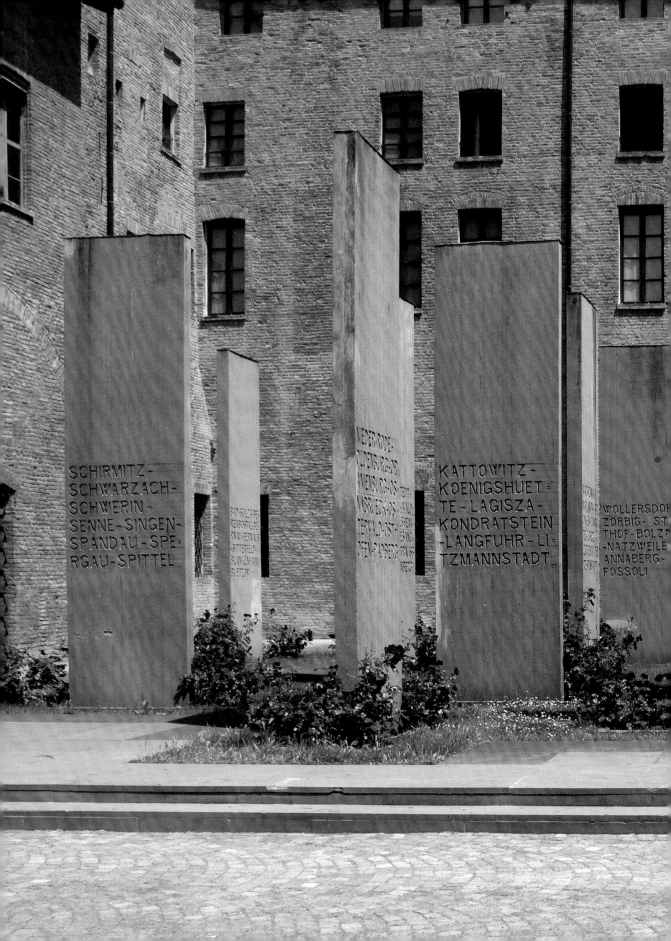

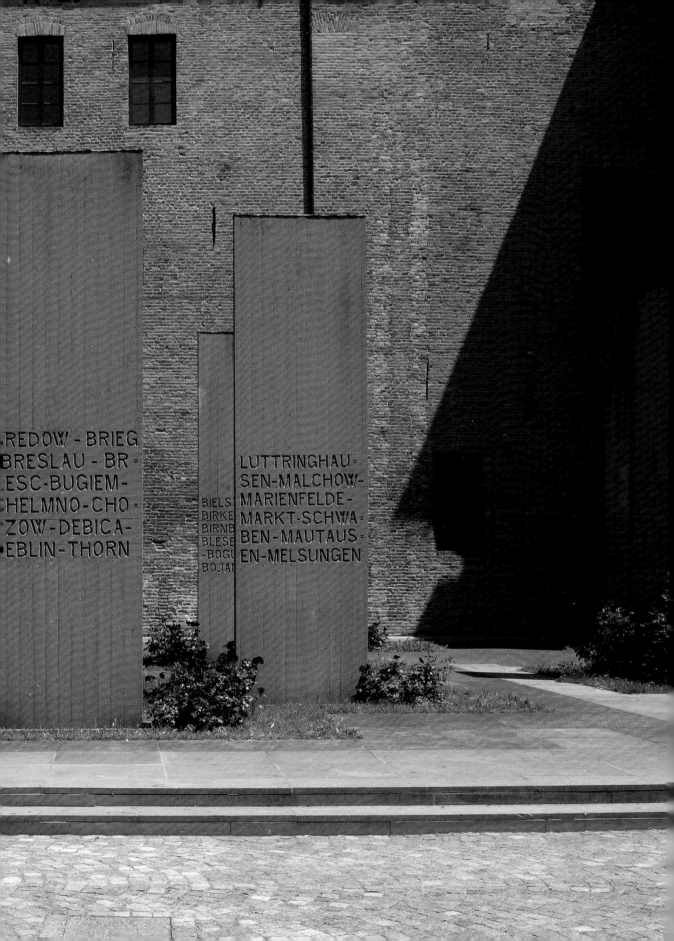

Preceding pages, above
and opposite: The names of
concentration camps were
inscribed on the stones outside
the castle, using moulds. The
font is linear and has some
special features, such as the
hook shape of the *Y*.

PRUSZKOW -PU=
SYKOW -PUTZIG
-RODOGOSZCZ-
TARNOWITZ -
TOMASZOW -
MAZOWIECKI

Letterforms as sculpture use
Barcelona's old Latin name
to pay homage to the city's
Roman origins.

Joan Brossa
Bàrcino

Avinguda de la Catedral, Plaça Nova,
Barcelona, Spain

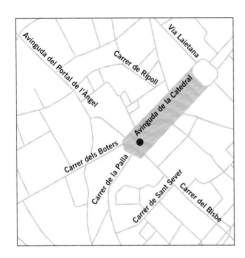

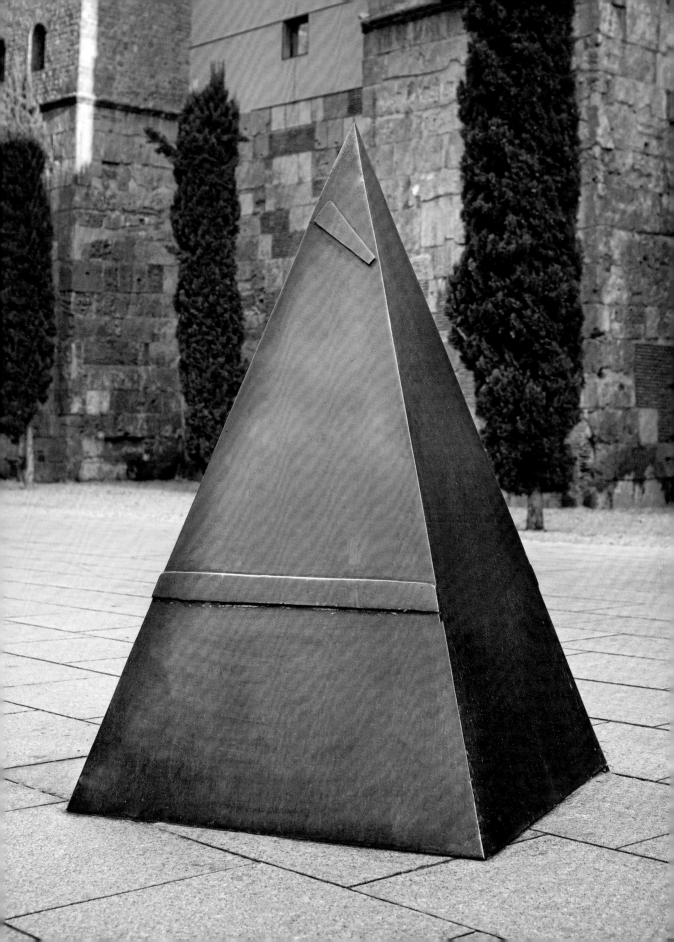

In 1994, Catalan artist Joan Brossa created six large letters in bronze and one in aluminium to make the word Bàrcino. Bàrcino is the Catalan spelling of Barcino, from the Latin name of Colonia Iulia Paterna Augustan Faventia Barcino, which was the Roman city that became Barcelona.

Commissioned by the architect Rafael de Cáceres, the project was initially intended to be an innovative solution to the regulation of traffic flow. This plan was eventually abandoned and the work became purely decorative. Located in Plaça Nova, the project does not specifically relate to a particular building; instead it creates its own space within the bounds of several existing elements. On one side, incised on the wall of a building, is Pablo Picasso's frieze, sculpted by Norwegian artist Carl Nesjar in 1962 on the Collegi d'Arquitectes building. Standing on the other side is the many-spired cathedral and, above all, the imposing walls dating back to Roman times. Brossa said of this project: 'I was commissioned by the city of Barcelona before the Olympics, and since there was much talk about the city, it occurred to me to use the name itself, but in its Latin form.'[1]

Brossa's work is installed on a site that is big enough to allow the letters to be viewed from all sides. They are conceived as three-dimensional sculptures, each of which could easily stand on its own. Two of the letters are easily recognized as such: the *B* (sans serif) and the *R* (serif). The remaining letters take the forms of different objects. Viewed individually, each of these could be a sculpture bearing no connection to the alphabet, but their proximity to one another (and in particular to the *B* and the *R*) make it clear that they are all letters of a single word.

It is the *À* that occupies the most space and captures our attention, perhaps because Brossa has always placed special emphasis on the first letter of the alphabet. It is a slender, pointed pyramid that seems to refer not so much to a real object as to a purely abstract geometrical shape. The *C* is represented as a crescent moon, the concave side of which suggests a human profile. The *I* perhaps contains a reference to the world of printing, the lower-case letter standing in relief within a frame that could represent a metal type piece. The *N*, the only sculpture made of aluminium, can be seen as resembling a bishop's mitre or a sail. On the surface of this sculpture, Brossa has added a small relief capital *N*, perhaps to help passers-by read the word. The *O* is represented by a round sun with rays, eyes and a mouth. The artist has placed his signature on this last letter.

[1] In Lluís Sierra, 'Letras monumentales de Brossa evocarán el pasado de Barcelona ante la catedral', *La Vanguardia*, supplement *Ciudades*, Barcelona, 10 October 1993, p. 37.

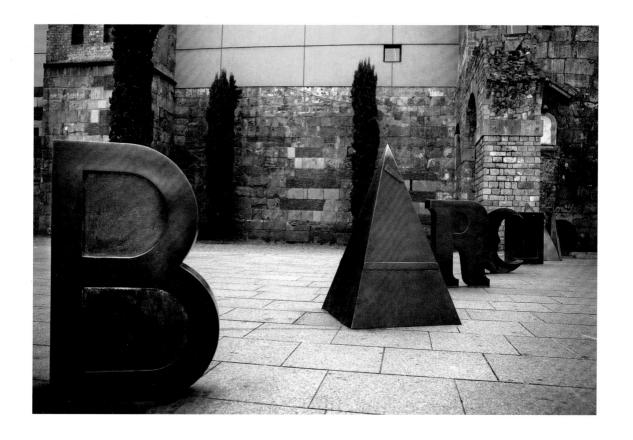

Above and following pages:
The arrangement of Brossa's
individual sculptures in front
of the original Roman walls.

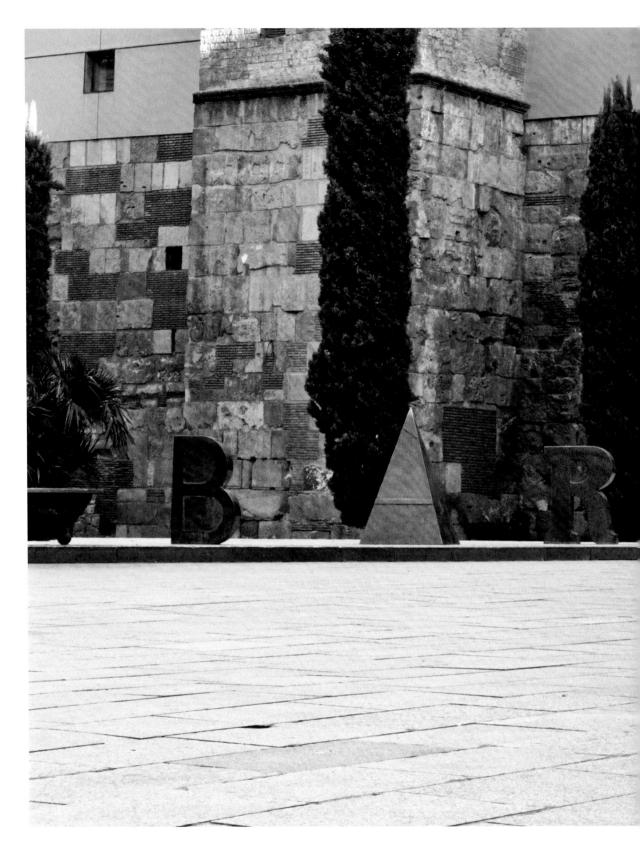

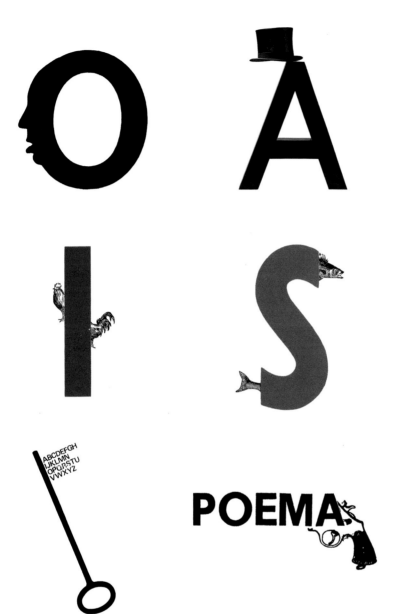

POEMA

Above: Some of Brossa's visual poems, in which we see the constant interplay between letters and objects.

Opposite: In *Bàrcino* the letter *C* recalls the waning moon.

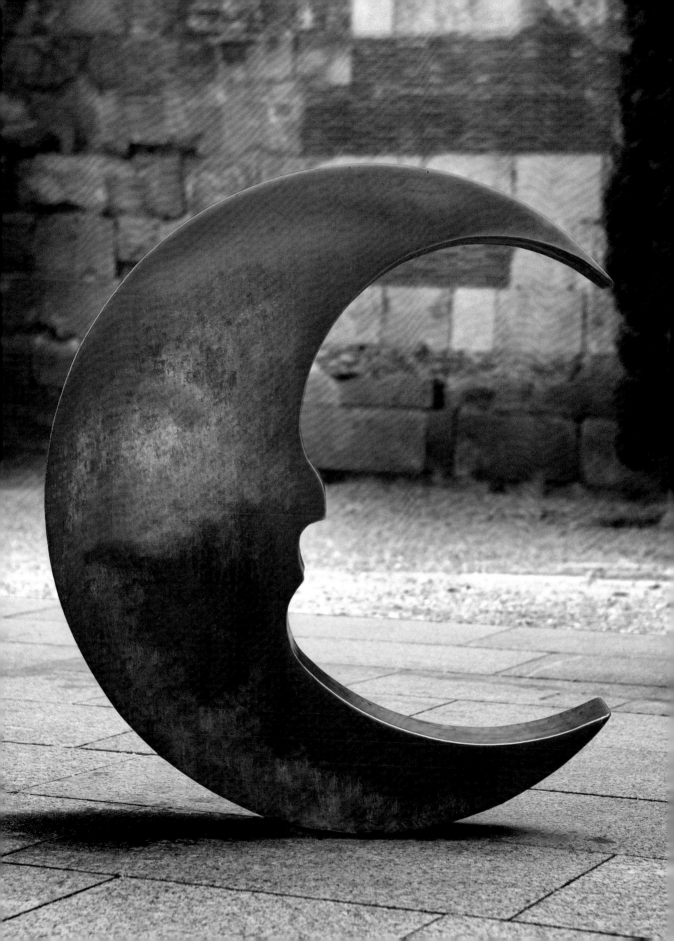

Two giant letter *A*s and
punctuation marks give free rein
to poetic imagination as public
sculptures in a Catalan park.

Joan Brossa
Transitable Visual Poem

Jardins de Marià Cañardo,
Barcelona, Spain

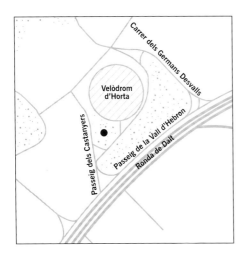

Architects Esteve Bonell and Francesc Rius built the Horta Velodrome in the Vall d'Hebron for the world cycling championships held in Barcelona in August 1984. Joan Brossa, a personal friend of Bonell, was invited to contribute a work for the surrounding area. In the small park, now dedicated to cyclist Marià Cañardo, he produced his first urban visual poem.

Brossa regarded himself primarily as a poet. His works include various forms of poetry: literary, theatrical (which he calls *poesìa escénica*), visual *poemas objeto*, scripts, posters, installations and *poemas corpóreos* that relate to 'public art', one example being the *Transitable Visual Poem*. Brossa's visual poems are an experimental art form drawing on both painting and poetry. They take the form of large public sculptures that refer to poetry but, at the same time, move ever closer to reality because 'the poet must broaden his scope and move away from the literary'.[1] This type of poetry allows Brossa to pursue projects in which letters and words become part of a new context: the landscape and everyday reality. Although these works are placed in public spaces, the cost is sometimes borne by Brossa himself. Themes are often taken from visual poetry but, because the works are intended for an outside environment, they are also inspired by the site where they are placed.

The walk-through *Transitable Visual Poem* consists of a path divided into three parts, marking the stages of life: birth, life with all its events and pauses, and death. In his article 'Projecte per un poema visual en tres temps', Brossa wrote, 'Impact and surprise presuppose the adventure of a number of letters and signs that seek their meaning away from any text or enemy of vegetation, the symbol of life itself.'[2]

The first phase of the trail starts in a paved area with a 6-metre-high (19-foot) stone sans serif *A* that stands like a door, symbolizing birth. The second consists of a number of punctuation marks scattered on a grassy slope among the Mediterranean vegetation. It represents the road of life and its difficulties: a full stop, a comma, three points, a question mark, an exclamation mark, a colon, quotation marks and a hyphen. The third phase is a big *A*, similar to that in the first phase, but now broken. The pieces, representing death, lie on a paved area at the top of the slope. Brossa has explained this design in terms of his conception of human life: 'The life of living beings is subject to a process of decay, ending with destruction.'[3]

Because of its location, this work is not seen by the masses of tourists who flock to the Catalan capital, but it is precisely the peacefulness of the place that enhances its strong poetic impact. Of all Brossa's works, this is the most extensive. It is impossible to see the three stages of the poem all at the same time; they can only be discovered by visiting them one by one.

[1] Joan Brossa, 'La poesia en present', *Anafil*, L'Alzina (collection), no. 16, Barcelona, 1987, p. 200.

[2] Joan Brossa, 'Projecte per un poema visual en tres temps', *Anafil*, L'Alzina (collection), no. 16, Barcelona, 1987, p. 5.

[3] Ibid., p. 184.

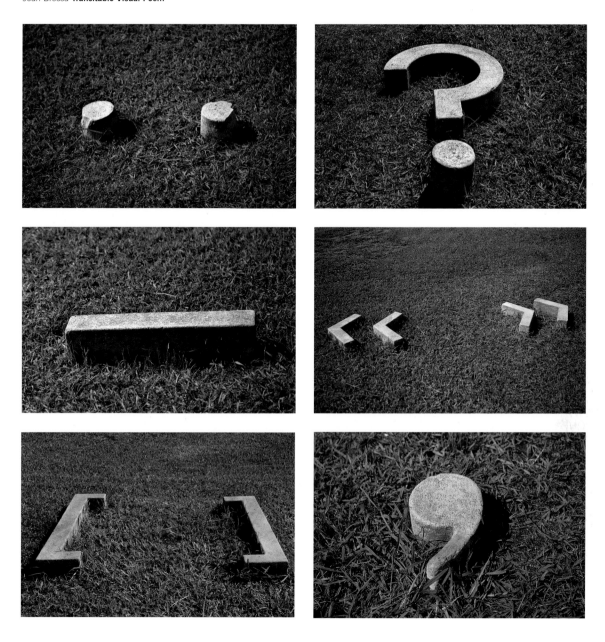

Some of the punctuation
marks that form part of the
sculpture's second phase.

**Sextine for a Transitable Visual Poem
in Three Times, Set in an Urban Space,
Around the Horta Velodrome**
Joan Brossa

For the architects Esteve Bonell and Quico Rius

The first of the letters,
is sixteen metres high, and is made of stone,
set amid rocking chairs and surrounded by trees.
(Later we shall see it broken into pieces.)
It's going to be like the first part of a book
where signs are nothing more nor less than signs.

Scattered all over a plot are the signs
of punctuation. Between the two letters
a red path runs (the course of the book).
At last, among willows, are blocks of stone
from the letter itself now broken into pieces.
The path is bordered on either side by trees.

This 'text' surrounded by trees
together with a plot full of signs
directs the passing of days to the pieces
of the second A. Amidst the letters
you'll discover plants, trees, grass and stone
and with it all you'll imagine a book.

It aims to be, like life, a book
with commas and full stops amid the trees,
a birth and a progression over stone
and only one end, removed from false signs
because life here runs away from letters
if with common sense you join the parts and pieces.

Many little bits make good-sized pieces.
Here the secret escapes from any book
and when you walk between the two letters
you can look at the path or listen to trees.
The things and the landscape are the signs
for intoning the discourse of stone to stone.

The final letter of stone
reminds us of fate, fallen in pieces:
the destruction of life; and the signs
of intonation or pause – like the book –
are episodes of discourse. (Also the trees
know how to speak more than the letters…)

With two letters and beating on stone,
on a path of trees you see breaking pieces
of words of a book born under ill-starred signs.

December 1984
Quart llibre de sextines (Fourth Book of Sestinas, 1981–86)
Translated by Julie Wark

Opposite: The first phase,
with the letter *A* surrounded
by vegetation, next to the
punctuation marks in the
second phase.

Following pages: The third
phase, with its destroyed
letter *A*.

Colour-coded lettering
brings new life to an
old facade.

Joan Brossa
Visual Poem for a Facade

Carrer del Bon Pastor, 5,
Barcelona, Spain

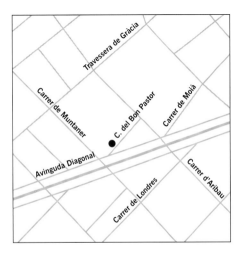

Joan Brossa's *Visual Poem for a Facade,* a new decoration for the Col·legi d'Aparelladors i Arquitectes Tècnics de Barcelona, was inaugurated in 1993. This work, which consists of 100 coloured capital letters placed on the front of the building, is the only one of Brossa's installations that might be considered 'architectural'.[1] In this case the installation is an integral part of the building, giving it an unmistakable identity. By contrast, Brossa's other works, although they interact strongly with the surrounding space, never refer to specific architecture.

The building is located in a narrow street in the heart of Barcelona, squeezed in between other buildings. The facade, the only element that is visible to passers-by, stands out thanks to Brossa's use of typography, which transforms it – to quote the college's publication – into a 'new symbol that will become in time part of Barcelona's architectural heritage, while at the same time encouraging debate about the contribution to art made by existing buildings and new architectural projects.'[2] Working alongside fellow artist Josep Pla-Narbona, Brossa placed a large grasshopper (a symbol of wisdom in some cultures) on top of the building, as a tribute to the talent of the surveyors who are educated at the institution.

At first glance, the playful and brightly coloured letters seem placed at random, but they are in fact arranged and colour-coded following a precise order. In Brossa's own words, 'The letters are perfectly arranged like bricks, and then rearranged to form the sign, in a meaningful disorder.'[3]

Each letter is characterized by one of sixteen different colours: red for *A*s, light blue for *B*s, turquoise for *C*s and so on (there is a comprehensive colour code on page 75). From a total of one hundred letters, fifty form the horizontal sign of the school located above the entrance. The other fifty, which repeat those used to compose the name, are arranged according to the architectural lines of the facade: five columns in alphabetical order from bottom to top.

The type stands out slightly from the facade, and this introduces a further spatial quality to the installation: as the letters have a nearly square section, they are given an extra dimension, gaining more weight and visibility in the urban context. The letters, composed in Univers, are made of plastic and, as Phil Baines says, 'never has plastic Univers looked so good'.[4]

[1] Phil Baines, 'Sculptured Letters and Public Poetry,' *Eye*, no. 37, December 2000, p. 42.

[2] *L'Informatiu del Col·legi d'Aparelladors i Arquitectes Tècnics de Barcelona* 30, Barcelona, June 1993, p. 3.

[3] In Isidre Vallès i Rovira, 'L'obra pública de Joan Brossa: Els Poemes corporis', *Journal of Catalan Studies*, May 2001. www.uoc.edu/jocs/brossa/articles/valles.html

[4] Baines, 'Sculptured Letters and Public Poetry,' p. 42.

Opposite and overleaf: The letters arranged vertically at the top of the facade; details show how the letters are installed.

Joan Brossa **Visual Poem for a Facade**

Univers 55 Roman

Above: The colour-coded letters
used in the installation.

Gates constructed from
letterforms grant entry to
one of the world's great
temples of learning.

Cardozo Kindersley Workshop
British Library Gates

96 Euston Road,
London, UK

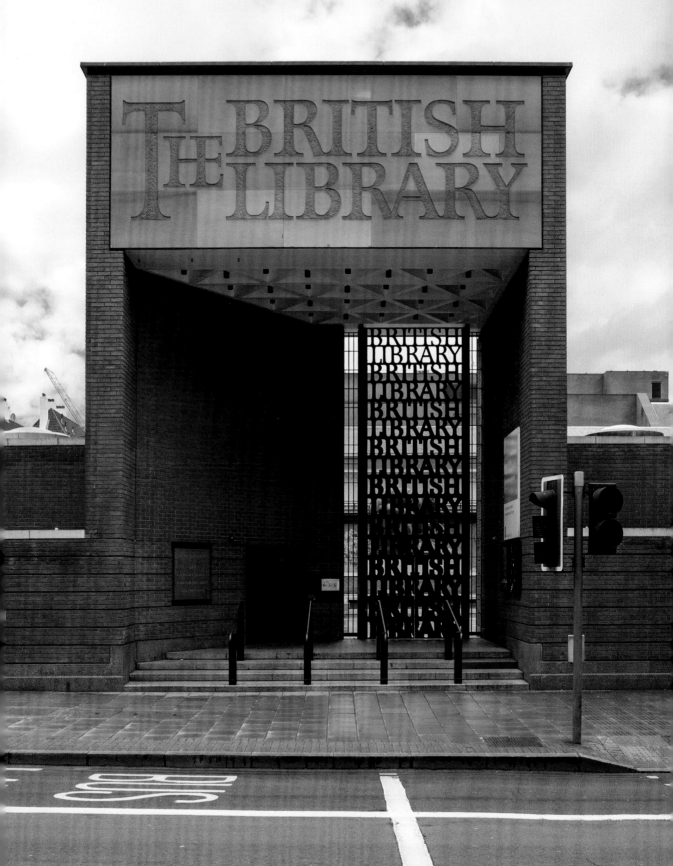

The British Library, incorporating the British Museum Library and other collections, is the UK's national library and one of the best stocked and most important in the world. The new library was established relatively recently as a result of a report drawn up in 1969 by the National Libraries Committee and the subsequent White Paper of 1971, which called for the creation of a national library for the UK. The British Library Act was passed by Parliament in 1972, coming into force the following year.

Opened in 1998, the main building in the north London district of St Pancras was designed by Colin St John Wilson, who devoted thirty years of his career to this construction of monumental proportions. From the outset, Wilson was eager to include artworks in his architectural design. Notable among the works chosen are the tapestry by Ronald Brooks Kitaj, the numerous busts by Celia Scott including one of the architect, and finally the statue of Isaac Newton in the forecourt by the Scottish sculptor Eduardo Paolozzi, who took his inspiration from a drawing by William Blake.

This marriage of art and architecture is evident right from the entrance, which is set back slightly from Euston Road. A high brick wall directs the visitor towards the imposing gates designed by the Cardozo Kindersley Workshop that lead into the forecourt. Made of thick steel sheets, the gates consist of 'British Library' repeated eight times with a gradual thickening of the strokes from light to extra bold. As Phil Baines says, the gates 'do not contain lettering, they are lettering.'[1]

The upper part of the structure reaches the lintel and is fixed, while the lower section is hinged at either side to allow the two halves of the gates to open. The first thing that strikes the visitor is the lettering on the portico and the gates, evoking the printed pages that make up the library's holdings. Gates such as these, based on letterforms, are an ideal choice for the entrance to one of the world's most comprehensive and prestigious libraries, creating an appropriate mood for visitors as they approach this building dedicated to books. The words 'British Library', arranged in layers, are separated by a horizontal line that incorporates the serifs running along the top and bottom of the letters. It is nevertheless still possible to make out that the lettering used by David Kindersley is Egyptian or Slab Serif.

Kindersley's workshop also designed the inscription reading 'The British Library' on the red sandstone lintel above the gates; however, although the individual words are well formed, this composition has a lesser impact than the gates, perhaps because of its disproportionately large 'The'.[2]

[1] Phil Baines and Catherine Dixon, *Signs: Lettering in the Environment*, Laurence King, London, 2003, p. 130.

[2] Ibid.

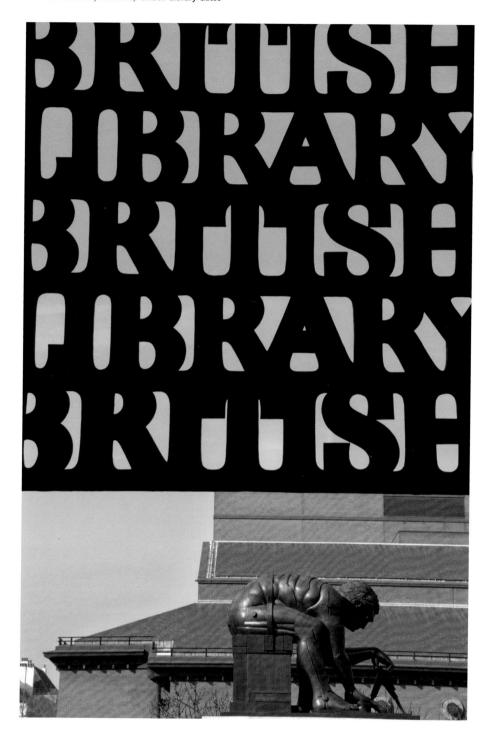

A view of the gates with
Eduardo Paolozzi's statue
of Isaac Newton.

Above and opposite:
Details of the 'lettergrid'
that makes up the gates.

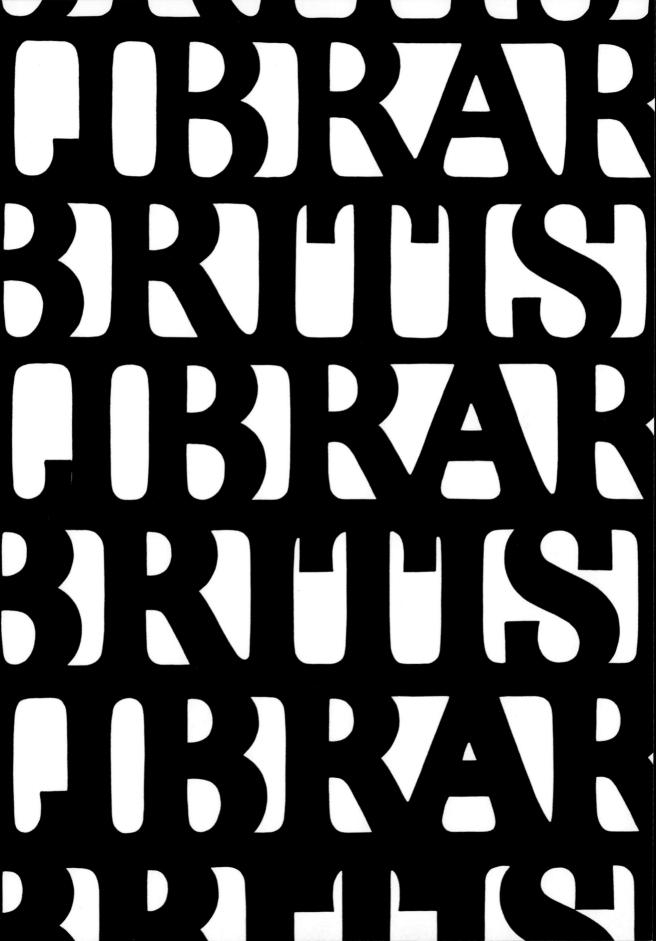

Using a fluid space in an
urban context to evoke the
history of a place.

Paul Carter
Nearamnew

Federation Square,
Melbourne, Australia

[1] Paul Carter, *The Sound In-Between*, New Endeavour/University of New South Wales Press, Sydney, 1992, p. 102.

[2] Paul Carter, *Mythform: The Making of Nearamnew*, Melbourne University Publishing / Miegunyah Press, Carlton (Victoria), 2005, p. 17.

In 1998, Paul Carter was invited by the Federation Square Public Art Program to create a work for a new square in Melbourne, designed by Lab Architecture of London in association with Bates Smart Architects of Melbourne. Completed in 2001, 'Fed Square' was created to mark the centenary of the Australian Federation, and features works of architecture and art that relate to the principles underpinning it. Paul Carter began work on his project *Nearamnew* when the square was still under construction. Rather than producing a monumental work, his intention was to evoke the history of the place while making the most of this fluid space. Starting from the idea that 'every single sound that's ever been made since the world came into being is still here,'[1] Carter gives a central role to words, asserting that they create the original vibration which generates the place itself. The name *Nearamnew* is derived from the pidgin 'Narr-m' or 'the place where Melbourne now stands'.

The work is made up of three elements that relate to the federal system: a spiral pattern embracing the whole square, referring to the global context; nine figures placed at certain points of the spiral, referring to the regional context; and nine texts etched on the surface that refer to the local context. The global spiral is laid out on the paving, and is composed of slabs of stone overlaid with other types of stone that have been selected for the richness of their colours or veining, creating whirling patterns and stratifications. The nine regional figures are each composed of nine rectangles in three different sizes, each of which is inscribed with one of the letters, in lower-case, that make up the word 'Nearamnew'. The rectangles are all arranged in one of three ways (linear, ring, zig-zag), but each individual figure is unique. The local texts express thoughts about the meaning of federalism, and each represents a different person: the child, the colonist, the migrant, the builder, the artist, the ferryman, the visitor, the maker and Alfred Deakin, politician and leader of the federalist movement.

Without punctuation or spaces between words, each text refers to a theme that characterizes the location. Starting from its original settlement by the Aboriginal people and mentioning events such as the floods from the nearby Yarra River and the foundation of the Commonwealth, the texts conclude with a reference to the construction of Federation Square. The carved depth of the letters plays an important role in the design: whereas the local texts are heavily emphasized and can be read by anyone coming close enough, the regional figures are carved with a depth of only 2 millimetres ($\frac{1}{16}$ inch) and are much less obvious, seeming to be partially eroded or accidents of the terrain. The areas of intersection are marked by further carved lines that affect the readability of the letters.

All of the texts are executed in a lettering specially designed for the project by Paul Carter with graphic designer Sean Hogan. It is inspired partly by inscriptions found on tombstones in Aquileia and partly by Erik Spiekermann's Meta font. As Carter says, 'The resulting typographical hybrid produced an equably proportioned, clearly legible alphabet, whose letters could easily be joined to create letter fields.'[2]

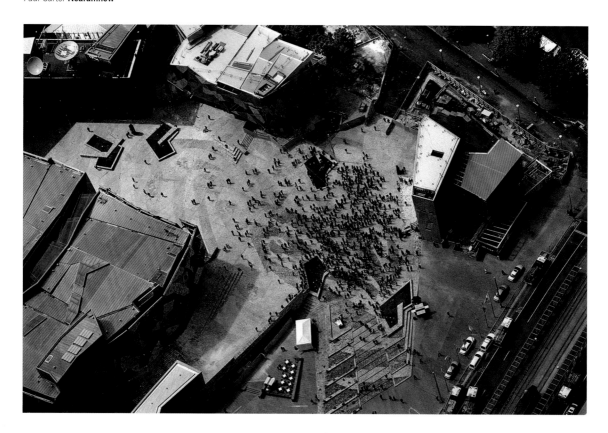

Above: The panoramic view from Federation Square.

Right: Diagram of the work.

1. The Maker's Vision
2. The Colonist's Vision
3. The Child's Vision
4. Alfred Deakin's Vision
5. The Migrant's Vision
6. The Builder's Vision
7. The Artist's Vision
8. The Ferryman's Vision
9. The Visitor's Vision

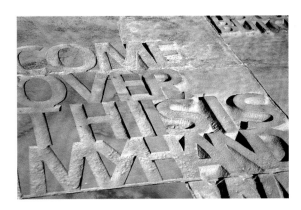

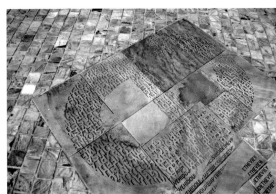

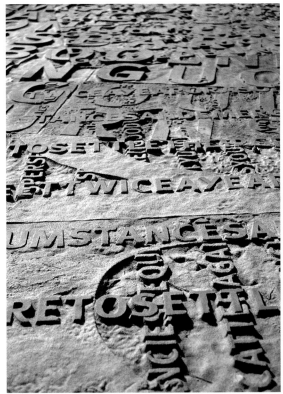

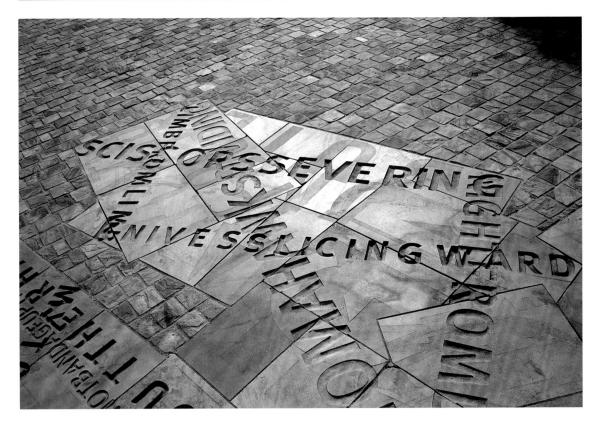

1

2

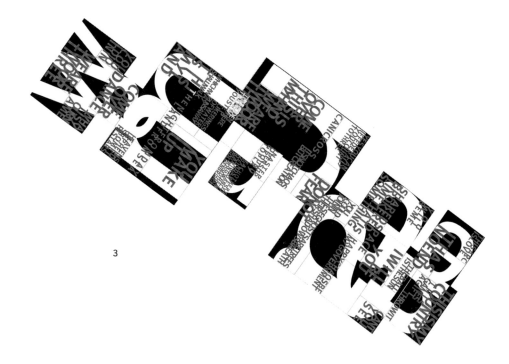

3

4

Preceding pages: Details of the installation.

These pages and overleaf: Outlines of the nine views, corresponding to the diagram on page 85, showing the depth of engraving. The increasing depth of the lettering is rendered through darker shades of black.

5

6

7

8

9

The slabs were carved by
stonemasons McMurtrie & Sons
in Orange, New South Wales,
who transferred the letterforms
onto the stone by means of
sheets of rubber.

G K KA

Federal Font

G KA

Meta Bold

Federal Font was designed specifically for *Nearamnew*, taking inspiration from Meta Bold.

Developing a strong local
identity by merging typography
with existing structures.

Caruso St John
Bankside Signage System

Southwark, London, UK

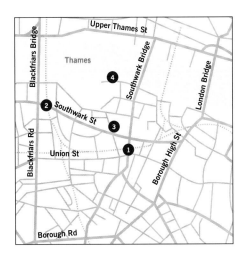

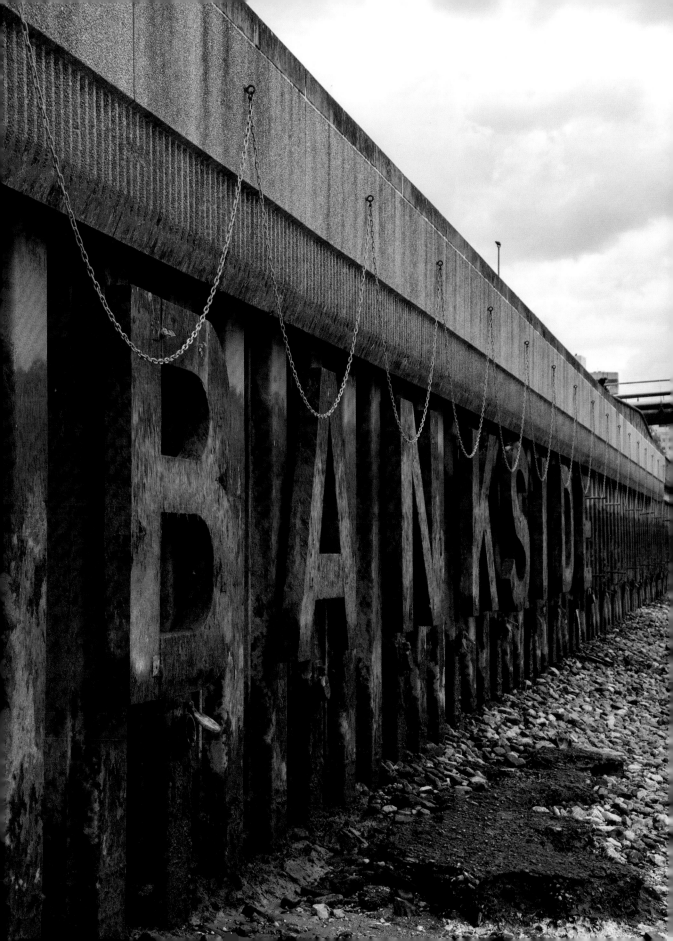

[1] Interview with Peter St John, 20 October 2011.

[2] Alessandro Rocca, 'Caruso St John Architects,' *Lotus International,* no. 106, September 2000, p. 121.

The Bankside Signage System is a project designed by the architectural firm Caruso St John as the result of a series of commissions from the London Borough of Southwark, completed in 1999. The intention was to give a new image to this part of the city and manage an increased flow of people, mainly due to the opening of the Tate Modern gallery in 2000. It is a signage system that not only highlights the main routes and provides information on the most important places, but also gives the area a strong identity.

Derived from the Middle English words 'banke' and 'syde', this area was mentioned in 1554 as the 'Banke syde' or street along the bank of the Thames, though by the late twentieth century the name was not widely known. As Peter St John says, '"Bankside" was about giving a name, and a brand, to a part of the city that didn't have one.'[1] Southwark is a very diverse neighbourhood with a mix of major infrastructure: railway viaducts, large office buildings, an imposing power plant and roads, some choked by traffic and others almost empty. Reflecting the complexity of the environment, the signage system designed by Caruso St John is diverse in size and content. As the architect and critic Alessandro Rocca writes, 'The complexity does not favour an approach organized around axes and points of reference, the project proposes a new system of communication in keeping with the different *souls* of the district.'[2]

There are horizontal signs, which are slabs of stone placed in the pavement and inscribed with the name of the place and an arrow indicating pedestrian walkways. Signposts on poles or existing surfaces show where you are and point towards the main locations of interest. Notable from the typographical point of view are the four large signs indicating the entrance to the neighbourhood that act as virtual gates to the district of Southwark. They are real typographic installations, each with specific characteristics but consisting entirely of letterforms. The capital letters spelling 'BANKSIDE' could be seen painted in large shiny white letters on the wall of an underpass, reproduced in blue on a high wire-mesh fence, in reflective material attached to a wall of exposed brick, or as large three-dimensional letters of iroko wood on the quay.

The diverse gates and other signs that make up the Bankside Signage System are unified by the use of a single letterform throughout: the nineteenth century sans serif Akzidenz Grotesk.

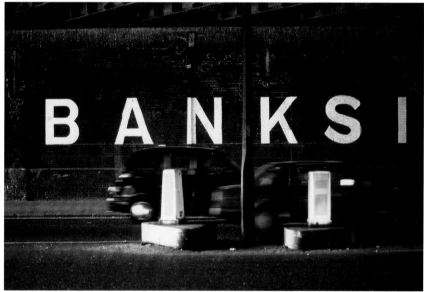

Top (no. 1 on the map, page 94): Silver letters on a brick wall just south of Southwark Street.

Above (no. 2 on the map, page 94): The Bankside sign painted in white on a brick wall under the railway bridge in Southwark Street. After being the object of an urban intervention by the graffiti artist Banksy, the letters were removed.

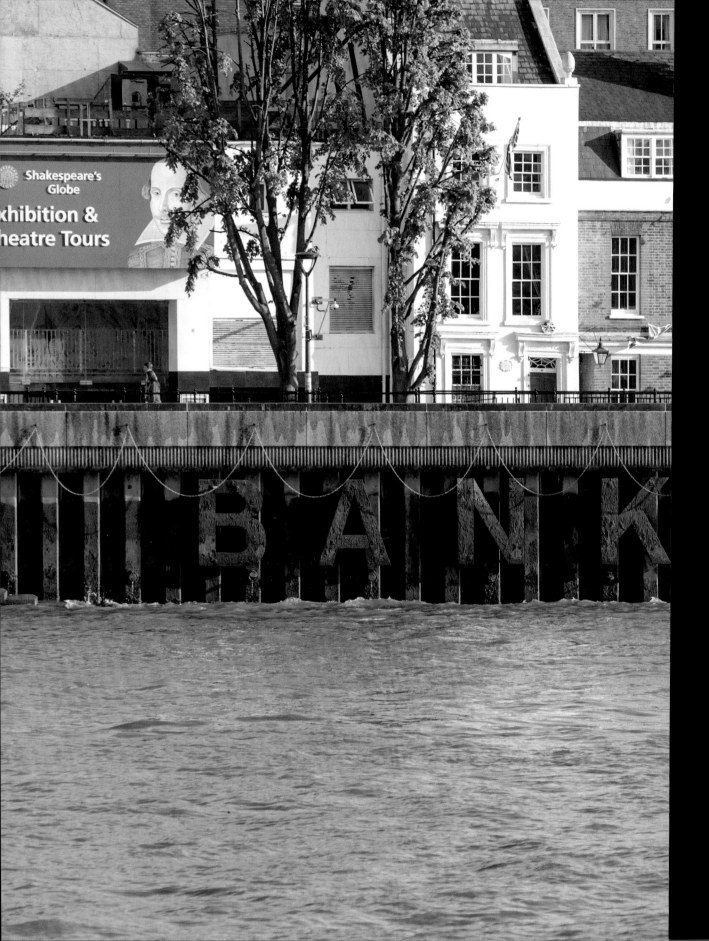

BANKSIDE

Akzidenz Grotesk Bold

Opposite and top (no. 3 on the map, page 94): 'BANKSIDE' is painted in blue onto an existing galvanized metal fence around a playground. The width of the fencing is such that the word can be only read clearly from an oblique point of view.

Preceding pages (no. 4 on the map, page 94): The wooden letters can be seen from across the river and from the Millennium Bridge. The letters are below the tidal line, so that they only appear at low tide. Over time they have been turned bright green by algal growth.

Above: Akzidenz Grotesk Bold is used for each 'typographical gate' and other forms of signage.

A 1.4-tonne steel '9' attracts attention
to one of Manhattan's iconic buildings
and guides visitors to its entrance.

Chermayeff & Geismar

9 West 57th Street

9 West 57th Street,
New York City, USA

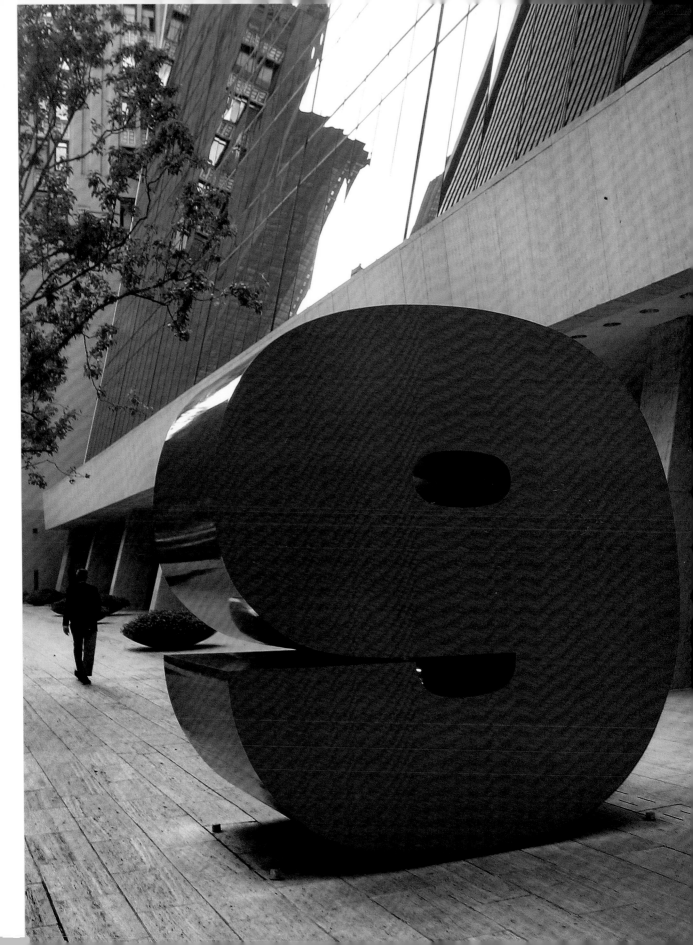

Opposite: The shiny red surface
reflects passers-by walking
on the pavement.

Above: The extra-bold silhouette
of the number 9.

[1] Interview with Esaú Acosta, 30 November 2011.

[2] Buj+Colon, 'Monumento a las víctimas de 11M', www.buj-colon.com/projects/monumento-11m--madrid

[3] Interview with Esaú Acosta, 30 November 2011.

This monument, designed by Estudio SIC & Buj+Colón in 2004 and built in 2007, was the winner of the city of Madrid's competition to commemorate the 191 victims of the terrorist bombings of 11 March 2004. Located in front of the Atocha railway station, the scene of one of the attacks, the monument was presented with the motto *La luz dedica un momento del día a cada persona ausente* ('Light dedicates a moment of the day to every missing person').

The installation has two parts: the cylindrical structure visible from the outside and a room below it. The cylindrical shape is made of blocks of glass bonded together with a transparent acrylic adhesive that allows the light to pass through. Inside is a thin membrane of ETFE (ethylene tetrafluoroethylene) on which are printed messages left at the Atocha station in the days following the attack to commemorate the victims. Architect Esaú Acosta saw this as 'a spontaneous creation of a collective catharsis in which the citizens left texts with questions, support, and so on. A place for externalization of collective sentiments. Somehow this place built with the word as a raw material should be kept forever.'[1]

The 11-metre-high (36-foot) glass structure protects the plastic membrane bearing the words from the outside elements. The architects' intention was to create a transparent and light-filled space. To achieve this, they dispensed with the structural elements normally required to support a plastic surface, using instead a series of fans to create a vacuum between the membrane and the glass, allowing the membrane to be suspended. The daylight that filters through the glass blocks is replaced at night by a sophisticated lighting system, consisting of ten projectors placed between the two structures and controlled by ColorShow software, that simulates the sun's movement and light. Because the plastic membrane is suspended, the messages appear to float in the air. Irregularities in the surface create interesting overlaps between the words, giving the feeling of something organic and moving. Visitors can read messages from a space below the dome, accessible from the main hall of the station. A glass wall allows the dome to be seen from the station, while at the same time cutting out the surrounding noise; the silence inside the room creates a soft atmosphere dedicated to introspection and commemoration. The effect is described on Buj+Colón's website: 'Inside the room, as on the sea floor, there is no noise and everything turns towards the natural light source in which the messages float.'[2] The lettering chosen for the texts is Isonorm because, Acosta says, 'it seemed clear, concise and neutral at the same time. It is a typeface that is not too loud, that won't distract from the message.'[3]

Top: From the outside the words are completely hidden by the outer wall of glass bricks.

Above: In the room accessible from the Atocha station visitors can read the messages on the dome and, on the entrance wall, the names of the victims.

No olvidemos... con mi vida. No olvidemos desde que os marchasteis. Con todo o meu agarimo. Sempre... con mi alma. Se llevaron... Tu alma en nuestras memorias. En nuestras memorias nunca que llevaron... people tha...

With all our love. Mis lágrimas con tener... Mi vida. Con hermoso... Con peace. ¡Los locos! ¡Que se ven los locos! El mundo tiene que cambiar... Si nadie llora mi corazón... alone and let the happiness... se ven. En porque... Justici... Vivir...

In memoriam. Non dimenticare... todos os recordo... Ahora hay un vací... no se olvidan. With... Hace falta mucha fantasía. Madrid, no os olvida. Tenemos el deber... es decir mil cosas. Som tots els que... ni religión, ni cultura, ni raza... De allí... recapacitar sobre... en el cielo. Amamos la vida... referencias superficiales... Nonostante questo... vosotros, para todos... padres. Madres... Educad en la paz... un amigo... deja mil de cordu...

Paz... nuestra... compartido tus ideales... otros que no se olvidan... Espero que por... nunca os olvidamos... perdido algo... Justici... vuestr... Vivir...

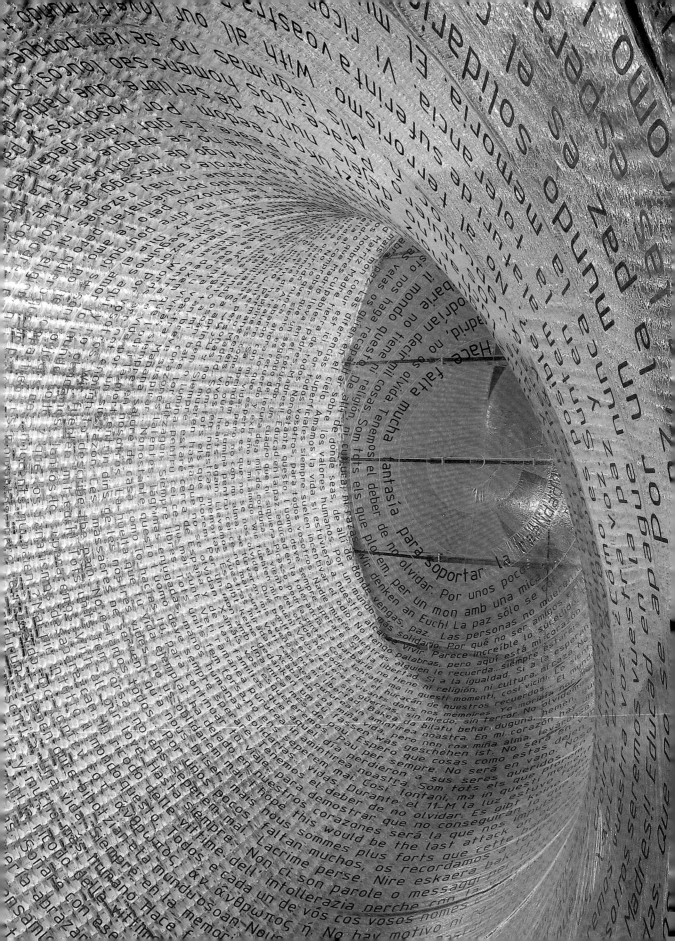

Hace falta mucha

Isonorm

fantasía para soportar la realidad. In memoriam.

'We need a lot of imagination
to bear reality. In memoriam.'

**Preceding pages: By day,
the whole space is flooded
with natural light. The words
seem to be written on the sky.**

**Opposite: At night, daylight is
simulated using sophisticated
technology.**

Keeping playwright August
Strindberg's great wit alive
by embedding his words in
a Stockholm street.

FA+
Citat
Drottninggatan,
Stockholm, Sweden

Och jag tror inte på Gud? Ajo det gör jag nog, men inte så där att jag ber och tror att Gud sitter och...

STRINDBERGS
CITAT
KONCEPT FA+
I FALK G AGUERRE

Citat was created in 1994 by FA+, otherwise known as the artists Gustavo Aguerre and Ingrid Falk, to commemorate the celebrated Swedish playwright August Strindberg on the occasion of the first festival dedicated to him in Stockholm.

Starting from the idea that 'the text is the writer',[1] the artists placed significant quotations by Strindberg along the Drottninggatan, a street with which the words are intimately connected. As Aguerre explains, 'Strindberg…lived the last years of his life on this street…. It is not unlikely that some of these words came to him during his strolls…. The words in the street represent his thoughts embodied, solidified.'[2]

The quotations run straight down the middle of the crowded shopping street, and this longitudinal arrangement, easily read from either side, emphasizes the linear structure of the space – as art historian Ximena Narea says, 'The street is, simply put, a path that takes us somewhere and not the destination itself. The linear structure of the texts is very well suited to represent this concept.'[3] By choosing provoking phrases such as 'libraries should be burned down every now and then' or 'I am under observation on suspicion of being clever', FA+ have sought to attract the attention of passers-by and to bring out the ironic and controversial aspects of Strindberg's personality.

The work was initially painted: with the help of the Strindberg Foundation and the Friends of Open Air Theatre, 11,000 letters were cut out to make the stencils used to paint the 83 quotations extending over a length of 1.2 kilometres (¾ mile). By the time the painted letters had worn out, it was clear that they had become an integral part of the urban landscape, and the people of Stockholm asked for a permanent installation. In 1998, when Stockholm was the European Capital of Culture, the space was closed to traffic and the lettering recreated in stainless steel. The placement of the texts in the middle of the street reconstructs the lane division, and the decision to use Helvetica and steel harmonizes with the asphalt and other common street materials.

One of Stockholm's most beloved pieces of public space art, *Citat* is a project that has closely involved the local community – the quotations were suggested by schools, libraries, literary associations and academics in the city. Providing a stimulating alternative to the visual pollution of the advertising and shopfronts on the street, *Citat* has become an essential sight on the visitor's circuit. Commissioned by the Stockholm Art Board and the City of Stockholm's street and building authority, the project received support from the Danieli Donation Fund and the Stockholm European Cultural Capital 1998 Fund.

[1] Interview with Gustavo Aguerre, 5 March 2008.

[2] Ibid.

[3] Ximena Narea, 'Facing the Physical and Cultural Space', *Heterogénesis*, www.heterogenesis.com/ Heterogenesis-2/Textos/hsv/ hnr27/Narea.eng.html.

Above: Various stages in the
construction of the installation.

Following pages: The installation
in the Drottninggatan.

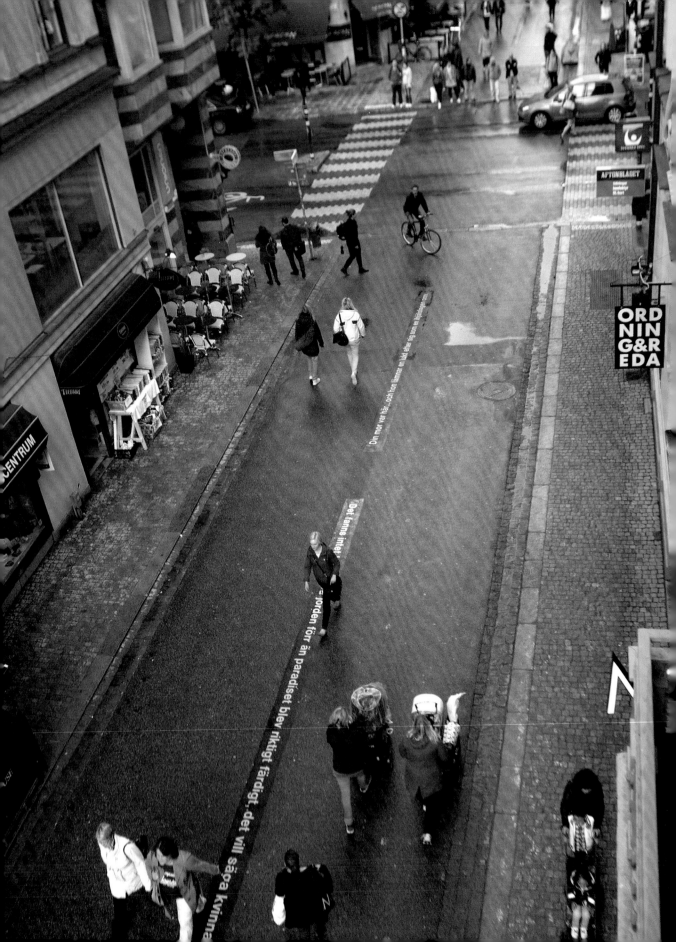

Citat is a first step towards a larger project, *The Universal Library,* the purpose of which is to promote poetry and, more generally, literature through the installation of significant quotations. Other installations forming part of this project are: *Zitat,* a quotation from Kant in Kaliningrad, Russia (top left); *Into death so loved*, a line by Adlesparre in Falun, Sweden (top right); *FA+Norén/WAR*, excerpts from Norén's play *War* in seven Swedish cities (bottom left); *Sitat,* quotations from Ibsen in Oslo, Norway (bottom right).

Finns det en medgörligare och oskyldigare

Helvetica

'Is there a more amenable and more innocent human than this former minister?'

Words, art and nature
are united in a garden
deep in the Scottish
countryside.

Ian Hamilton Finlay
Little Sparta

Stonypath, Dunsyre, Lanarkshire,
Scotland, UK

The history of this garden began in 1966, when Ian Hamilton Finlay moved with his wife to Stonypath in southern Scotland. They relocated to an empty piece of land occupied only by an old ruined farmhouse. Without attempting to create a unified work, Finlay started to design inscriptions and other garden ornaments traditionally featuring words, such as sundials. He went on to make benches, recalling those that are donated to parks as memorials, and then plaques to be fixed onto tree trunks or placed at their bases, an idea perhaps inspired by a book on the art of Roman gardens. The entire garden space gradually filled up with poems, aphorisms and quotations, placed here and there, engraved not only on stone but also on less traditional surfaces such as fencing, flowerpots, brick paths, rocks and watering cans.

Words are central to all of Finlay's work. Aided by professional stone-carvers, he inscribes quotations or his own words to comment on aspects of history, particularly the French Revolution, and the world of art from ancient Greece to the present day, often focusing on Neoclassicism. His work is a reinterpretation of the modern sculpture garden. Rather than a copy of a particular aesthetic, it is intended as an indictment of the general decline in cultural values.

It was in the 1980s, following a dispute with the Scottish Arts Council, that Finlay christened his garden Little Sparta, in reference to the heroic ideals of the ancient Greek city-state, contrasting it with the present-day 'Athens of the North', the city of Edinburgh. His first 'battle' is celebrated by a memorial in bronze showing a machine gun next to the words 'Flute, begin with me Arcadian notes – Virgil, Eclogue VIII – 4 February 1983'.

Many of the works at Little Sparta bear similarly significant meanings. Of particular interest is the monument executed by the sculptor Nicholas Sloan. Consisting of eleven massive blocks of stone, it is inscribed with the words of Louis-Antoine de Saint-Juste: 'The present order is the disorder of the future.' This phrase, in its original context of the French Revolution, was a condemnation of a corrupt society; Finlay instead leaves it open to different interpretations: every block of stone bears one word so that the visitor can arrange the words in different orders, suggesting new meanings.

A more elegiac inscription appears on the work *Upper Pool,* made with John Andrew: '*See* Poussin. *Hear* Lorrain'. The text refers to two seventeenth-century French painters: Nicolas Poussin, the painter of formal landscapes and architecture, and the more lyrical Claude Lorrain. In *Middle Pool*, one of the rocks covered with moss and marsh buttercups that form stepping stones across the pond quotes the dictionary definition of 'ripple': 'Ripple, n. a fold, a fluting of the liquid element'.

In Little Sparta there are numerous references to painters and artists of the past. In *Temple Pool*, for example, there is a small island with a tribute to the artist Albrecht Dürer, consisting of a block of stone carved by Nicholas Sloan bearing the monogram 'AD'. The same monogram is also found hanging from a tree branch in *Woodland Garden*, in reference to Dürer's *Adam and Eve.*

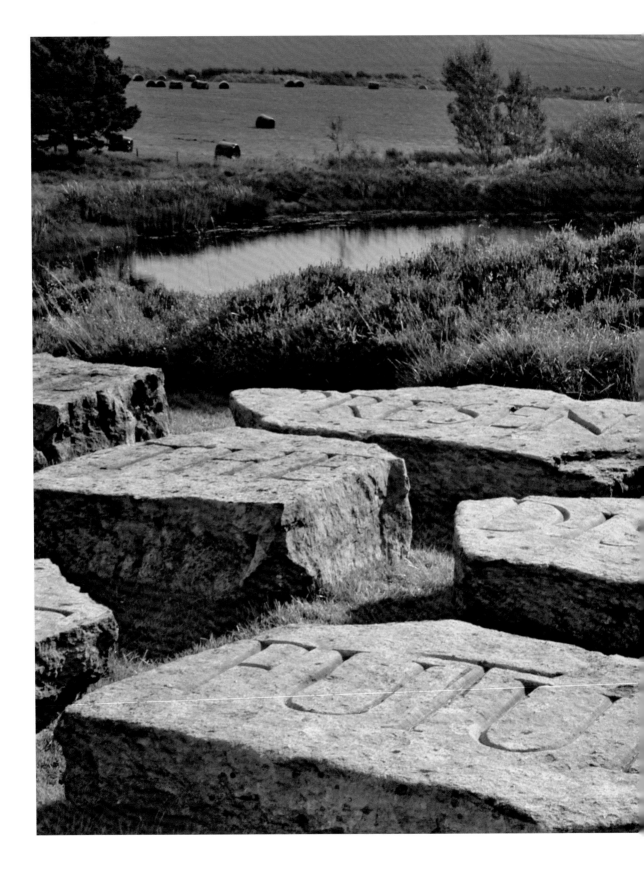

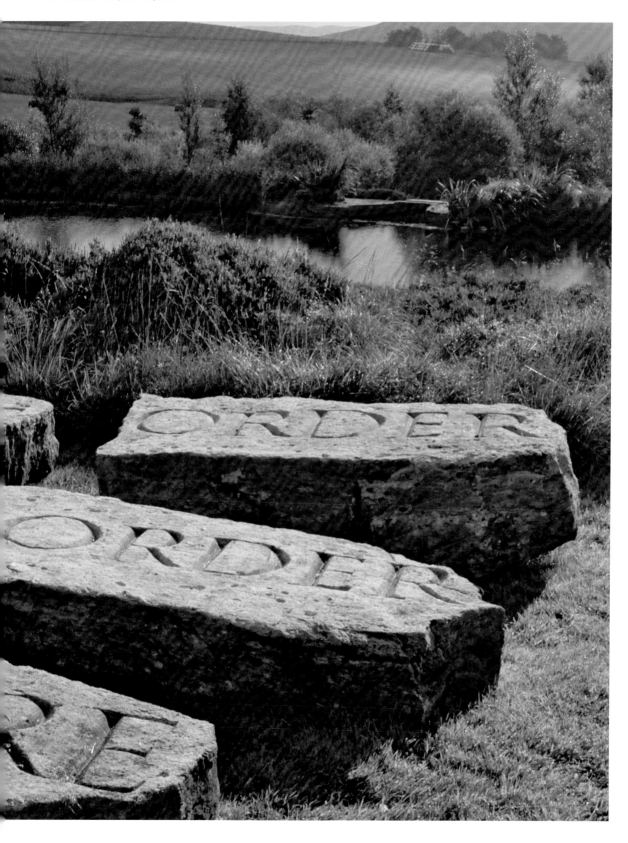

A waterfront typographic
tribute to a city celebrates
the words of national writers.

Catherine Griffiths
Wellington Writers Walk

Wellington Waterfront,
Wellington, New Zealand

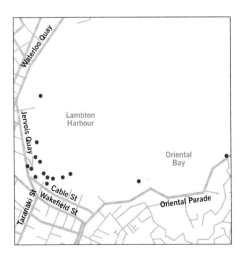

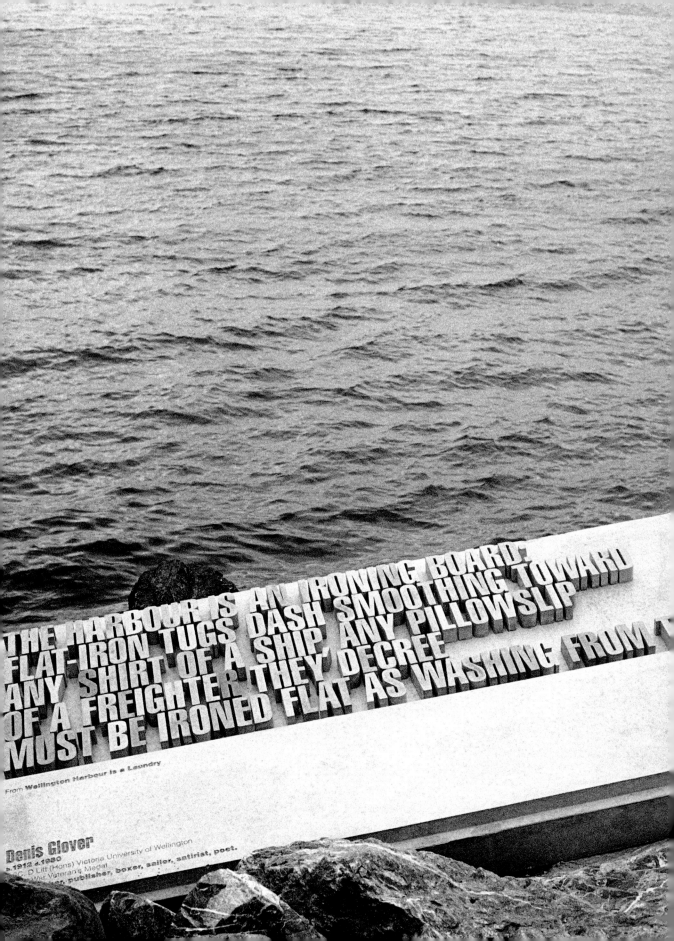

THE HARBOUR IS AN IRONING BOARD:
FLAT-IRON TUGS DASH SMOOTHING TOWARD
ANY SHIRT OF A SHIP, ANY PILLOWSLIP
OF A FREIGHTER THEY DECREE
MUST BE IRONED FLAT AS WASHING FROM

From **Wellington Harbour is a Laundry**

Denis Glover
b.1912 d.1980
CBC D Litt (Hons) Victoria University of Wellington
War Veteran's Medal
publisher, boxer, sailor, satirist, poet.

Wellington Writers Walk is a project consisting of fifteen typographical sculptures placed on the waterfront in Wellington, one of the city's most important public spaces. Each pays tribute to the city using quotations from the works of New Zealand writers that refer in some way to the waterfront, though one exception is a quotation from Robin Hyde that relates to the writer's craft.

Commissioned by the New Zealand Society of Authors and designed by Catherine Griffiths, the project is integrated into the urban environment, extending from Te Papa Tongarewa (the Museum of New Zealand) as far as Frank Kitts Park, passing the Circa Theatre and Civic Square. It is intended to make local people more aware of their literary heritage.

Particular care has been taken in the placement of each sculpture to show it off to greatest effect. Some are on the ground, others in the air, in the water, on the rocks or elsewhere. Griffiths wanted the reader to experience 'something that gives the written texts a new context; not simply words presented in a book, but words that could evoke feeling and emotion with a sense of place. And space.'[1]

The installations are executed in concrete, which required close collaboration with technical experts who carried out the various stages of the work. Griffiths chose Helvetica Extra Compressed for the lettering on the panels on which the letters are raised, and Optima for those on which they are sunk. The texts in Helvetica were created from individually made letters 10 centimetres (4 inches) high and 3.5 centimetres ($1\frac{1}{16}$ inches) deep. Each letter was hand-fixed in concrete to the concrete panels. The texts in Optima, carved to a depth of 1 centimetre ($\frac{6}{16}$ inch), were created at the same time as the concrete panels on which they appear.

From the outset, Wellington Writers Walk has been popular with the inhabitants of the city and it is possible that, if further funds are made available, the project will be enlarged with more quotations and sculptures.

The work has received numerous awards, including, in 2002, the Stringer Award, one of the most important prizes in New Zealand for graphic design. In 2003 it was included in the British *D&AD Annual*. As architectural historian Justine Clark has stated, 'The outcome is a fine example of how a designer can, with determination and the support of all involved, push a project well beyond the client's initial expectations. Where the instigators imagined a series of small bronze plaques set in Civic Square, designer and typographer Catherine Griffiths saw the opportunity for a much tougher, more powerful approach, one that would use typographic design to complement the strength of the writing.'[2]

[1] Interview with Catherine Griffiths, 29 November 2011.

[2] Justine Clark, 'Writing by Types', *Artichoke*, April 2003.

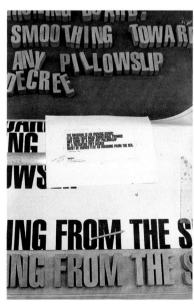

Above and left: The construction of the installation.

Following pages: The panels in position.

I ASK NOT ONLY THAT MY CITY,
BUT ALL, GIVE THEMSELVES
TO THE ESSENCE OF OUR CULT—
THE RITUAL ASSEMBLY OF AN
INTERESTED COTERIE IN A SPACE
WHERE MAGIC CAN BE MADE
AND MIRACLES OCCUR.

From **Theatre in 1981: Omens and Portents**

Bruce Mason
b. 1921 d. 1982
D Litt (Hons) Victoria University of Wellington
...e **The End of the Golden Weather**
... critic.

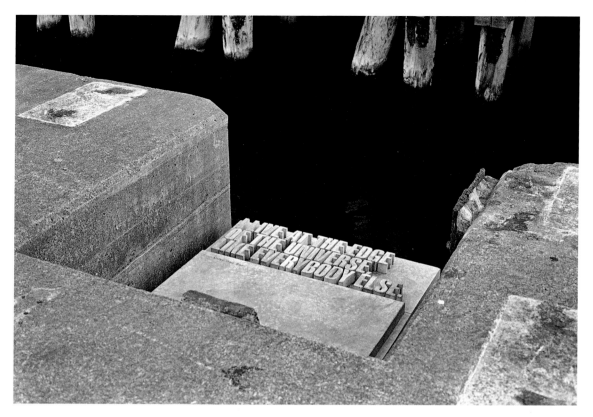

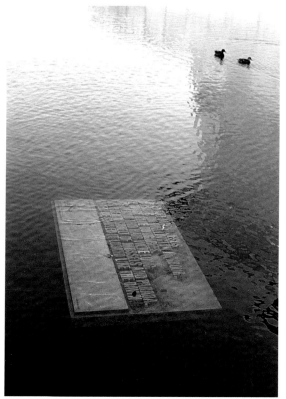

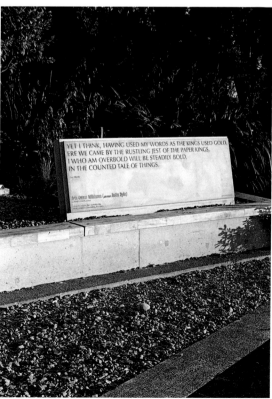

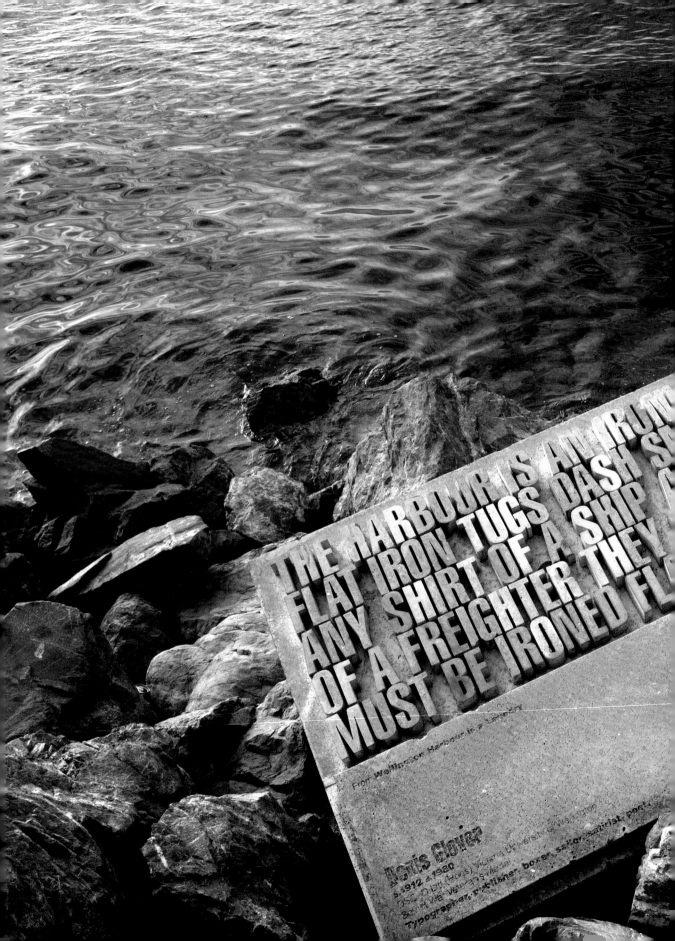

THE HARBOUR IS ANY RUM
FLAT IRON TUGS DASH SP
ANY SHIRT OF A SHIP
OF A FREIGHTER THEY
MUST BE IRONED FL

From Wellington Harbour is a Laundry

Denis Glover
b.1912 d.1980, Victoria University of Wellington
DSC (Dublin Docks) Victoria University of Wellington
Soviet War Veterans Medal
Typographer, publisher, boxer, sailor, satirist, poet

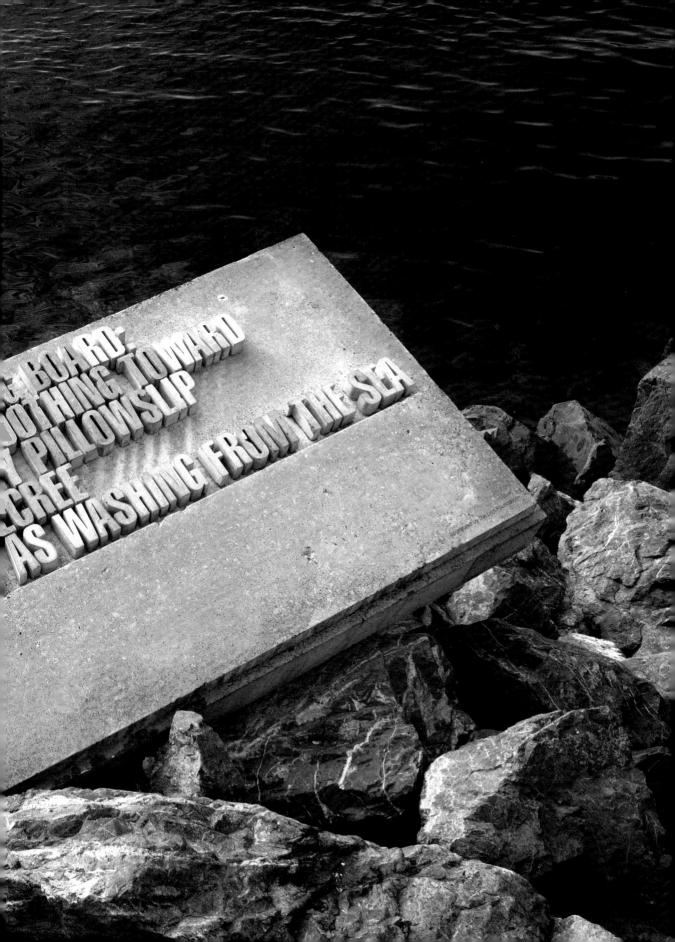

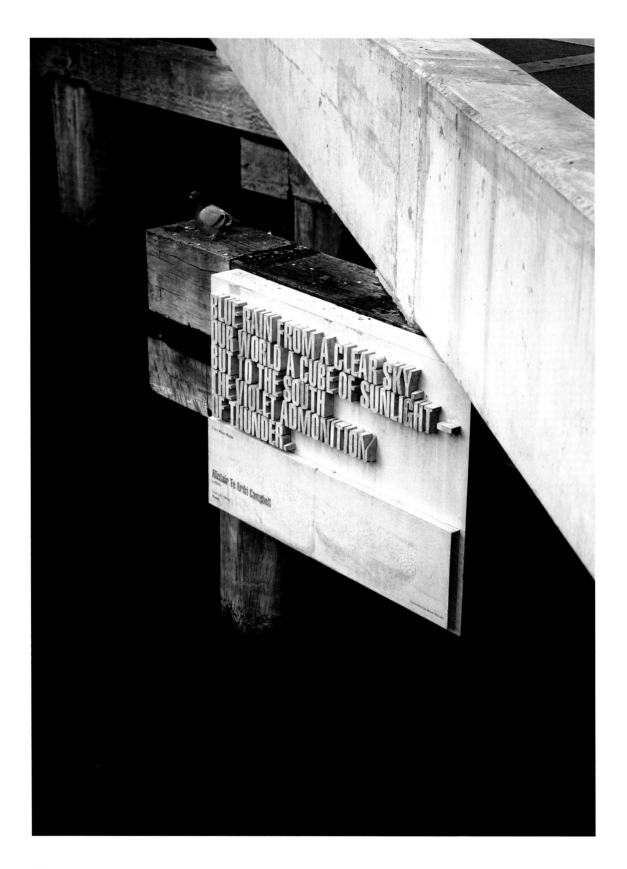

BLUE RAIN FROM A CLEAR SKY
OUR WORLD A CUBE OF SUNLIGHT
BUT TO THE SOUTH
THE VIOLET ADMONITION
OF THUNDER

Alistair Te Ariki Campbell

140

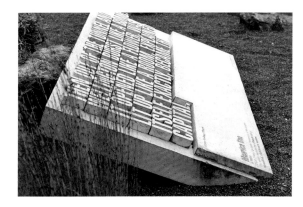

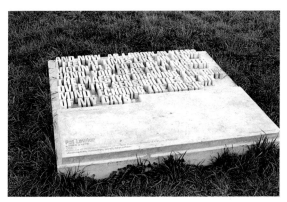

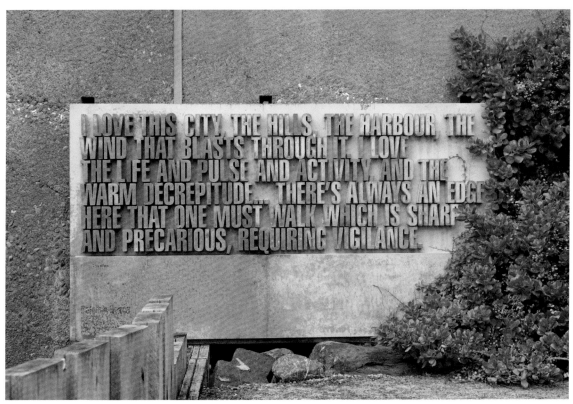

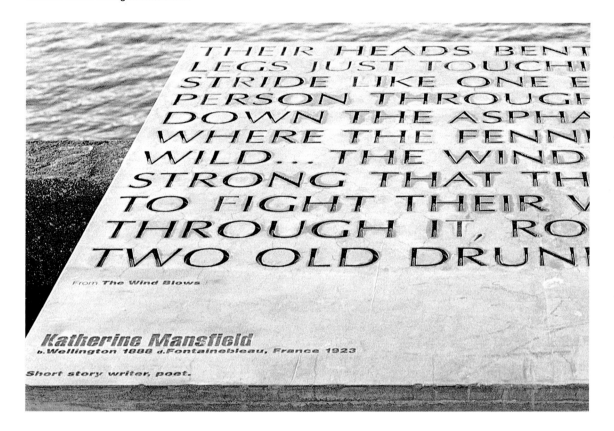

From **The Wind Blows**

Katherine Mansfield
b.Wellington 1888 d.Fontainebleau, France 1923

Short story writer, poet.

WELLINGTON

Helvetica Extra Compressed

PERSON

Optima

A numerical-typographic facade
in the heart of Manhattan's
financial district.

Rudolph de Harak
Digital Clock

200 Water Street,
New York City, USA

[1] Steven Heller, 'Rudolph de Harak: 1992 AIGA Medal', www.aiga.org/medalist-rudolphdeharak

[2] Ibid.

[3] Reinhart Braun, 'Graphics and Lettering on Buildings and Shop Fronts', in Walter Herdeg (ed.), *Archigraphia: Architectural and Environmental Graphics*, Graphis, Zurich, 1978, p. 126.

In the course of his prolific career, Rudolph de Harak devoted himself to graphic design, teaching, and environmental design for public and private institutions. An example of the latter, and one of his most popular pieces, is his work for the entrance and facade of 127 John Street in Manhattan's financial district. The building – a typical New York City steel-and-glass skyscraper – is transformed by a series of de Harak's interventions. Designed by Emery Roth & Sons, the building is thirty-two storeys high, its facade composed of horizontal bands of aluminium alternating with tinted glass windows. It was the building's commissioner, Melvyn Kaufman of the William Kaufman Organization, who was responsible for inviting de Harak of Corchia–de Harak Associates to redesign the ground floor. Among the changes introduced by de Harak were a steel framework that supported coloured canvas sun-shades, a mysterious tunnel with neon lights leading to the main entrance, and a digital clock.

The clock is an enormous typographical installation, approximately 7 metres (23 feet) high and 14 metres (46 feet) wide. It covers the facade of an adjacent, lower building, concealing an unexceptional wall and extending upwards for three storeys on the Water Street side of 127 John Street. The clock is made up of a total of seventy-two squares, arranged in six rows and twelve columns. Each 1.2-metre (4-foot) square contains a number. The top row has the numbers 1–12 for the hours while the lower rows display the numbers from 00–59 for the minutes and seconds. The time is shown by different coloured lights: red for the hours, blue for the minutes and yellow for the seconds.

The clock's numbers are set in Akzidenz Grotesk, a letterform of particular significance in de Harak's work. As Steven Heller has explained, 'This bold European typeface effectively anchored de Harak's design approach and afforded him a neutral element against which to play with a growing repertoire of images.'[1] De Harak used only a limited number of different typographical letterforms in his work, choosing them with great care: first Franklin Gothic and News Gothic, then Akzidenz Grotesk and finally Helvetica. He once said that a crucial point in his life 'was when I was introduced to specimens of Berthold's Akzidenz Grotesk from Berlin.'[2]

With the passing years, de Harak's design has undergone a number of modifications. At the end of the 1990s, the Rockrose Development Corporation converted the building from an office block into luxury apartments, changing the name to '200 Water Street'. The conversion stripped the building of the majority of de Harak's interventions. Only the clock remains, and, although today it does not keep very good time, it survives as one of the symbols of Lower Manhattan. As Reinhart Braun has written, 'The example of 127 John Street shows how a designer can add a whole dimension of communication to architecture.'[3]

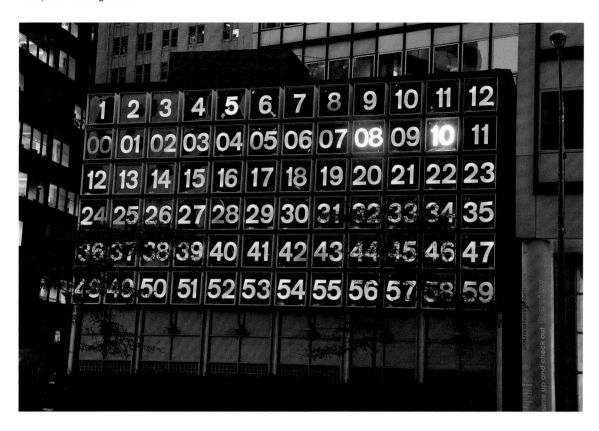

Above: Illumination ensures
the installation is also visible
at night.

Following pages: The clock in
its urban context in the heart of
Manhattan.

Akzidenz Grotesk

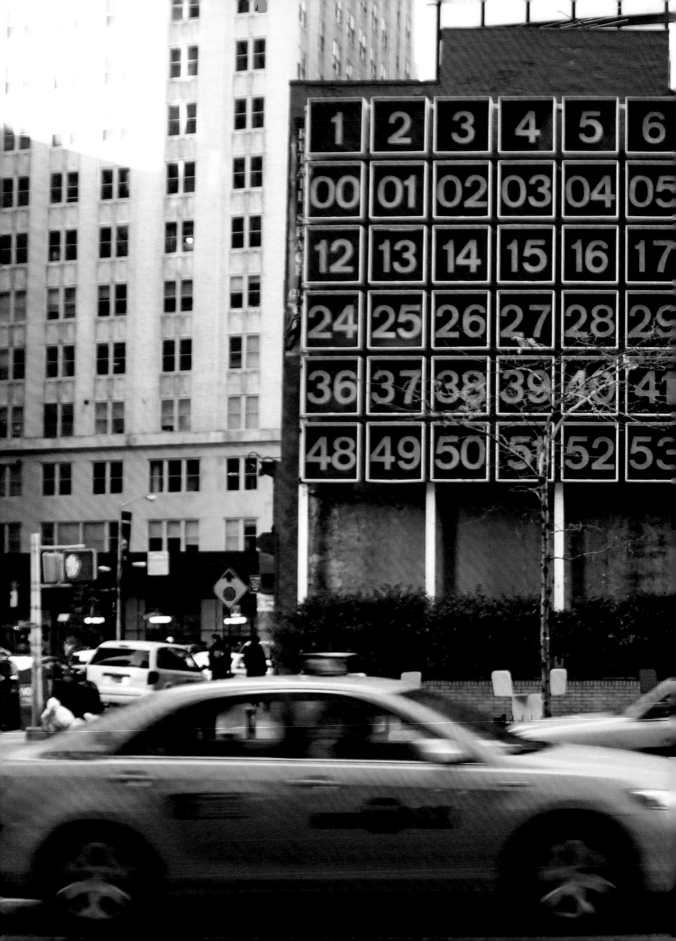

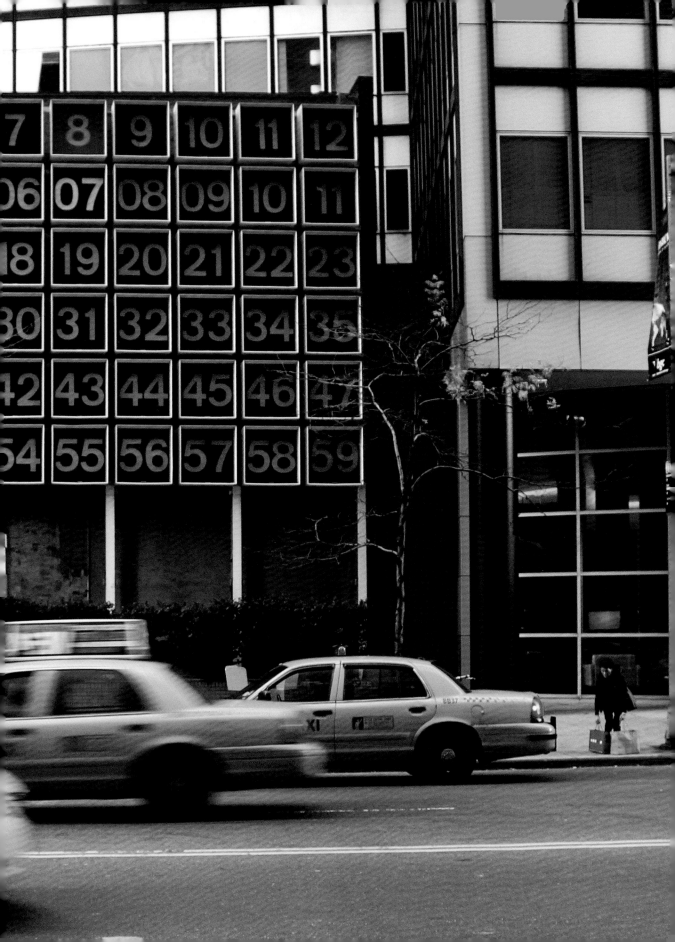

The evolution of Indiana's
idea from art piece, to public
installation, to Pop icon.

Robert Indiana
LOVE

JFK Plaza,
Philadelphia, USA

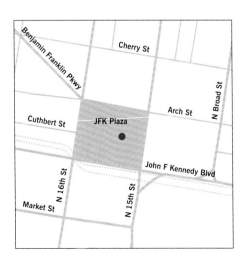

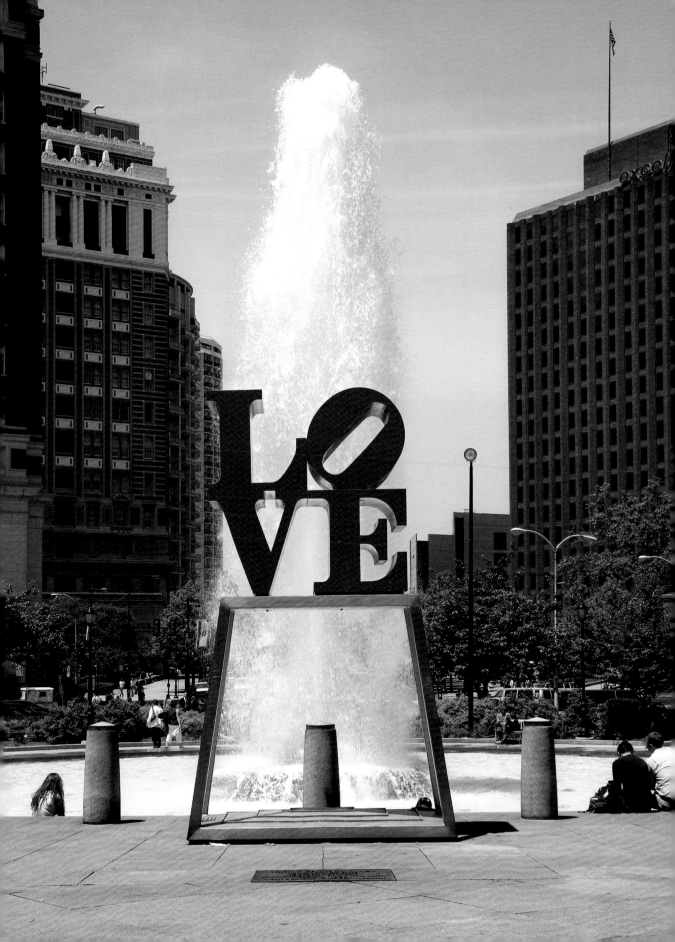

Robert Indiana's best-known work is *LOVE*, a composition in which the four letters making up the word are contained within a square field, filling it as efficiently as possible and with the *O* tilted at a 45-degree angle. This Pop Art icon appeared for the first time in its famous form in 1965 as a Museum of Modern Art Christmas card. Since then, it has been repeated in numerous other versions, in different colours, materials and dimensions.

Love is a recurring theme in Indiana's work, which, considering his Christian Scientist faith, might be spiritual in nature; the motto 'God is love' appears in every Christian Scientist church. Indiana returned to this theme in 1977 with his sculpture *Ahava*, which means 'love' in Hebrew, on display near the Israel Museum in Jerusalem.

Many two-dimensional versions of *LOVE* have appeared as prints, paintings, tapestries and postage stamps (in 1973 it appeared on the 8-cent stamp, followed by the first series of 'Love Stamps' published by the United States Postal Service).

There have also been several three-dimensional versions of *LOVE*. In his monograph on Indiana, Carl J. Weinhardt has written, 'The head-on view of that logo as seen in painting or serigraph may be thought of as an architect's facade elevation for an environmental structure that one could walk around, climb on, crawl through, or stroke to receive sensations of texture, hardness, warmth, or cold from the material.'[1] The *LOVE* sculptures have been produced in a variety of sizes and materials. They include a 30 × 30 × 15-centimetre (12 × 12 × 6-inch) format made in 1966 for the edition sponsored by Multiples in New York, for which six pieces of engraved aluminium were executed in technical collaboration with Herbert Feuerlicht. The smallest version was produced in 1968 by a jeweller in Philadelphia as a limited-edition gold ring. The largest version dates from 1970 and was made of Corten steel by the Lippincott foundry in Connecticut; it measures 3.6 × 3.6 × 1.8 metres (12 × 12 × 6 feet). In 1972, a version in multicoloured aluminium was made, reviving the bright red used in the 1966 painting. Today it stands in front of Indiana's painting *The Great American Love (Love Wall)* in the Galerie Denise René in New York.

The *LOVE* sculpture can also be seen in many public spaces. One of the most famous examples is in Philadelphia, a city whose name means, appropriately enough, 'brotherly love'. The stormy history of this sculpture began in 1976 when it was temporarily lent to the city for the United States Bicentennial celebration. Its removal from the centre of the square two years later triggered a general outcry, and it was bought by F. Eugene Dixon, president of the Philadelphia Art Commission, who presented it to the city, which still has it today. The square where it stands, originally known as JFK Plaza and used in the 1980s and 1990s as a skateboarding area on account of its curved steps and granite surfaces, is now commonly called Love Park in honour of the sculpture.

[1] Carl J. Weinhardt, *Robert Indiana*, Harry N. Abrams, New York, 1990, p. 192.

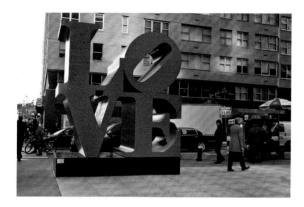

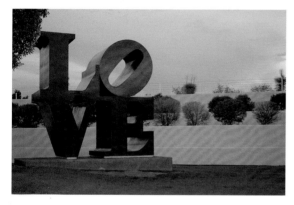

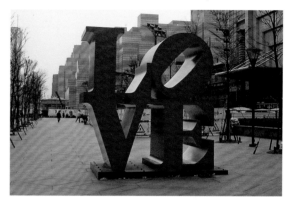

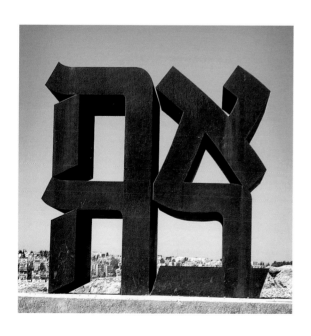

Above: Different versions of the sculpture: on 6th Avenue, New York (top left); in the Pratt Institute, New York (top right); in the Scottsdale Civic Center Mall, Arizona (bottom left); in front of the Taipei 101 skyscraper in Taiwan (bottom right).

Left: *Ahava*, the Hebrew word for 'love', at the Israel Museum, Jerusalem.

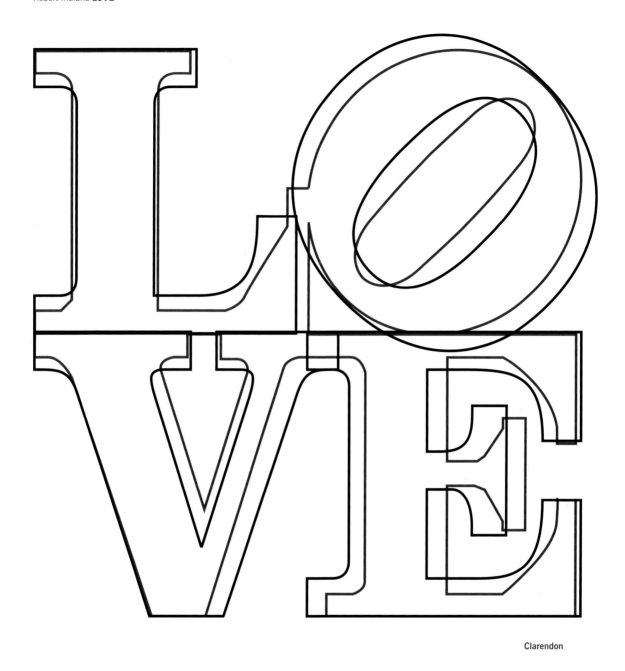

Clarendon

Opposite: Detail of the sculpture
in Philadelphia. This version is
red when viewed from the front,
with other surfaces in green and
pale blue.

Underpasses reimagined
as urban memorials bring
the city's history into
the present.

Intégral Ruedi Baur
Urban Design
for the Epidème Quarter
Tourcoing, France

The Urban Design for the Epidème Quarter project was commissioned for the French city of Tourcoing, on the border with Belgium, with the aim of redeveloping the areas around the La Tossée and Roubaix underpasses at a time when work was being carried out there by the French national railways (SNCF).

The competition asked for submissions that would enhance the landscape seen by passengers on the high-speed TGV service. In fact, the draft prepared by Intégral Ruedi Baur et Associés with Philippe Délis, Florence Lipsky and Pascal Rollet (architects) and Véronique Kagerman (historical research) was mainly concerned with what lies beneath these two infrastructures, over which the railway passes. The railway line is seen by the inhabitants as dividing the city into two zones, and, in particular, cutting off the district known as Epidème (because it was once the place where people were quarantined) from the city centre. The project sought to reunite the two areas through the use of graphics and typography. The meaning of the space has been explored using the memories of local people, which are expressed through signs placed in the area. Architectural efforts were directed towards softening the appearance of the underpasses, and the old heavy iron parapets were replaced by light railings dotted with bright glass balls.

The inhabitants of the area, for whom the project was chiefly intended, were involved in the process through a series of meetings and on-site consultations. The information obtained from archival research has been integrated with over 100 pieces of first-hand evidence on the two sites. Short phrases have been created out of this material and reproduced on 2,000 glass bricks, which have been inserted into the fabric of the walls beneath the underpasses. The glass blocks are therefore not merely structural, and can be read by the pedestrians walking by.

In addition, the ceiling of the underpass has been plastered and inscribed with the names of different places, thus emphasizing the links that exist between Tourcoing and its immigrants' countries of origin, and between Tourcoing and the rest of the world in general. It also records the infamous Loos train that carried children to German concentration camps.

Typography, architecture and light combine to minimize the interruption caused by the railway line, presenting the underpasses not as obstacles but as links, and creating walkways that stand as memorials to the city's past.

The intention was to avoid creating 'non-places', instead transforming these underpasses into spaces rich with meaning: gateways connecting the outskirts of the city to its centre; places of memory and symbol. Subsequently, the main road through the district of Epidème was also upgraded.

Above and following pages:
Some of the glass bricks
containing phrases and
drawings. The names of places
around the world are inscribed
underneath the railway lines.

La dernière *péniche* est

Univers 67
Bold Condensed

Sabon Italic

passée en 1983,
le premier *TGV*, pas bien plus tard.

Univers 58
Condensed Oblique

160

STOCK HEREFORD → TO

RCOING →ABRUD TOU

I JLIA →TOURCOING \

NG ST MICHEL DE MA

Frutiger Black

RCOING MILANO CENT

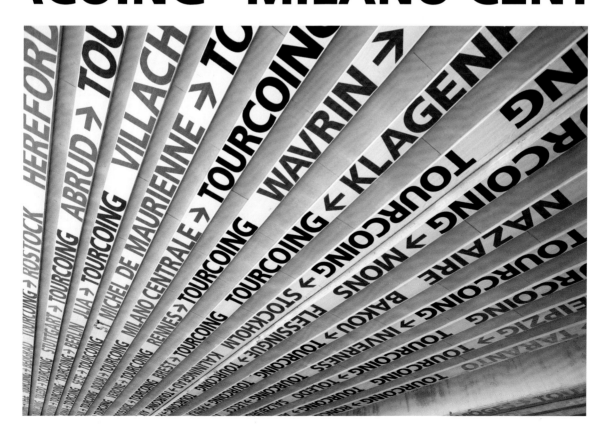

Lettering that invites us to
lie on the grass, look to the
sky and see the words
dissolve into blue.

Ilya Kabakov
Antenna

Kardinal-von-Galen-Ring,
Münster, Germany

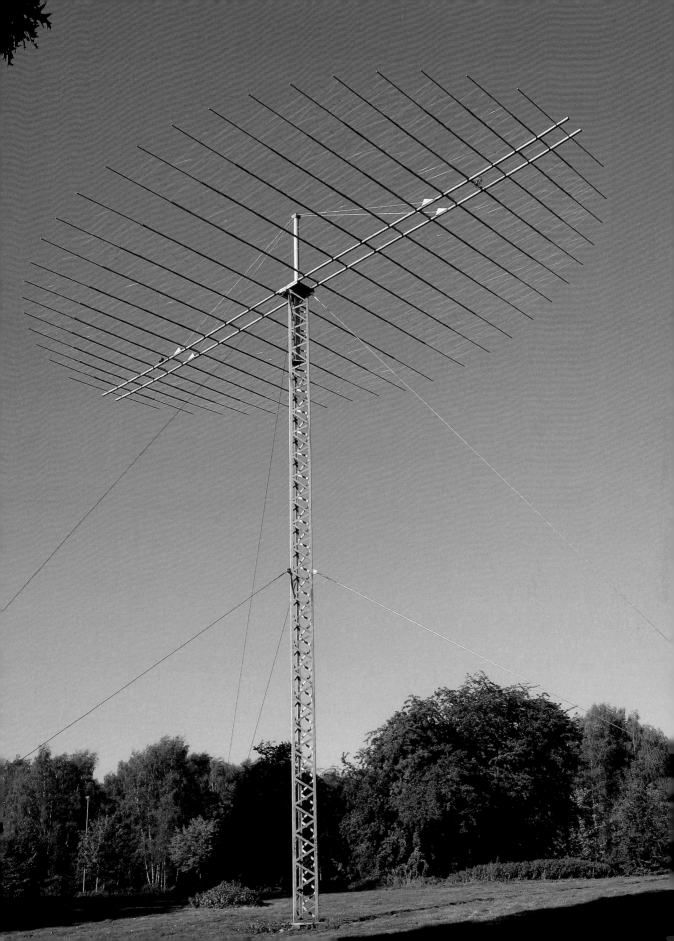

In 1997 Ilya Kabakov created *Antenna* (also known as *Looking Up, Reading the Words*) as a contribution to the Skulptur Projekte (Sculpture Project) in Münster, Germany. As one looks up at the metal sculpture, it is possible to see letters and then, with care, make out an entire text in German. As Kabakov has said, 'It is only when you are lying flat on the earth – in a flophouse, for instance – that you begin to look at the sky: the man who lies in the dirt looks on high....'[1]

The Skulptur Projekte is a contemporary art event that has taken place every ten years since 1977. Works by renowned artists from all over the world are installed in the green area surrounding Münster's old town, with the intention of showing that art can be inserted into an urban space without compromising its meaning. *Antenna* is located on a semi-circular bank, halfway between two sculptures made for the previous project by Claes Oldenburg and Donald Judd.

The artists who participate (a total of seventy in 1997) have the task of creating works that deepen the relationship between contemporary sculpture and public space. As the Skulptur Projekte's website explains, 'By incorporating the works of art, the city gradually changes its face – a dynamic process is set in motion.'[2] The letters are composed in Rabbit, a letterform designed by Kabakov especially for this installation. In his words, 'rabbits run fast and can hide in the grass'[3] (referring perhaps to the immateriality and lightness that characterizes the typeface). The letters, made of thin 3-millimetre ($^2/_{16}$-inch) wire, are installed almost 13 metres ($42\frac{1}{2}$ feet) above the ground, making them practically invisible from below. It takes a significant effort to decipher the whole of the text, which seems to dissolve into the sky. This effect coincides with the ambiguous meaning of the text (see opposite), enhancing its evocative and visionary character.

The structure designed by Kabakov is transparent and is permeated by elements of the landscape: sky, air and light. The installation consists of a central steel shaft, triangular in section and 15 metres (49 feet) high. It is fixed in the ground in a concrete block. At the top is the antenna, consisting of twenty-two metal elements to which the letters are welded or screwed.

This installation has some similarities with a normal antenna, which captures information and relays it to the listener; in this case, however, the intention is to send a message from the heavens by means of a tangible text. 'I didn't choose the words. They just "appeared" by themselves inside the antenna. I merely fixed them in metal wire,' says Kabakov.[4] Whereas a normal antenna is a symbol of progress and civilization, Kabakov's antenna invites us to detach ourselves from the world to enter quietly into contact with nature, taking our time, stretching out on the grass and watching the sky glimpsed behind the words of the text.

[1] In Boris Groys and Ilya Kabakov, *Die Kunst des Fliehens,* Hanser Verlag, Munich, 1991, p. 27.

[2] Skuptur Projekte, www.skulptur-projekte.de/information/ausstellung/?lang=en

[3] Interview with Ilya Kabakov, 30 January 2008.

[4] Ibid.

Ilya Kabakov **Antenna**

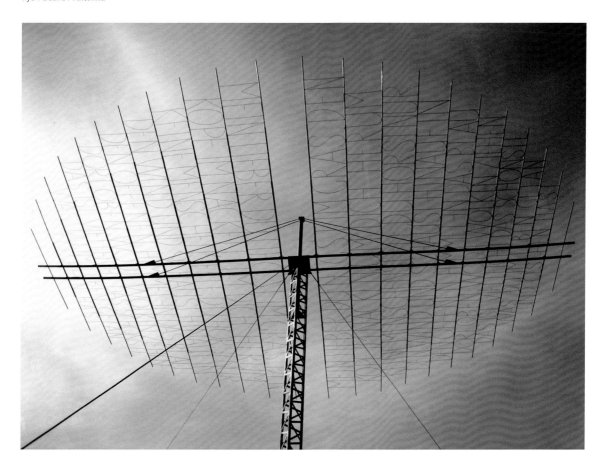

'My Dear One! When you are lying in the grass, with your head thrown back, there is no one around you, and only the sound of the wind can be heard and you look up into the open sky – there, up above, is the blue sky and the clouds floating by – perhaps this is the very best thing that you have ever done or seen in your life.'

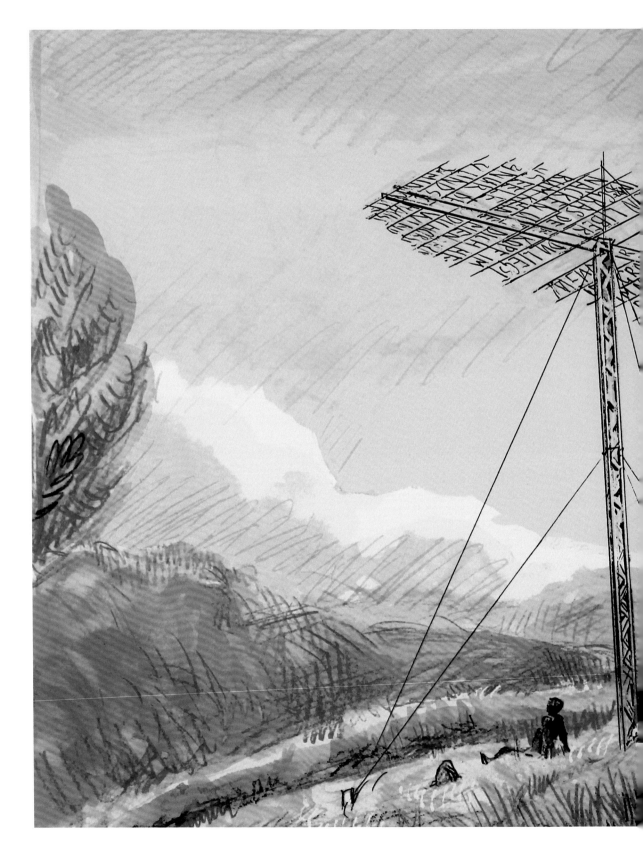

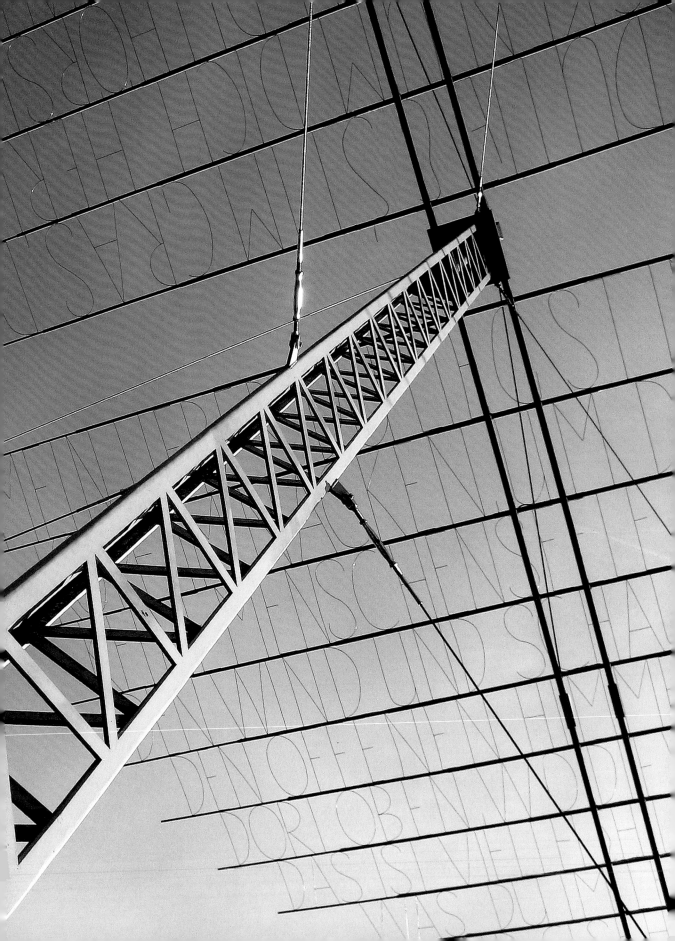

KRU

KEINEMENSCHEN

Rabbit

**Preceding pages: General view
of the installation.
Drawing by Ilya Kabakov.**

**Opposite: The central shaft of
Antenna.**

Concrete inscriptions tell
tales from local history to
Underground travellers.

Richard Kindersley
Canning Town Underground

Victoria Dock Road,
London, UK

THIS INSCRIPTION COMMEMORATES THE SITE OF THE

THAMES IRONWORKS SHIP BUILDING AND ENGINEERING COMPANY LTD

SITUATED NEARBY
AT THE CONFLUENCE

OF THE LEA & THAMES
AT BOW CREEK
CANNING TOWN.

CONSTRUCTION STARTE

Commissioned by Britain's Public Arts Commission, the work of Richard Kindersley for London's Canning Town Underground Station is made up of inscriptions recalling the history of the area. It was Jamie Troughton, one of the architects involved with the design of the station itself, who suggested the use of lettering on the wall.

The text commemorates the former purpose of the site, once a shipyard: episodes of local history alternate with the exploits of West Ham United, the local football team, and references to the most important ships constructed in the old shipyards, including the legendary HMS *Warrior*, the first warship with an iron hull, built for the Royal Navy in 1860. The inscription, engraved on the wall and then painted grey, engages with the architectural shape of the station, unrolling along the walls flanking a flight of stairs down to the Jubilee Line, and ending with a phrase that accompanies travellers on their way. The text forms waves and curls, coiling around itself or creating diagonal lines, evoking the movement of the waters ploughed by HMS *Warrior*.

The unusual thing about the Canning Town inscription is that it is etched into concrete, a difficult material to work with, its texture giving unpredictable results compared to traditional materials, such as stone. The words are inscribed on separate concrete panels that were matched up and attached to the wall. The lettering used is intrinsically related to the material and establishes a link with the architecture of the place. Kindersley says, 'As the lettering is carved directly into the surface of the building the letterform is influenced by the concrete...the letterforms had to be robust and pared back to skeletal yet elegant forms.'[1]

Kindersley combines his love of letterforms with careful study of the architecture and materials to give meaning to a text. The inscription becomes a texture that interacts with the surface, inviting us to admire the harmony of its composition as much as to read the contents, as Kindersley explains: 'Like much of my work, it operates on two levels: first, the direct meaning of the words, and second, the way they are assembled and set out providing further meaning.'[2]

This composition has also been designed by Kindersley with the typical users of Canning Town station in mind, commuters who pass the inscription daily while changing platforms. He says, 'The decorative element will obscure the message, which is about local history, and with this intentional obscuring the message will not immediately yield up the words, but over many visits to the station people will slowly decipher the writing. In this way interest in the piece will be prolonged, hopefully for many visits.'[3]

[1] Interview with Richard Kindersley, 21 October 2011.

[2] Ibid.

[3] Ibid.

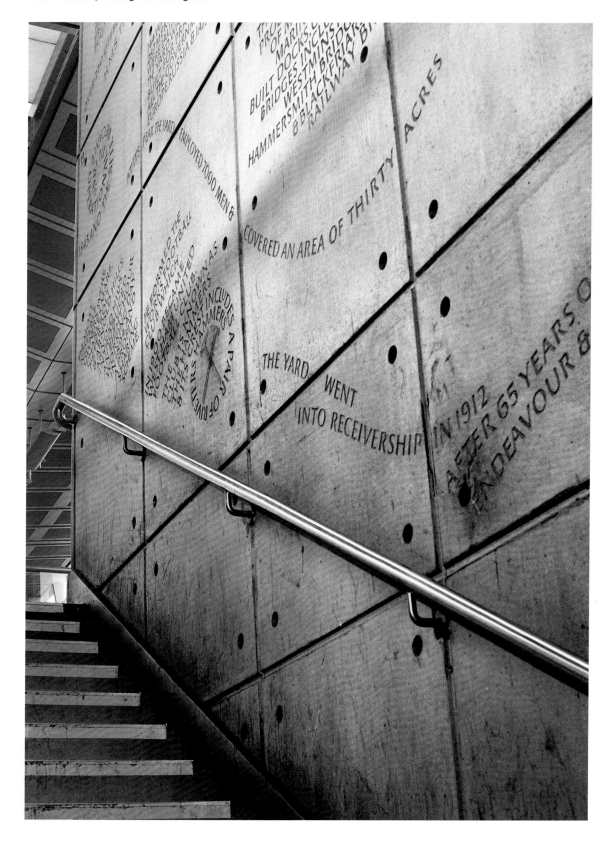

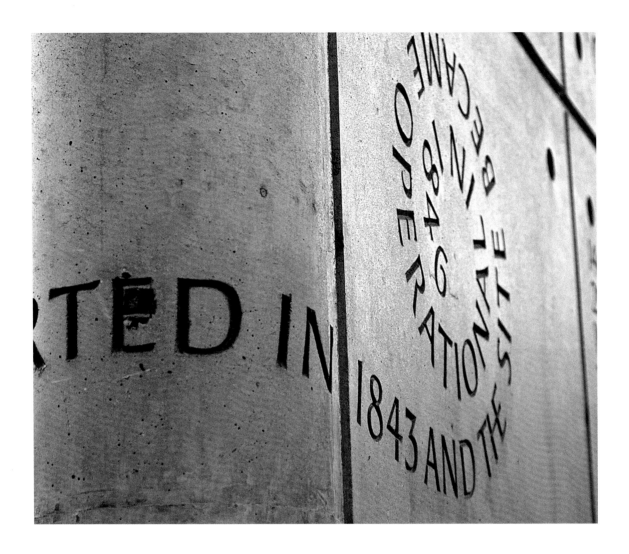

Preceding page and above: The
text is developed in winding
lines that evoke waves.

Opposite: One of the panels that
make up the installation also
has a small drawing integrated
into the text.

'He [Arnold Hills] formed
the works football club which
in 1900 became West Ham
United Football Club.
The Club is known as the
Hammers and its crest includes
a pair of riveters hammers.'

YARD ... EMPLOYED 7000 MEN & CO...

HE FORMED THE
WORKS FOOTBALL
CLUB WHICH
IN 1900 BECAME
WEST HAM UNITED
FOOTBALL CLUB.
THE
CLUB IS KNOWN AS
THE HAMMERS
& ITS CREST INCLUDES A PAIR
OF RIVETERS HAMMERS

An artistic alphabet
designed by children adorns
Amsterdam's tram lines.

René Knip
ABC on the Hoofdweg

Hoofdweg,
Amsterdam, the Netherlands

The project *ABC on the Hoofdweg* was created in Amsterdam in 2002 by René Knip with K. Schippers, with the support of the Amsterdams Fonds voor de Kunst.

K. Schippers – the pseudonym of Gerard Stigter, a well-known short-story writer and poet – sought to create a work of public art for the urban area in which he grew up. His design was intended as a gift to his neighbourhood, a poetic installation in which each letter would become a pure idea.

The installation *ABC on the Hoofdweg* invites passers-by to look up and see the letters of the alphabet. For this work, students from local primary schools were asked to draw letters and punctuation marks, and the most interesting designs were selected by typographer René Knip, who then executed them. By adapting the letters and producing them in appropriate materials, it was possible to create 'typographical totem poles': twenty-six sculptures representing the alphabet and five punctuation marks mounted on poles of the existing tram line. In addition, all the sketches, the selected children's designs and poems written by K. Schippers for each of the letters were published together in the book *Het ABC op de Hoofdweg*.

René Knip works in the area of type design, but none of his scripts has been published for commercial purposes, many being inspired by ideas and enthusiasms quite independent of the project and the client. From an early age, Knip's personal interests led him to experiment with different types of lettering in which letters are combined with drawings, and his influences include vernacular typography, commercial lettering and Art Deco period lettering, as well as all characters designed in the Netherlands during the period 1920–60 whose success has been overshadowed by those of the Modernist avant-garde. He has drawn on these styles, using details such as an *E* in which the central bar is placed higher or lower than normal.

However, Knip's inspiration does not come only from historical typefaces; he is also inspired by many forms found in the streets of Amsterdam. He seldom relies on a specific model, preferring to experiment, creating a world of as-yet unexplored characters.

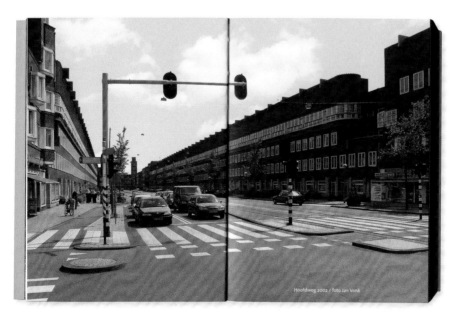

Above: From the book
Het ABC op de Hoofdweg:
drawings of the letter *A*,
rendering of the typographic
pole with the selected design
and text of a poem by
K. Schippers.

Left: View of Hoofdweg, where
the installations were placed.

Following pages: Designs
selected for the project.

A typographic installation
addresses dark moments in
Hungarian and world history.

Attila F. Kovács
House of Terror Museum
Andrássy út 60,
Budapest, Hungary

The House of Terror Museum commemorates the victims of the two totalitarian regimes that had such a devastating influence on twentieth-century Hungary – German Nazism and Soviet Communism – and gives a picture of life during those periods. The building at Andrássy út 60 was completely renovated inside and out, and the museum was inaugurated in 2002, with facade, interiors and fittings designed by architect Attila F. Kovács.

This Neo-Renaissance building, built by Adolf Feszty in 1880, was formerly the place where opponents of both regimes were interrogated and tortured. Before the Second World War it was the Nazi headquarters infamously known as the 'House of Faith'. At the end of the war, when the regime was overthrown and Hungary was occupied by the Soviets, the building became the headquarters of the Hungarian secret police. In the same rooms where, before the war, opponents of the Nazi regime were tortured, often to death, after the war, opponents of the Communist regime met a similar fate.

Kovács's work on the exterior retains its original appearance while adding a dramatic feature. A black frame runs along the upper edge of the building before descending to street level, where it is transformed into a black granite pavement. Following the shape of the corner block, the cornice has the word 'TERROR' cut out of the metal in large extra-bold capitals. He says, 'I used the written word because the propaganda the Communists and Fascists used were slogans, so words were always important as a visual symbol of the meanings, together with the political signs.'[1]

The word appears twice, so that it can be read from the two streets on which it stands, Andrássy út and Csengery utca. Looking up, 'TERROR' is seen in negative space, and casts a positive, though distorted, shadow onto the facade of the building and the street. The legibility of the word, both in the cut-out metal and in the shadow, is influenced by the choice of the typeface. Kovács says, 'I designed the typeface, following the simple stencil designs of the 1950s. They had to be practical, easy to cut out...and have a characteristic shadow.'[2]

Passers-by are obliged to cross under the cornice through two rectangular openings on the pavement. Here they are drawn into an atmosphere of oppression and anguish created by the black metal with its inscription. This structure, Kovács explains, 'functions like a bookmark from the row of buildings on the boulevard.... This was a real place, where people were executed – hanged and tortured to death. The black cornice creates a virtual, dark space around one of Budapest's most feared buildings.'[3]

[1] Interview with Attila F. Kovács, 3 January 2012.

[2] Ibid.

[3] Ibid.

Opposite: Kovács's frame encloses the Neo-Renaissance building.

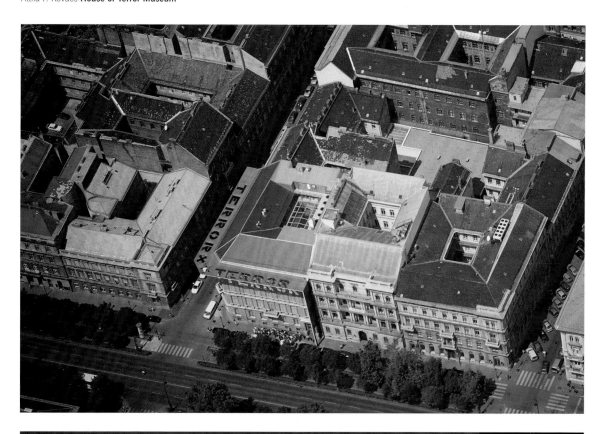

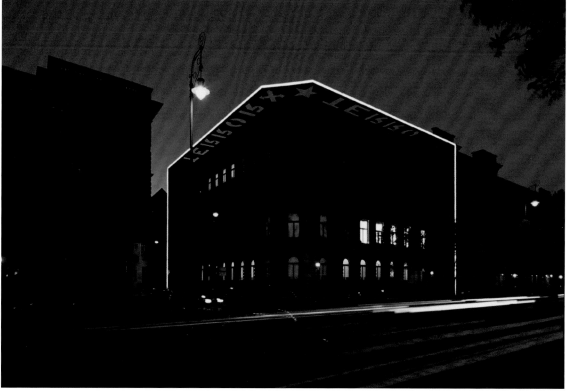

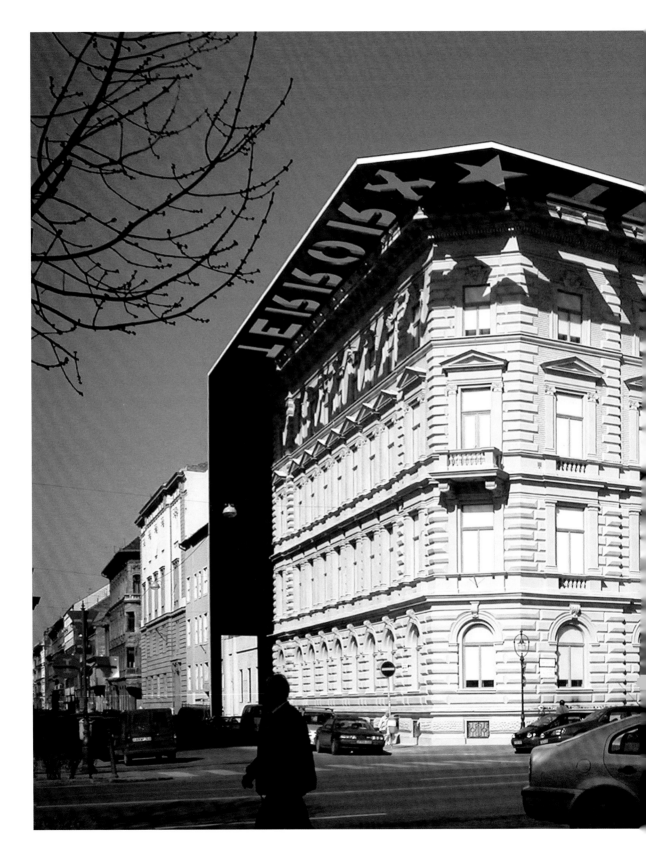

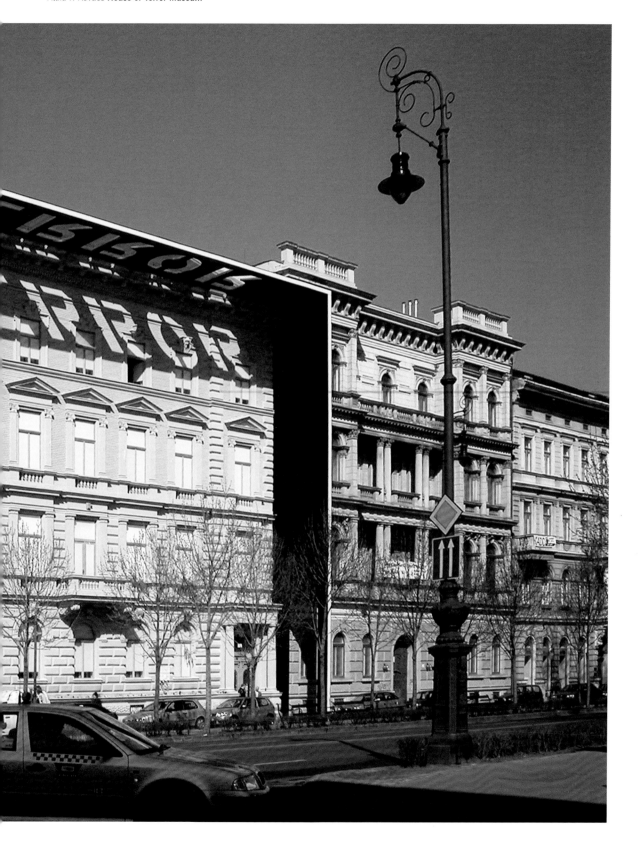

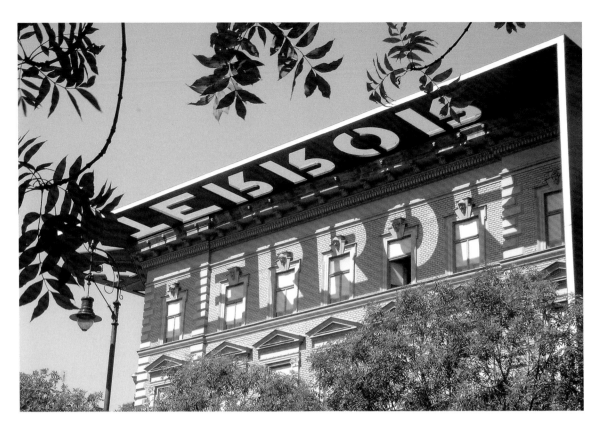

TERROR

Preceding pages and opposite top: The word 'TERROR' exists in immaterial form as a shadow; on the facade, on the street and, materially, on the cornice.

Opposite bottom: The 'Hall of Tears' inside the building.

Above: The stencil letterform was designed by Attila F. Kovács, inspired by the lettering of the 1950s. As well as the repeated word 'TERROR', two symbols associated with Nazism and Communism can be seen on the cornice.

Memory and grief conveyed
through the endless repetition
of names etched in stone.

Maya Lin
Vietnam Veterans Memorial

Constitution Avenue,
Washington DC, USA

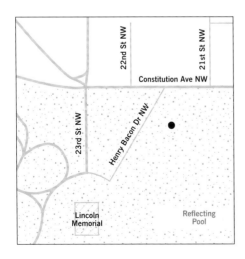

WILLIAM L HAMLIN • EUGENE

SAM R JONES • EDWIN W MARTIN

LEONARD PHILLIPS • WILLIAM C ALLEN

ELWOOD BAKER • CRAIG B CAREY

GERRITH L KIBBE • JEFFREY D McCLURE

DAVID N PARKS • MICHAEL D PERKINS

JERRY L STEED • THOMAS C BENCE

LUIS F CORREA • WILLIAM K CARDELL

THOMAS C GUDEN • CARL E HOUSER

ALFRED W MURPHY • KIERAN STARK

JAMES S McARTHUR • JERRY THOMAS

ANGEL MERESI CORREA • EARL DAVIS

GODFREY • TEDDY W

Designed by Maya Lin in 1981 – when she was just twenty-one – the Vietnam Veterans Memorial is an installation that commemorates more than 58,000 US soldiers who died in the Vietnam War. The memorial was commissioned by the Vietnam Veterans Memorial Fund Inc. (VVMF), a non-profit organization founded by veteran Jan Scruggs, following a competition in which this project was the winner.

Located on the National Mall near the Lincoln Memorial and the Washington Monument, the project consists of two long black granite walls that meet at an angle of 125 degrees, creating a wedge-shaped plan. The height of the walls gradually increases from the ends to the centre. The visitor is confronted with seventy panels of polished black granite bearing the names of the victims, the opaque light-grey lettering standing out clearly against the material on which it is inscribed. The surrounding landscape can be seen reflected in the stone: on one side the monument contrasts with the Neoclassical urban context, and on the other it blends into the park itself. By embedding the wall in the ground, Maya Lin has sought to create an intimate space fostering commemoration and reflection. The names, arranged chronologically according to year of death, are separated from each other by a small symbol providing information about the preceding name: a diamond if the person has been declared dead; a cross if missing. The cross can easily be transformed into a diamond or, if the person is discovered still alive, a circle. Unfortunately, no circle has yet been added to the wall.

The endless succession of so many names has a powerful effect on the viewer, creating a sense of vertigo. Here visitors express their emotions with the utmost freedom. Many also keep an image of the wall by taking a rubbing of the names incised there.

To ensure that the wall would be ready for inauguration during Vietnam Veterans Week, the names were engraved using photo-stencil gritblasting, a computerized system developed specifically for this memorial. As the website for the memorial explains, 'It involves a film negative at one-third size from which an enlargement is made, a film positive (stencil) at full size. The next step is coating the granite, which has been polished with a photo-sensitive emulsion, and the image is then transferred from the enlargement to the stone in a process very similar to silkscreening. When this step has been completed, the stone within the area of the letters is exposed and the remaining surface is protected by the emulsion.'[1]

The font used throughout is Hermann Zapf's Optima, the names all in one size, with the years appearing in a larger size. The list is right-aligned on the stone panels to the west of the central junction, and left-aligned on those to the east.

[1] Vietnam Veterans Memorial, www.thewall-usa.com/information.asp

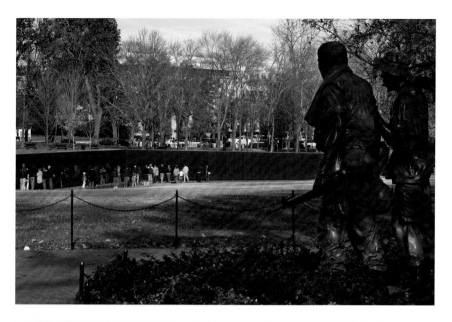

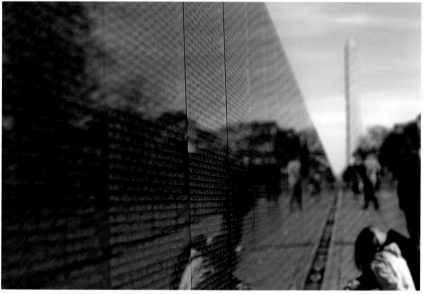

The monument's shape is wedged in the ground of the National Mall. The Washington Monument stands tall in the background.

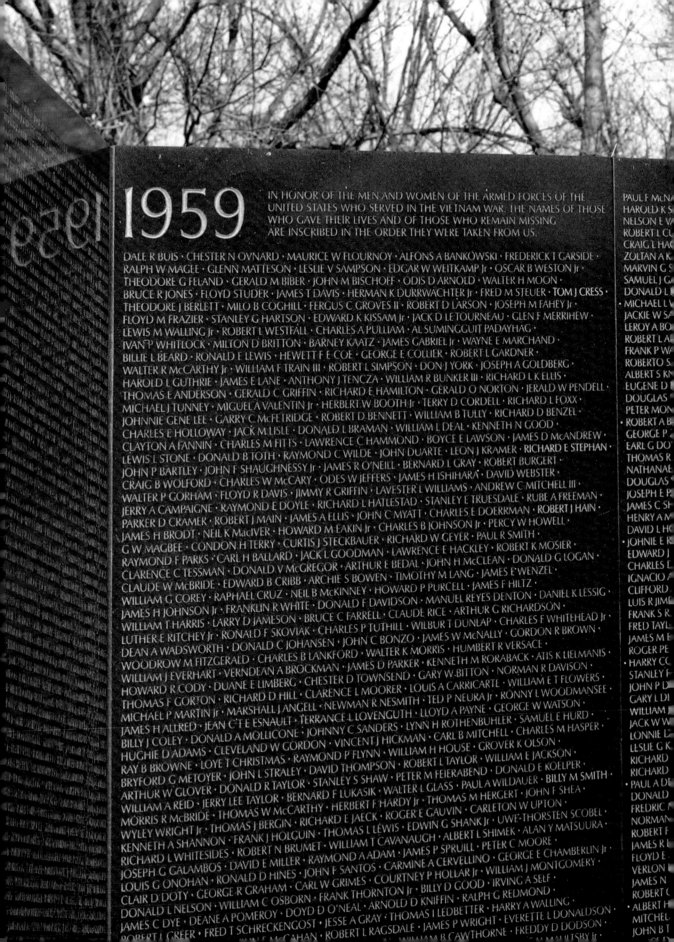

**Opposite and above: Some
58,000 names are inscribed
on the memorial.**

'Everyone was shocked at the
size of text and they argued,
"You can't do that." Because a
text in public spaces should be
large. I equate it to when you
read a billboard, yes you read
it en masse. But it's more of a
personal connection if you read
a book 'cause you're just so
connected to it.

So can you put a book out in
the public realm? Can we make
it that personal and still be in
a very large public space? And
again, there's another one of
those opposites. Very public,
but intensely private.'

Maya Lin in Bill Moyers, *Becoming
American: The Chinese Experience*,
PBS, 2003.

A fitting typographical
decoration for a printing
house emphasizes the
building's function.

Karel Martens
Veenman Printers
Maxwellstraat 12,
Ede, the Netherlands

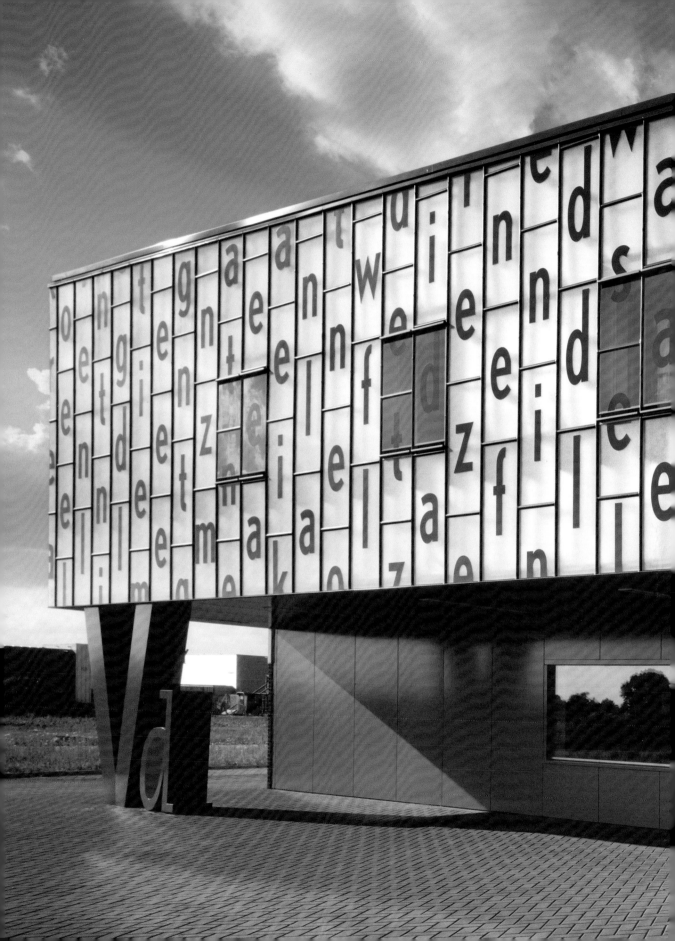

[1] Maria Argenti, 'Tipografia Veenman', *Materia*, no. 32, 2000, p. 58.

[2] Willem Jan Neutelings, interview for *OASE*, 1997, quoted in Bart Lootsma, 'Printing press, Ede, Holland', *Domus*, no. 807, 1998, p. 38.

[3] Maria Argenti, 'Tipografia Veenman', p. 58.

The building that houses Veenman art printers is located in an industrial zone of the Dutch town of Ede, an area characterized by the typical buildings found on the outskirts of cities. The architects Neutelings & Riedijk designed this building between 1995 and 1997, paying special attention to the interior. Landscape architects West 8 designed the internal garden onto which these spaces open. Completely different from the structures around it, the Veenman building is instantly recognizable from the outside, even when the observer is speeding by on the nearby motorway. This is thanks to graphic designer Karel Martens's treatment of the exterior. As Maria Argenti says, 'Neutelings & Riedijk's building facade is intended as an advertisement for itself. A means of communication through the creative use of graphics.'[1]

The facades were made employing a low-cost system of a glass wall mounted on a metal structure, similar to that used for greenhouses. The inner side is coated with a white insulating material, with spaces that allow the windows and lights from the offices to be seen. A poem by K. Schippers was used by Karel Martens as the literary basis of his installation, but, since each letter is placed within a rigid geometric structure, it is impossible to read it as such. The poem is deconstructed in meaning and turned into a kind of puzzle.

In an interview for the magazine *OASE*, the architect Willem Jan Neutelings describes his work on the graphic installation: 'Our projects are born naked. Once they are born, we look and see how they should be dressed. Our design work is programme-based; the outer walls are seen to at a later stage. The outer wall-cladding is determined afterwards to emphasize the concept. This method of design can be compared with dressmaking: the cut, the style is essential. Then you go in search of materials to abstract the form. The patterns of the materials vary: one season it may be checks, the next polka dots.'[2] The initial idea, which was not carried out, already pointed to an integration of architecture and graphics: it was intended that an outer coating of paper (consisting of posters created by graphic designers) would be changed every year, like a piece of fabric.

Martens's installation uses Nobel, a typeface designed by Tobias Frere-Jones. Each letter is about 1 metre (3 feet) high and the black concrete base helps to highlight the glass boxes in which they are placed. Positioned on the glass, says Argenti, 'the letters cast a shadow on the insulating material beneath that seems as if it might detach itself at any moment and float off into the air.'[3] The facade is completed by the typographical logo of the Veenman company, arranged as a column supporting the canopy over the entrance to the building, which recalls the Minnaert building at Utrecht University, also designed by Neutelings & Riedijk.

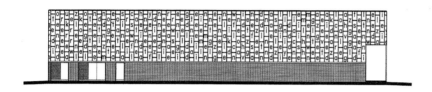

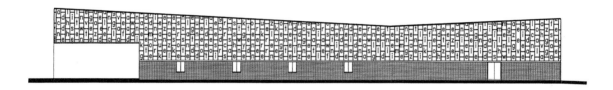

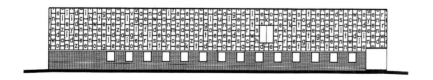

Diagrams showing all sides of
the building's exterior.

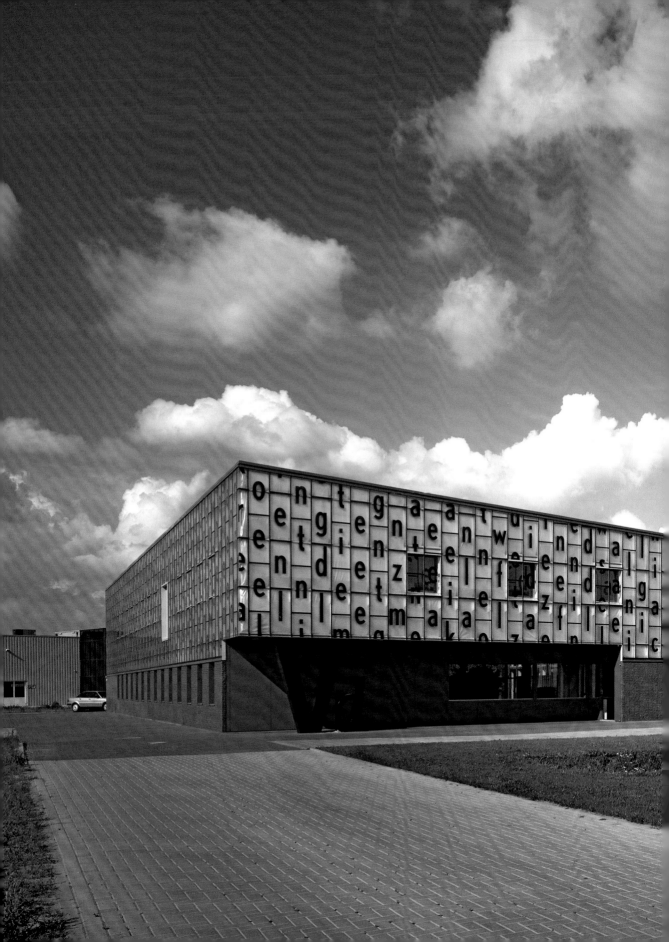

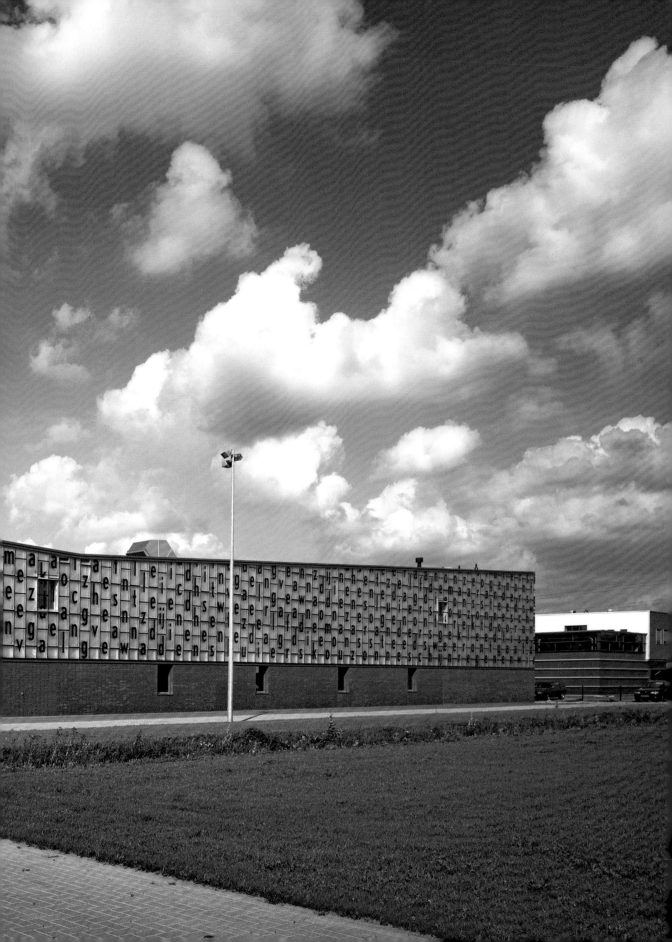

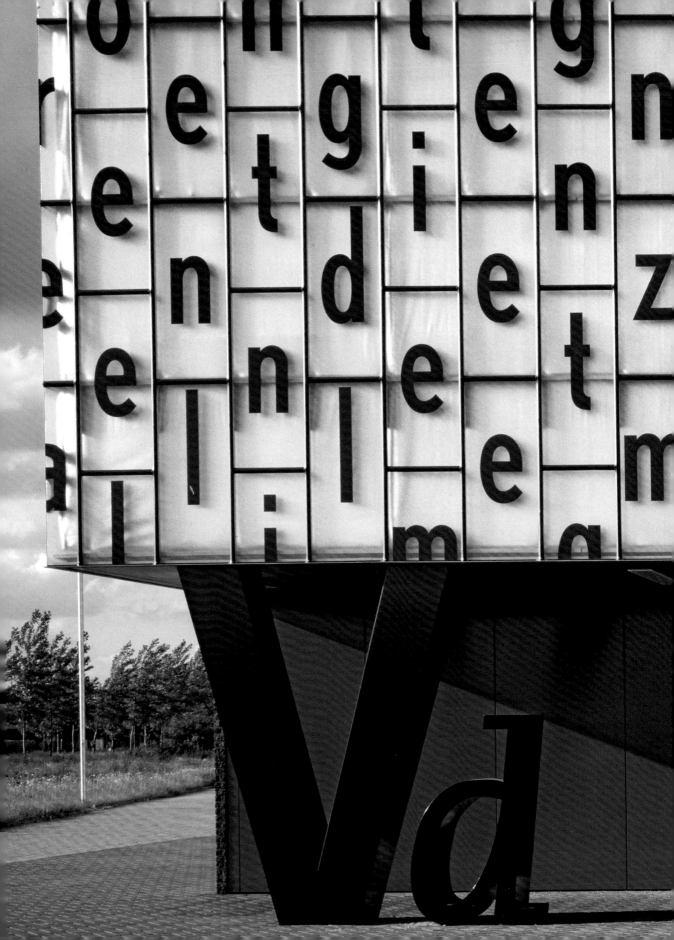

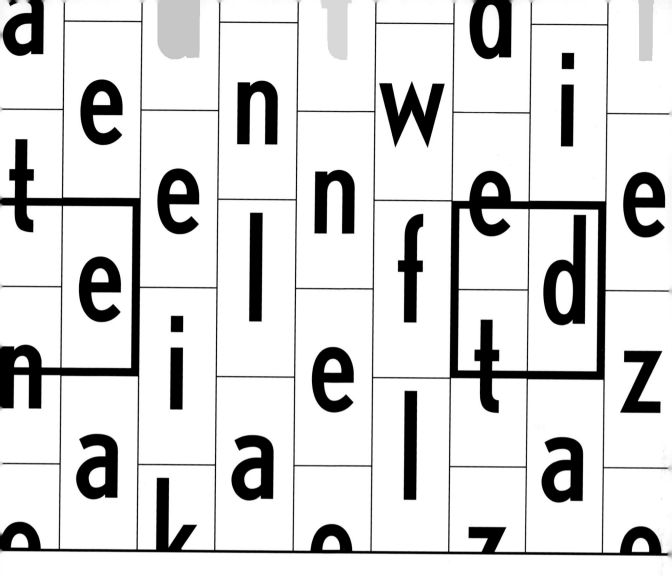

Nobel Regular Condensed

All days are the same but dressed differently
It's (one and) the same day that ever again

draws itself from our eyes through other hues
a cleverly chosen light gowns veils

cold sunshine rain and wind all derivations
from that one day

that keeps on escaping us
that we just don't see

K. Schippers

Preceding pages and opposite:
Veenman's logo acts as a
support column at the building's
entrance.

Following pages: The rear of the
building.

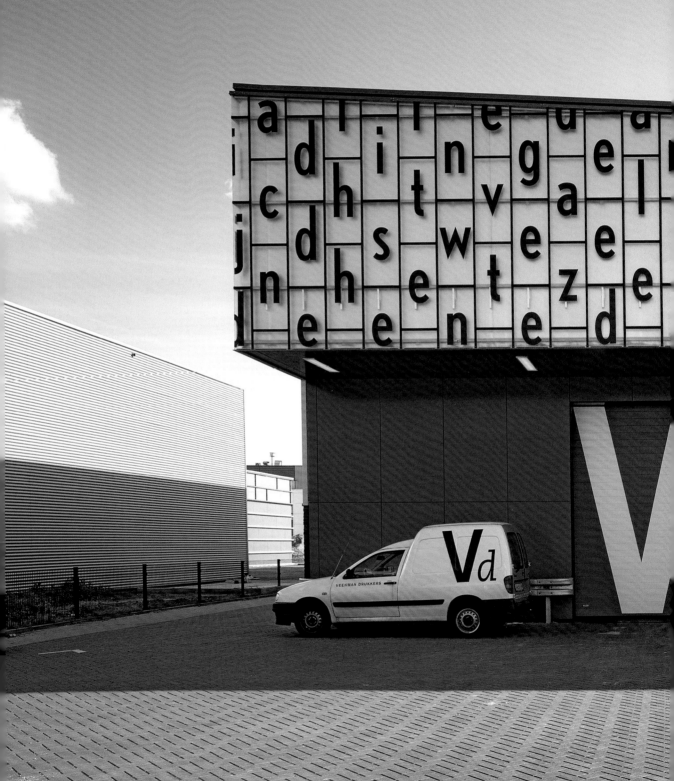

An urban public art
intervention inspired by Braille
symbolizes the difficulty of
modern communication.

Anton Parsons
Invisible City

Lambton Quay,
Wellington, New Zealand

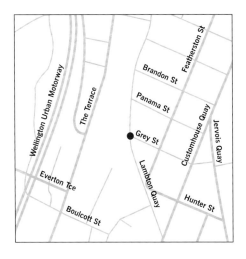

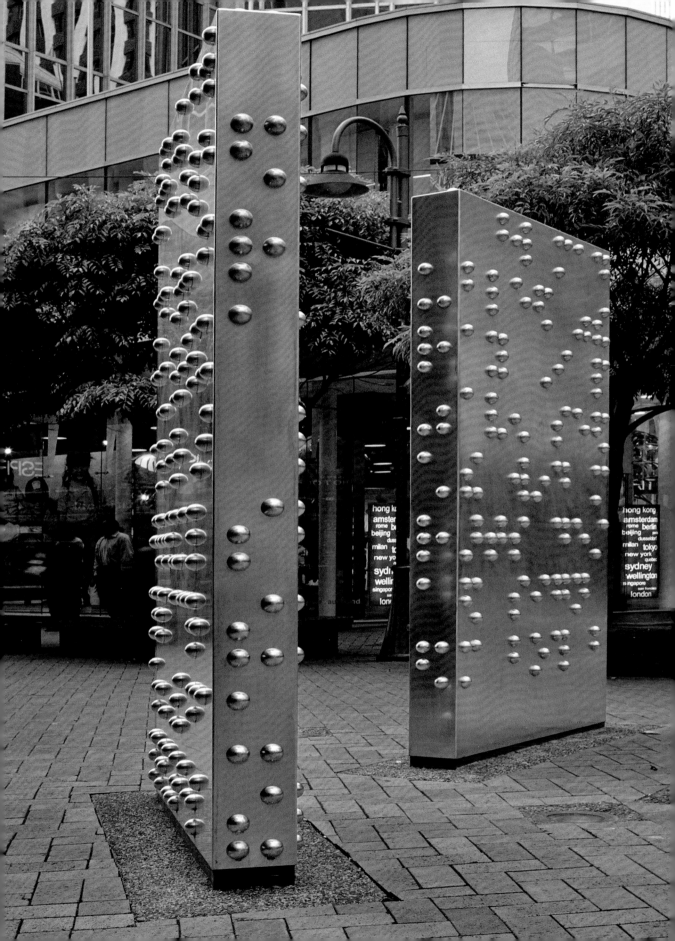

In 2003, the artist Anton Parsons created the sculpture *Invisible City* for the Wellington Sculpture Trust, an organization that commissions sculpture for public spaces to enhance urban areas and to encourage the creative arts in New Zealand.

Originally executed in wood for a private gallery, *Invisible City* is made up of two shiny stainless-steel rectangular shapes (2.2 × 1.2 metres; 7 × 4 feet) covered a in large quantity of half-spheres. These spell out a text in a giant version of Braille. For this installation it was decided to use contracted Braille, a form that allows more text to be written in a smaller space by using a single cell for more than one word or sound.

Braille is a system of tactile writing invented by the Frenchman Louis Braille in the first half of the nineteenth century. It uses a collection of symbols comprising at least one but no more than six raised dots. These are arranged in a cell of three lines in two columns. The dots are normally punched into sheets of paper and can be read by touch. A Braille cell has a standard size of 3 × 6 millimetres ($^2/_{16}$ × $^4/_{16}$ inch) so that the entire surface can be felt by reading horizontally, following the direction of the words. Braille is not a language per se, but an international method for writing. It can be used to represent alphabetic letters, punctuation, numbers, mathematical symbols and musical notation.

The text used in *Invisible City* is a poem by the blind poet Peter Beatson, written in memory of his dog, his essential guide to the city of Wellington. No translation of the Braille is provided, which symbolizes the difficulties of communication in the modern world, particularly between disabled people and the rest of the community. Parsons designed the work in such a way that the text is completely unintelligible even for the non-sighted. The individual Braille cells have been blown up to such a size that they can no longer be read with the fingertips but require a whole hand. While the physical relationship between body and text is preserved, it is impossible decipher the words. Parsons explains, 'As a result, an artwork called *Invisible City*, which uses the alphabet of the blind, is actually invisible in terms of meaning.'[1]

As a work of art, it does not need to be read to be appreciated, but it is precisely the difficulty in deciphering the text that suggests different ways of approaching it. Its smooth surface, which reflects the surrounding area, invites us to explore it with our hands. The impossibility of understanding the text creates a kind of challenge. According to Parsons, 'Because there is an implicit understanding by sighted people that the Braille words "must mean something", the relationship is ongoing, like a missing word from a crossword puzzle, where you look at the clue again and again, knowing the answer is there if you only think hard enough.'[2]

[1] Interview with Anton Parsons, 5 December 2011.

[2] Ibid.

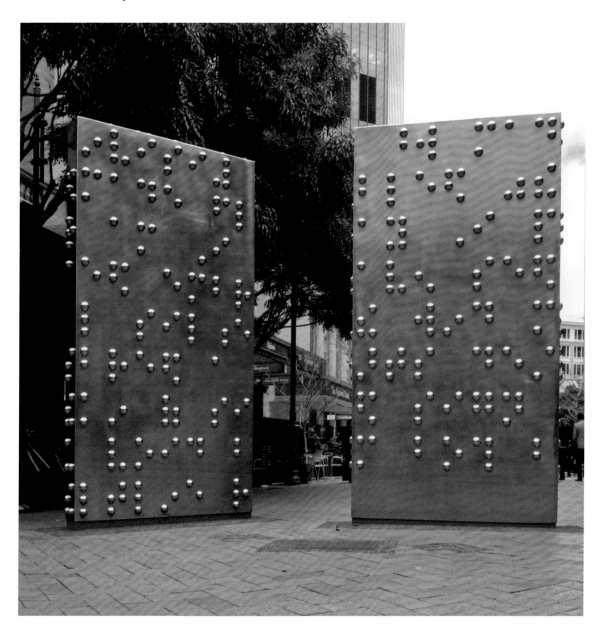

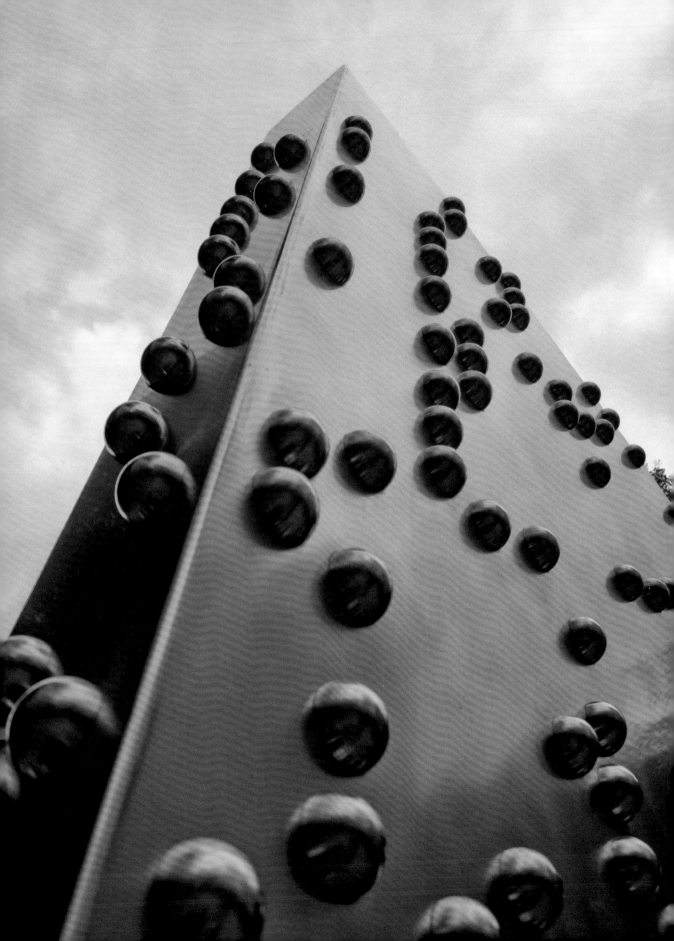

Preceding page, opposite and above: Some views of the installation.

Right: An outline of a Braille cell showing its reading direction.

A complex large-scale
installation that integrates
an established identity with
the building's facade.

Michael Bierut / Pentagram
Signage for the *New York Times* Building

620 8th Avenue,
New York City, USA

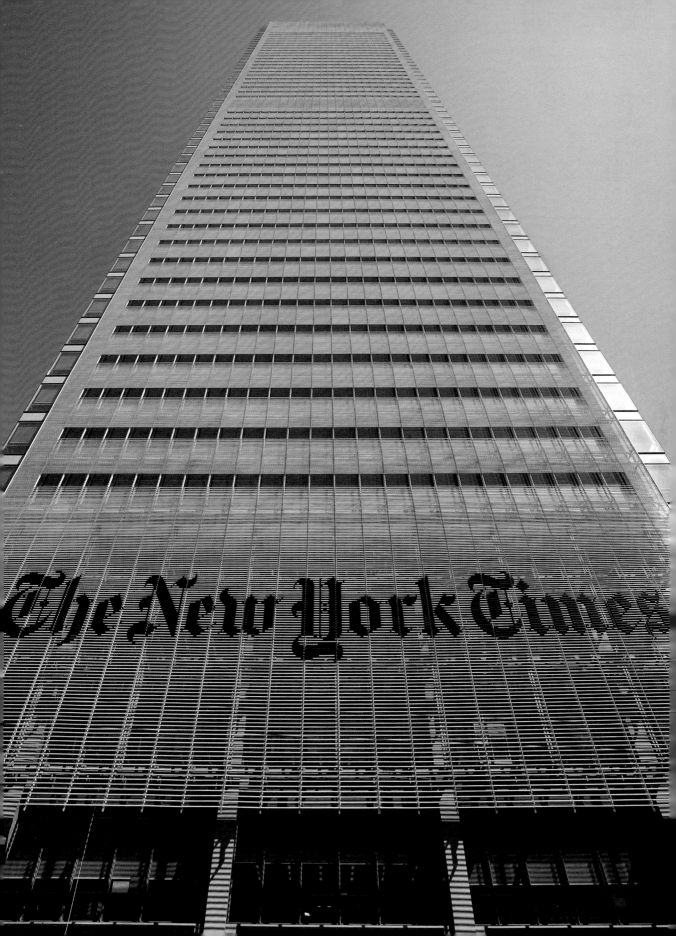

¹ Pentagram, 'Sign of the Times', pentagram.com/en/new/2007/07/ sign-of-the-times.php

In 2007, Pentagram's Michael Bierut was commissioned to provide environmental design for the new skyscraper designed by the Renzo Piano Building Workshop for the *New York Times*.

Located in Manhattan, in Times Square (the district that takes its name from the newspaper that, until 1913, was based on 42nd Street), the transparent and easily accessible design of the fifty-two-storey skyscraper is intended to convey a sense of the close relationship that exists between the newspaper and the city. It is possible to see through the doors into the lobby, beyond which are a semi-public auditorium, restaurants and shops. An internal garden, open to the public, is visible from the street. The walls of the skyscraper, made of ultra-clear, low-iron glass, have an external curtain wall of horizontal bars made of white ceramic that extend up beyond the level of the roof, with a distance between the bars and the glass walls of 61 centimetres (24 inches). Mounted on an aluminium framework, they not only protect the internal spaces from sunlight and heat but also change colour during the day. This skyscraper is the first in the US to use a technology of this kind, which, by allowing natural light to enter the offices, reduces energy costs.

To create this installation – consisting of the famous newspaper's logo blown up to a huge scale on the facade facing onto 8th Avenue – Pentagram not only had to find a way to realize a complex design but also had to comply with the guidelines for Times Square established in 1993 by Robert A. M. Stern and Tibor Kalman. This plan specified a minimum size for signs in relation to the area of the facade and encouraged signs attached to buildings rather than lettering integrated into the architecture.

Pentagram was able to reconcile these requirements with the building's unique design by exploiting the outer cladding itself. The huge *New York Times* logo was divided up into many pieces, both to avoid obstructing the view from inside the building and to leave the overall external structure intact.

Each letter, set in Gothic Textura (characterized particularly by the *o*, which is almost hexagonal in shape) was rasterized and divided into horizontal bands, the number of pieces varying from 26 for the *i* to 161 for the *Y*, making 959 pieces in all. Each piece was constructed as a three-dimensional tube so that it could be slipped onto the ceramic bars. A slight protrusion – or a 'beak', as Pentagram calls it – on the external side of the tube makes the logo more easily visible from the street. As Pentagram says, 'The result is a sign that is dramatically legible from outside, but that can barely be seen from the inside. It at once satisfies the area's signage requirements, while integrating perfectly with the structure's distinctive facade.'¹

Already a striking presence in Manhattan's urban landscape, the installation is part of a larger project carried out by Pentagram for the *New York Times* building. This includes internal signage, internet site (newyorktimesbuilding.com), publicity materials advertising the spaces available for letting, art direction by the photographer Annie Leibovitz, development of an identity for TheTimesCenter and enhancement of some aspects of the *Times* identity.

Opposite and following pages: Interior and exterior views of the facade.

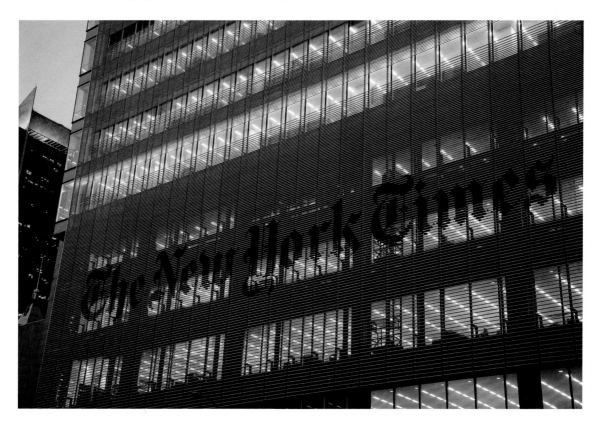

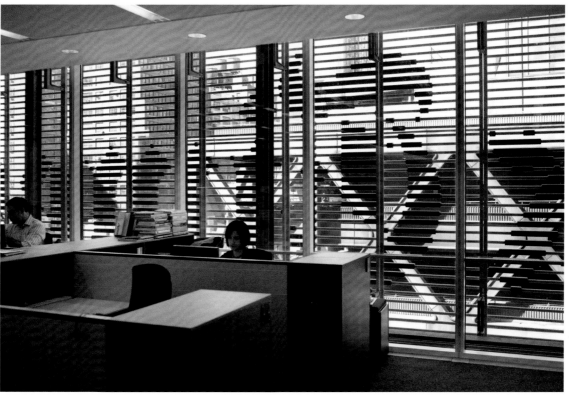

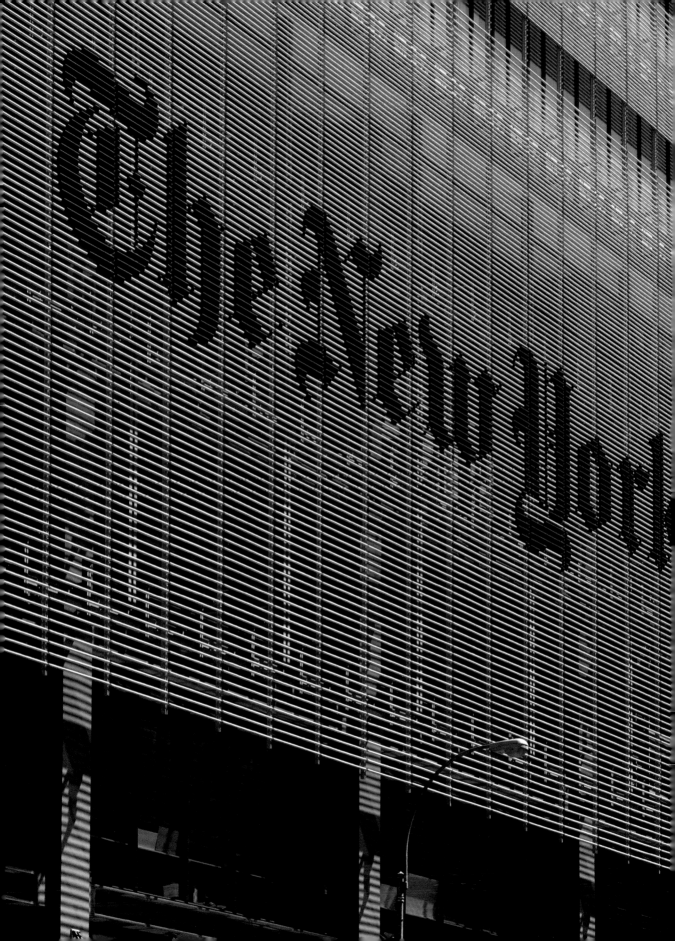

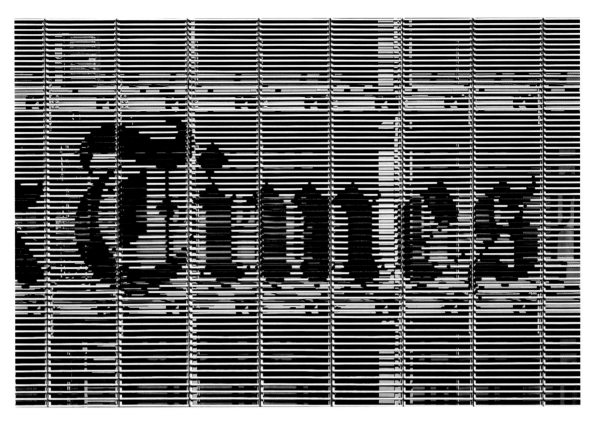

Details of the front view
and the installation process.

The New York Times

Gothic Textura

The *New York Times* logo was
divided into 959 pieces.

A painted-on typographical
installation enhances the
identity of a performing arts space.

Paula Scher / Pentagram
New Jersey
Performing Arts Center
24 Rector Street,
Newark, New Jersey, USA

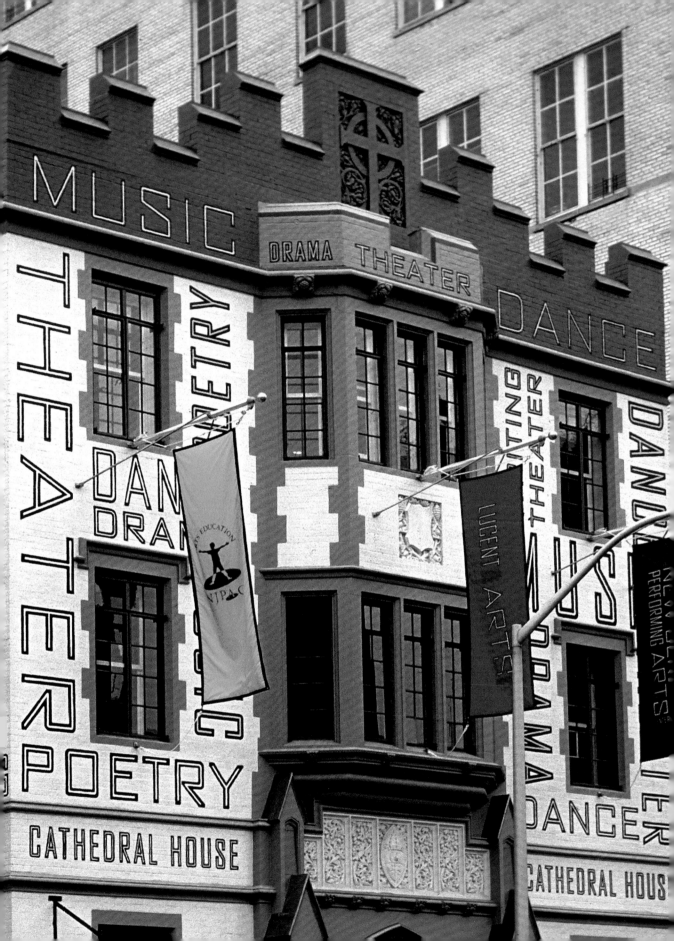

¹ Interview with Paula Scher, 26 November 2007.

² Ibid.

Paula Scher's (Pentagram) typographical installation for the New Jersey Performing Arts Center / Lucent Technologies Center for Arts Education (NJPAC) was created in 2000. The centre is based in an old school building in Newark dating from the 1940s and renovated with the assistance of a grant from Lucent Technologies. The architectural renovation was carried out by local firm Kaplan Gaunt DeSantis. Scher was commissioned by the president of NJPAC, Larry Goldman, to create a new image for the centre, but within the limits of a very small budget.

Working with photos of the facade, which had originally been painted beige and brown, Scher tried out various possibilities that might make the structure stand out more among the other buildings of the city. Ideas included triangular pennants, such as those used by second-hand car dealers, a magic castle, painted stars and painted words indicating the activities going on inside the building. Goldman went with the words.

Scher finalized her typographical contribution, making some changes to her original design, including somewhat reducing the size of the lettering and rearranging the positioning of the words. These were placed on all parts of the building, including corners, turrets and areas hidden from view. Typography was applied even onto the large air-conditioning ducts, turning these previously obtrusive elements in the architecture into the aspect of the building that is most striking and unique.

Scher explains the inspiration for her typographical work with reference to the past: 'It was common practice in Victorian times to paint the sides of theatres with information about the performances and plays. You can see the faded lettering to this day on the sides of theatres in Covent Garden in London.'[1]

Scher's work for the NJPAC, which also included the interiors, is a good example of the optimum use of resources, in which limitations are turned into opportunities. The result of her project, with its lettering simply and economically painted on the walls, is a typography that relates to the building, enhancing it, emphasizing its structure and making it instantly recognizable. An important aspect of this work's success was the client's brave decision to accept the challenge of an unusual proposal.

In her work, Scher distances herself both from the type companies that produce elegant or 'fashionable' fonts and from the dominance of Helvetica-based graphics, International Style and ITC. Her typographical preferences lead her to use Victorian, Art Nouveau, Art Deco and Streamline typefaces. Other fonts that have influenced her work come from old alphabet books found in flea markets and wood-type alphabets (such as the American wood types of the Morgan Foundry, now owned by Haber Typographers in New York), which she collects in the form of prints. The font selected for the NJPAC project is Morris Fuller Benton's Agency Gothic. She says, 'I chose the font Agency because it has a condensed form. In all caps it could easily conform to the ins and outs of the building.'[2]

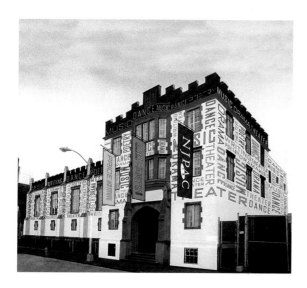

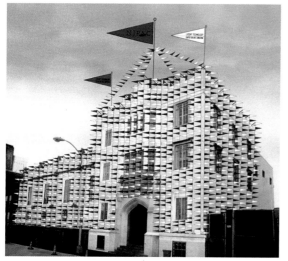

Proposals for the project
superimposed on photos
of the facade.

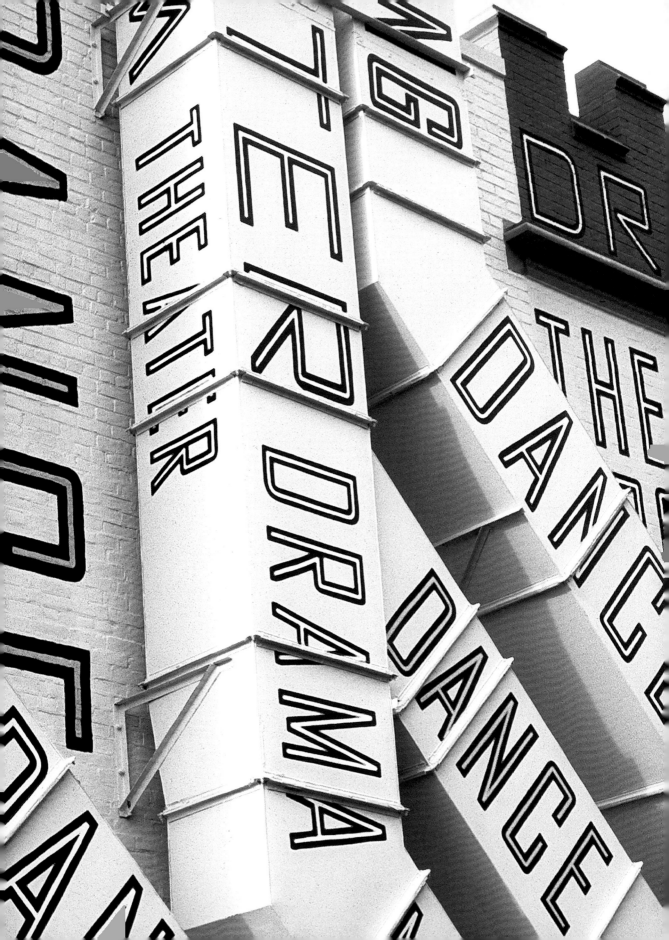

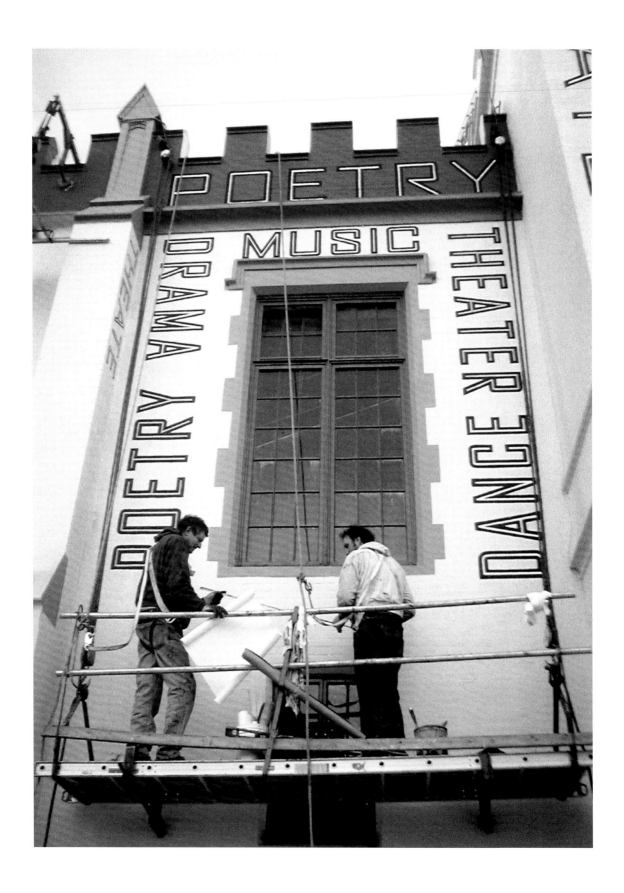

MUSIC

Agency Gothic Regular

Agency Gothic Regular Extended

Preceding pages, opposite and top: Posters designed by Paula Scher in 2001 for NJPAC (above), based on the same typographical models as the exterior (preceding pages and opposite).

A monumental *M*:
the initial letter of the city
and of innumerable other
evocative words.

Roberto Behar
& Rosario Marquardt /
R & R Studios

M

88 SE 4th Street,
Miami, Florida, USA

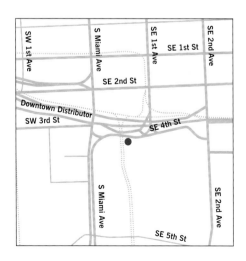

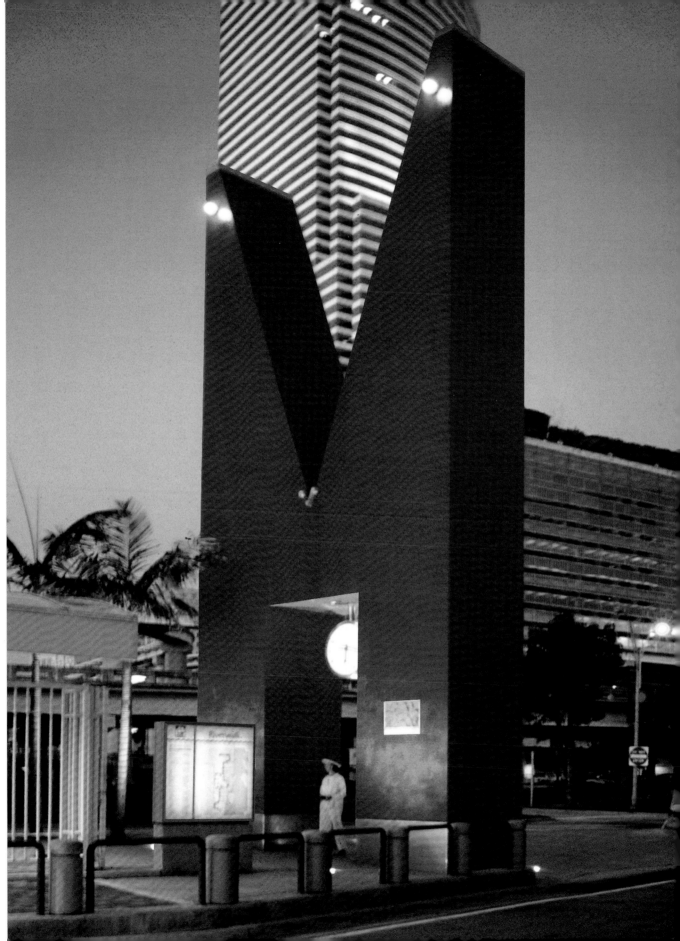

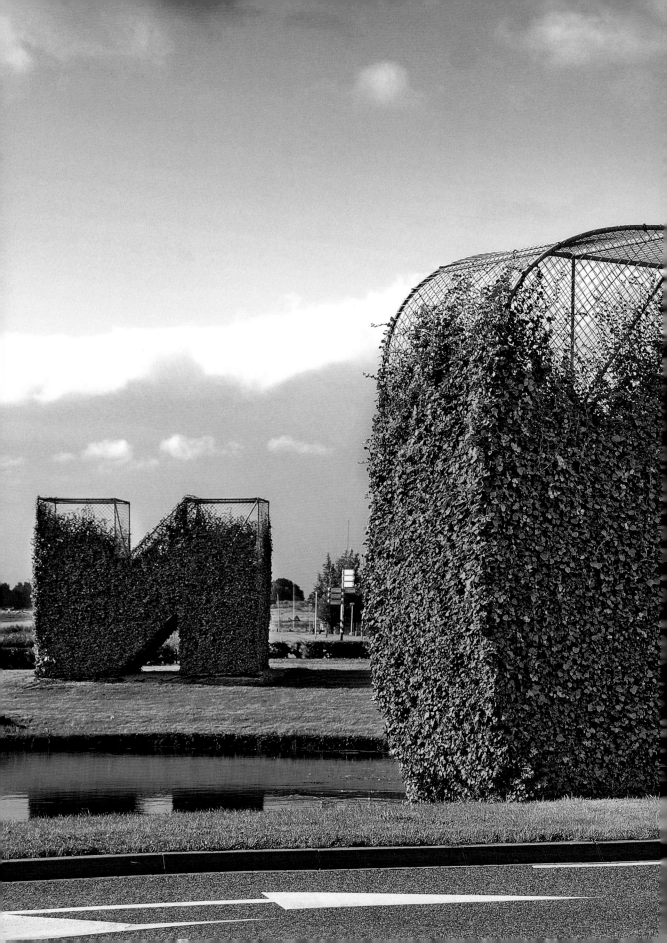

G.R.O.E.N. is public art project created for Carnisselande, a housing estate on the outskirts of the town of Barendrecht, south of Rotterdam. Maarten de Reus created it in the context of the 1999 cultural development plan for Barendrecht Carnisselande. The Netherlands has a long tradition of siting artistic works in public spaces thanks to a law enacted in the 1950s that stipulated that 1 per cent of the budget of any large building must be devoted to works of public art.

[1] Interview with Maarten de Reus, 26 October 2011.

[2] Ibid.

De Reus's installation focuses on the use of letters, an area in which he initially became interested while still a student, before starting his 'word-image' works as a commission from the Municipal Museum of Arnhem. He was asked to rejuvenate an old art-kiosk in the city centre. Along with Rob Hamelijnck, he adorned the structure with the word *kunst* (Dutch for 'art') in upper-case letters. Their idea, much discussed in the newspapers of the time, was to create something very definite without artificially altering the structure. Since then, de Reus has returned periodically to the use of the written word in his works of art, sometimes in collaboration with typographer Wigger Bierma.

The *G.R.O.E.N.* installation consists of five letters that are 5 metres (16½ feet) tall, 7 metres (23 feet) wide and 2 metres (6½ feet) deep, forming the word *groen* (Dutch for 'green'). The project aims to promote environmental awareness through these large letters that are designed to be completely covered by plants, with their maintenance entrusted to a local agricultural college. The wire grid structure of the letters was completed and inaugurated in 2002. It will take several years for the vegetation to cover the installation, completing the effect desired by the artist. Located in the middle of a roundabout, the work can only be read letter by letter; there is no point from which it can be seen as a whole. Relationship with place is a theme that has been particularly dear to de Reus since his student days. As he explains, 'I like how things not only take up space, but how they make space around them meaningful. How they charge the environment with points of view rich in meaning.'[1]

The shape of the letters was specially designed by the artist with the precise intention of giving them an almost three-dimensional architecture. 'I am not a typographer. I do not have a great knowledge of typography nor a great sensitivity for it.... For *G.R.O.E.N.* they needed to be boxy and bold. I made them the way they need to be,' he says.[2]

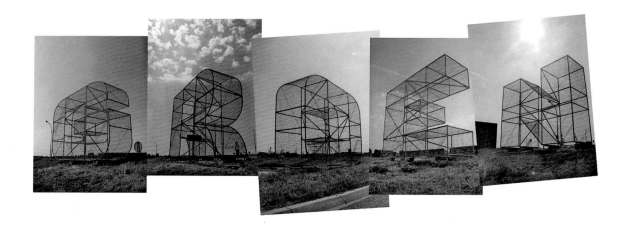

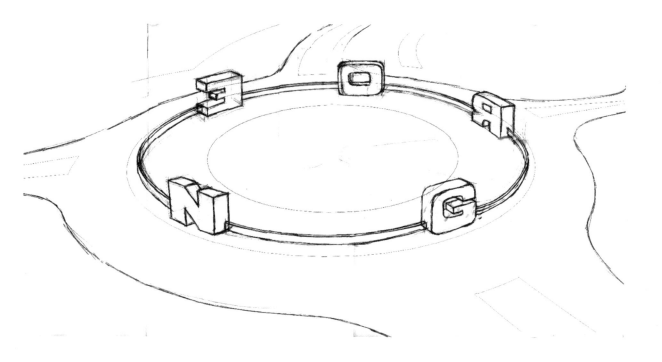

Top: The letters' metallic
structure (at time of
installation).

Above: Author's illustration of
the letters on the roundabout.

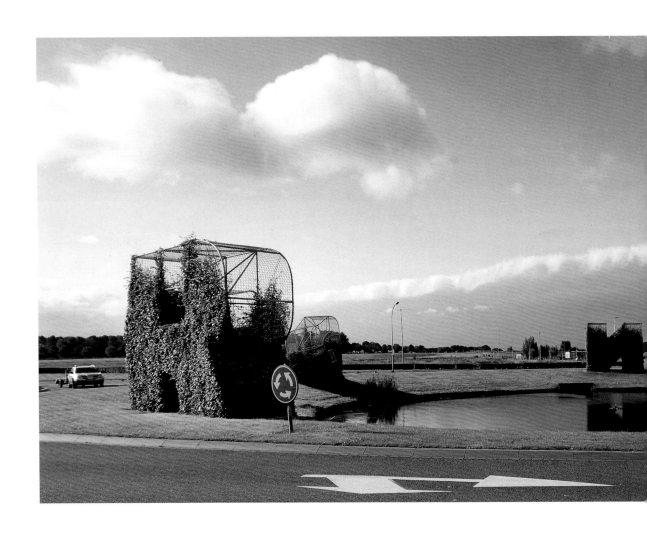

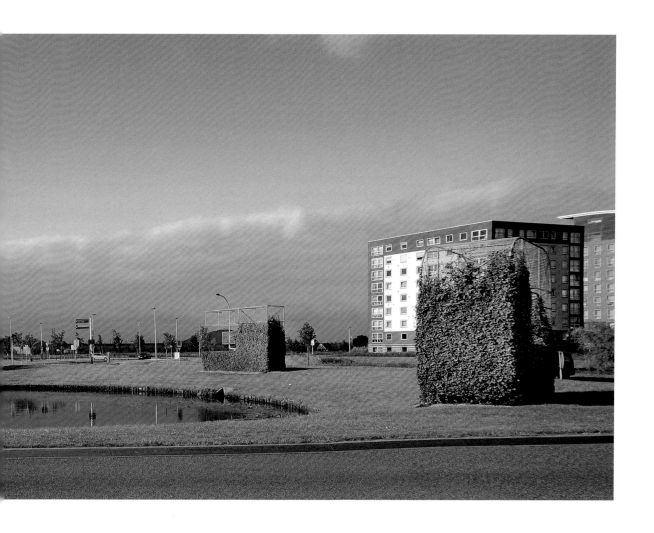

The letters have been gradually
covered by vegetation.

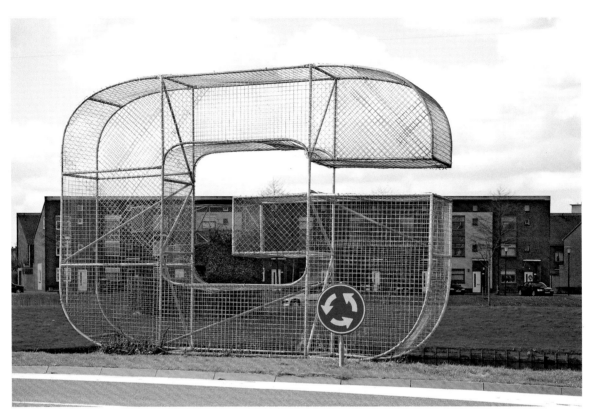

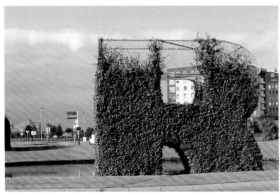
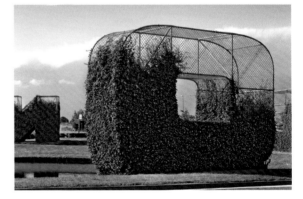

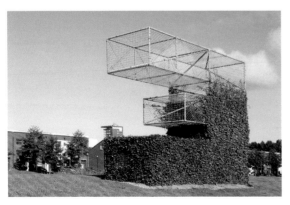
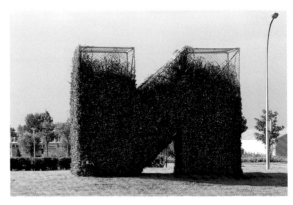

244

GROEN

Opposite: The *G* was substituted
after a car accident destroyed
the original.

Above: An extended sans serif
typeface was used for the
lettering.

A custom-made font
mimics the dynamics and
movements of dance.

Pierre di Sciullo
National Dance Centre

1 rue Victor Hugo,
Pantin, France

Av. du Général Leclerc

La Guimard

Quai de l'Ourcq

Quai de l'Aisne

Rue Victor Hugo

Rue Étienne Marcel

Rue Hoche

Rue Florian

Rue Montgolfier

Since 1997 the National Dance Centre in Pantin has been based in a building that originally served as the administrative headquarters for the town. Designed by architect Jacques Kalisz in 1972, the construction is characterized by the use of *béton brut* (exposed or unfinished concrete).

The renovation in 2000 was entrusted to architects Claire Guieysse and Antoinette Robain, who were awarded the Équerre d'argent prize for the project in 2004. Other artists involved in creating a new image for the centre were Hervé Audibert (lighting), Michelangelo Pistoletto (furniture design) and Pierre di Sciullo (internal and external signage).

Di Sciullo's contribution to the facade of the building is a typographical installation of the word *danse*, arranged in huge letters on the roof. He used the written word 'because it was the best way to provide the essential information.... I didn't want to install an "institutional sign" on an urban scale; it would have been a contradiction to the actual use of research and creation in the world of dance.'[1]

In designing his installation, di Sciullo sought to relate it to the urban landscape in which it stands: 'Pantin is an industrial suburb: factories, warehouses, old industrial mills.... Often, big signs are installed on these buildings. To install a similar sign was my way to play with the frame of reference.'[2] The five letters of *danse* are made of red aluminium and measure, in total, 10 metres (33 feet) in length and 3.5 metres (11½ feet) in height. The whole structure – letters and concrete support – weighs 2.4 tonnes (2.6 tons). At night the word is illuminated by neon lighting. The typeface used, a variation on Minimum, with its dynamic forms, represents a tribute to dance. Whether understood as a noun or an imperative from on high, the sign has a simplicity and an immediacy that make it both an informative installation and a joyful exhortation.

The sign was made possible by the existence of the '1 Per Cent Fund'. The French government earmarks 1 per cent of the construction costs of new public buildings for the purchase of one or more works of art designed specifically for the new building. This makes it possible for artists to create works for everyday public spaces in collaboration with architects, thereby encouraging an appreciation of contemporary art.

Pierre di Sciullo also used the Minimum font family for the internal signage system. For the various rooms, he employed Minimum Relief, a variant of Minimum Bichro, where letters are formed by square-section wooden rods. The letterform chosen for the direction panels is Minimum Bong, where the letters lean alternately to one side and the other in a rhythmic pattern.

[1] Interview with Pierre di Sciullo, 21 February 2008.

[2] Ibid.

Opposite: Di Sciullo's enormous lettering sits atop the building.

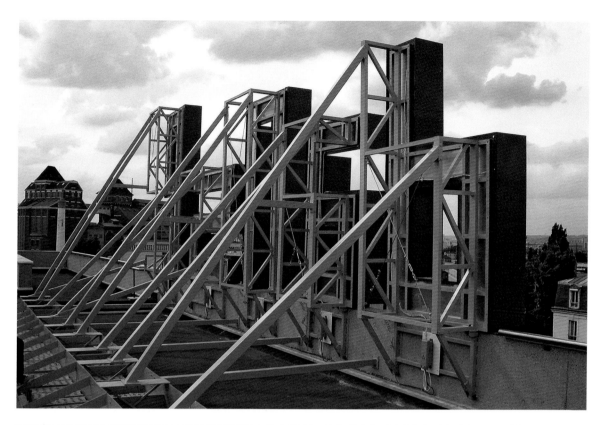

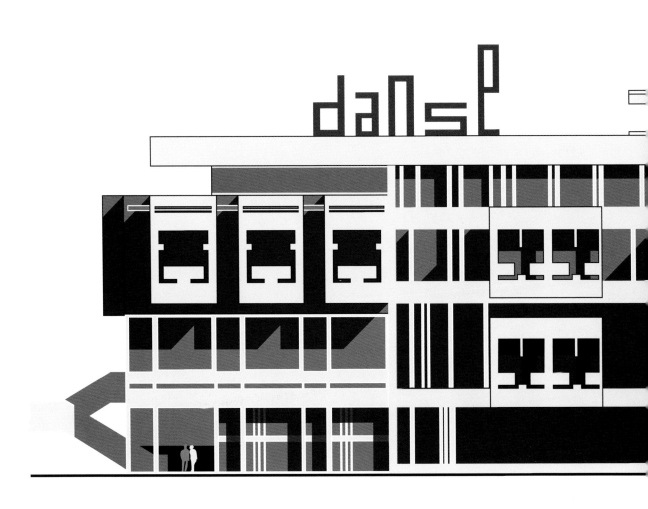

atrium ovest

Minimum Bichro Medium

Opposite and above: The word *danse* interacts with the orthogonal designs of the facade. The sign outside was developed by di Sciullo based on Minimum.

Right: Fonts used for the internal signage.

ici niveau 2

Minimum Bong Black

An imposing interaction between
typography, art and architecture
for a museum park.

Smith-Miller + Hawkinson,
Barbara Kruger,
Quennell Rothschild,
Guy Nordenson
Imperfect Utopia
2110 Blue Ridge Road,
Raleigh, North Carolina, USA

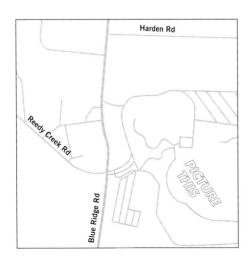

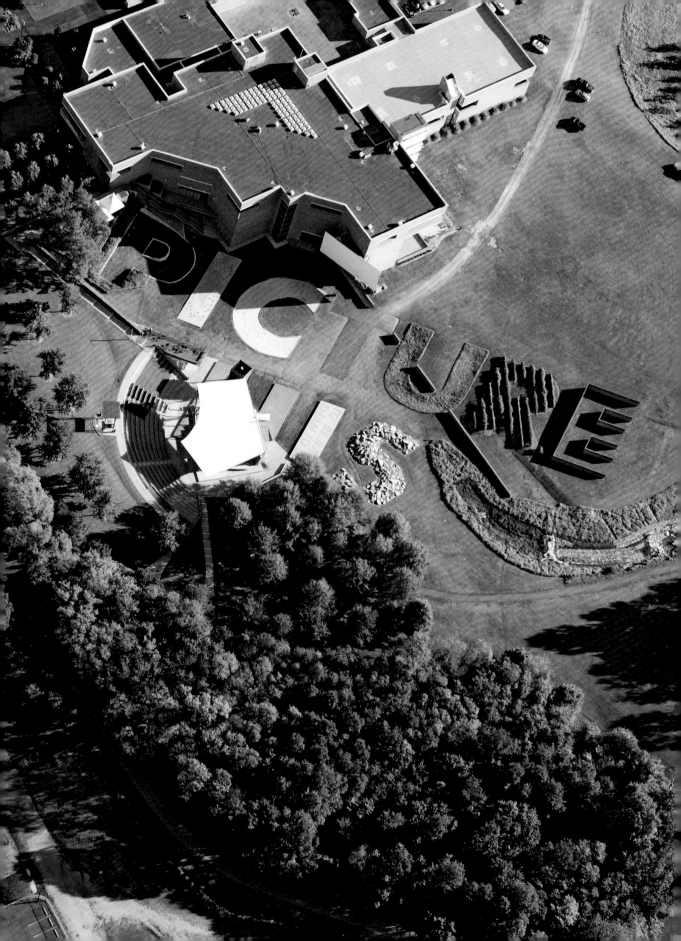

The North Carolina Museum of Art (NCMA) competition entitled Imperfect Utopia: A Park for the New World arose from a desire to combine public space and contemporary art. This idea was developed by involving professionals from different backgrounds – a process called 'aerosol' – ranging from architecture (Laurie Hawkinson and Henry Smith-Miller), art (Barbara Kruger), landscape design (Nicholas Quennell) and structural engineering (Guy Nordenson).

The park is located in Raleigh, the capital of North Carolina, in an area of 670,000 square metres. Standing in the middle is the NCMA, designed by Edward Durrell Stone in the late 1970s and opened in 1983. Central to the design of the park is Kruger's textual element. The structures that determine the amphitheatre, cinema and outdoor recreation area all revolve around the letters as central reference. Critic Anthony Iannacci has explained, 'For this section the team has incorporated what can be described as a textualized landscape where gigantic letters, created with architecture, sculpture and landscape devices, have been placed into the site to create the text *PICTURE THIS*.'[1]

Although *Imperfect Utopia* is a great work of public art, Kruger distanced herself from this definition: 'I should say that I feel uncomfortable with the term public art, because I'm not sure what it means. If it means what I think it does, then I don't do it. I'm not crazy about categories. I'm an artist who works with pictures and words. Sometimes that stuff ends up in different kinds of sites and contexts which determine what it means and looks like.'[2] The amphitheatre and cinema can accommodate up to a maximum of 2,300 people. The screen is attached to part of the pre-existing museum and is visible from Blue Ridge Street, while the amphitheatre is centred on the letter *H*.

The phrase '*PICTURE THIS*' is a tangible space that can be used by the visitor. Each letter is treated differently, integrating with the area around it: sculpture, green space and architecture. The *P* is dug into the ground and has a retaining wall with a text by Kruger lit from below. The *I* is made of concrete and features a map of North Carolina showing its most important places. It is slightly slanted to provide seating for spectators. The *C* is a play area, a sandpit bordered by red-painted concrete edges. The *T*, made of asphalt painted with stripes and cat's-eye reflectors, is a platform designed to receive visitors. The *U* is dug into the ground and features aromatic plants illuminated by ground-level lighting. The *R* is formed by a rock garden with parallel rows of supports for climbing plants. The edges of the *E* are marked by two brick walls, 2 metres (6½ feet) high, accessible from both inside and out, on which are inscribed a series of provocative phrases. The *T* of 'THIS' is a proper architectural element, accommodating service areas. The *H* consists of several levels: over the concrete stage is a loading area and a fibreglass and aluminium roof. The *I*, also inclined to provide a seating area for viewers, is incised with the motto of North Carolina: *Esse quam videri* (To be rather than to seem).The *S* is made up of large stones. The typeface used in this installation is Futura Bold Oblique. Kruger's work has become associated with the Futura letterform as she uses it in the majority of her works.

[1] Anthony Iannacci, 'Il parco multi-funzionale: A park for the North Carolina Museum of Art,' *L'Arca*, no. 82, May 1994, p. 73.

[2] In Thyrza Nichols Goodeve, 'The Art of Public Address,' *Art in America*, November 1997, pp. 92–99.

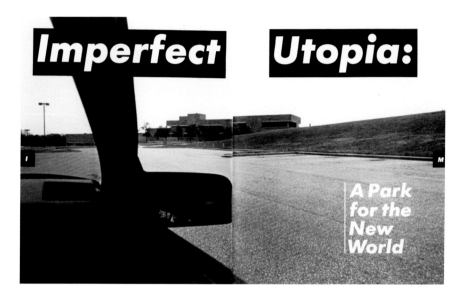

Imperfect Utopia:

A Park for the New World

The Theory

To disperse the univocality of a "Master Plan" into an aerosol of imaginary conversations and inclusionary tactics.

To bring in rather than leave out.

To make signs.

To re-naturalize.

To question the priorities of style and taste.

To anticipate change and invite alteration.

To construct a cycle of repair and discovery.

To question the limitations of vocation.

To be brought down to earth.

To make the permanent temporary.

To see the forest for the trees.

To have no end in sight.

The Program

To restructure the approach to the museum.

To allow for laboratory settings for artists and designers.

To provide a visible, inexpensive, short-term botanical strategy to alter the place.

To introduce movie-going, walking, wading, eating, reading, bird watching, relaxing and other familiar pleasures.

To punctuate the site with regional, cultural and vernacular signage.

To replace the forest that's been lost.

Top and above: Some pages from the article 'Imperfect Utopia: Un-Occupied Territory', published in the magazine *Assemblage*, December 1989.

PICTURE THIS

Futura Bold Italic

PLEASED TO MEET YOU • PLEASE READ THE WRITING ON THE WALL • PLEASE DO UNTO OTHERS AS YOU WOULD HAVE OTHERS DO UNTO YOU • PLEASE DON'T TURN ME INSIDE OUT • PLEASE DON'T LET HISTORY REPEAT ITSELF • PLEASE LOOK FOR THE MOMENT WHEN PRIDE BECOMES CONTEMPT • PLEASE PLEASE ME • PLEASE LIVE AND LET LIVE • PLEASE LET EMPATHY CHANGE THE WORLD • PLEASE

These pages: Technical drawings of the project.

Following pages, clockwise from top left:

'To be rather than to seem': detail of the motto of North Carolina.

Night view with fireworks.

Detail of the wall; each phrase begins with the word 'please'.

The letter *C*, with the amphitheatre in the background.

A frieze establishing
an intrinsic and intimate
relationship between
letters and architecture.

Josep Maria Subirachs
Frieze for the New Town Hall

Plaça de Sant Miquel 4–5,
Barcelona, Spain

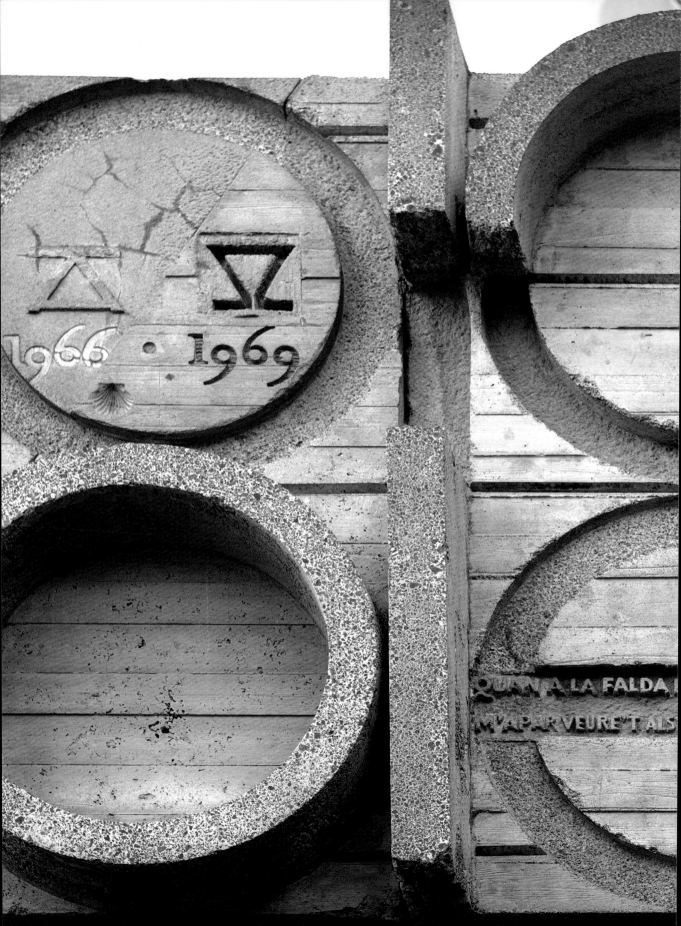

Josep Maria Subirachs designed the frieze for the facade of the new Barcelona town hall in 1969. Located in the historic Plaça de Sant Miquel, it stands next to the original town hall in Plaça de Sant Jaume. It is one of Subirachs's largest works in concrete. Measuring 2.5×45 metres (8×148 feet), according to Phil Baines it 'represents a subtle, intelligent (and non-commissioned) civic branding.'[1]

In this piece, a series of descriptive and symbolic elements combine to evoke the history of the city and the construction of the building itself. Almost the entire area of the frieze is occupied by the word 'Barcelona' and a map of the city. Geometric shapes (such as crosses, triangles, squares and circles) alternate with numbers, symbols and short texts. The letters forming the name of the city are organically integrated with the rest of the frieze, being adapted to the modular form of the facade. Subirachs's creation of an intrinsic relationship between letterforms and architecture is a distinctive feature of his work. Unlike that other great Catalan sculptor of letters, Joan Brossa, Subirachs's work 'exists on buildings rather than in the spaces between them'.[2]

For the Barcelona town hall, Subirachs created a lettering based on a grid of straight lines and circles, and the letters integrate perfectly with the numerous other descriptive elements of the frieze. The highly abstract geometric shapes make the word 'Barcelona' almost unrecognizable at first glance. Only the most observant passer-by would be able to see it and, indeed, it seems that the artist himself was not able to read it in 1969 when he saw the completed frieze for the first time.

To give movement to the composition and to highlight the text, Subirachs used the effects of varying depths and textures, creating alternating areas of light and shadow in the concrete.

A similar type of lettering is used by Subirachs in other works. A frieze dating from 1979 above the entrance to the main Barcelona railway station, Sants, features the name of the city, this time with a lower-case *b*, in a structure made of concrete slabs marked by straight lines and circles. In this case, the geometric elements refer to the shape of train wheels. Subirachs's other projects with similar usage of typography are an underground car park with a wall covered with the repeated letters *pb* ('parking barcelona'), and a building bearing the name of the bank Indaban. There are many other pieces in which Subirachs makes use of letters, notably in the frieze for the Faculty of Law at the University of Barcelona, made in collaboration with Antoni Cumella, that uses Roman numerals to refer to the Ten Commandments.

[1] Phil Baines and Catherine Dixon, *Signs: Lettering in the Environment,* Laurence King, London, 2003, p. 132.

[2] Phil Baines, 'Sculptured Letters and Public Poetry,' *Eye,* no. 37, Autumn 2000, p. 46.

Opposite: The word 'Barcelona' is not immediately recognizable.

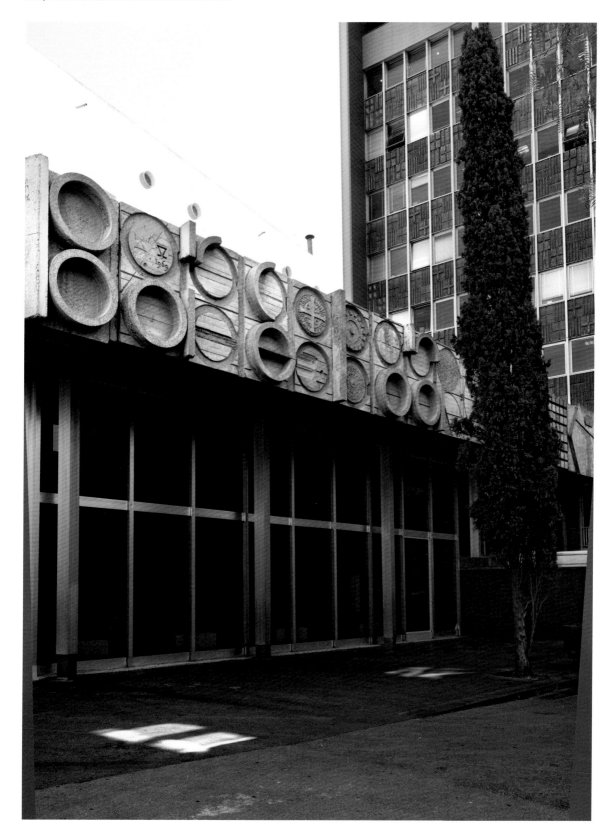

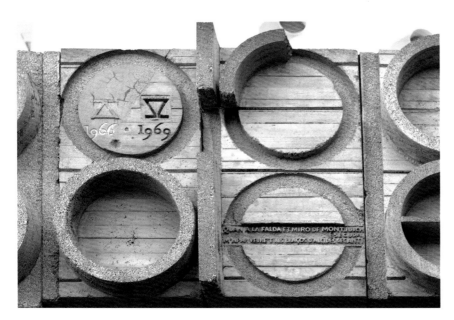

Opposite, top and above: Details of the facade of the new town hall, and an illustration of the lettering (opposite bottom) showing how it is perfectly integrated into the modular scheme of the design.

A strong message in cast
iron celebrates the importance
of language.

Lawrence Weiner
A Translation from
One Language to Another

Spui, Amsterdam, the Netherlands

A TRANSLATION
FROM ONE
LANGUAGE
TO ANOTHER

EEN VERTALING
VAN DE ENE TAAL
NAAR DE ANDERE

In 1969, the University of Amsterdam commissioned artist Lawrence Weiner to produce a work for the Spui, a square in the centre of Amsterdam, bearing the text 'A Translation from One Language to Another' in Dutch, English, Arabic and Sranan. Built over a filled-in canal, today the Spui is a lively square close to the university, with bars, shops, a book market and artists' exhibitions.

A Translation from One Language to Another consists of three pairs of slabs. The slabs were originally in bluestone but, following racist-inspired vandalism to the Arabic text, they were replaced by a more resistant version in cast iron. The shape of the pairs of slabs, each measuring 120 × 100 × 16 centimetres (47 × 39 × 6 inches), resembles an open book with its spine facing up. On each pair is, on one side, the Dutch phrase, *Een vertaling van de ene taal naar de andere*, in adhesive black plastic letters and, on the other, a translation into English, Arabic or Sranan, in yellow, green or red respectively.

With this project Weiner asserts the importance both of language – as one of the materials that make up the work – and of typography, not only for its purpose as signifier but also for its aesthetic qualities independent of linguistic meaning.

Weiner's artistic production is intimately tied up with typography and he chooses the letterforms in his works with great care, often working in collaboration with typographers. He dislikes Helvetica which, he has stated, represents a Modernism to which he cannot relate, and he generally avoids characters with serifs that may be seen, he asserts, as rendering a text too 'intellectual and intelligent'[1], adjectives that he finds inappropriate for his own work. His preference is for sans serif letterforms, particularly Franklin Gothic, which he maintains are capable of communicating the meaning behind the work in the most direct way. He has said, 'An artist's body of work is not supposed to make sense; it is supposed to have meaning. There is a difference. And by not using serifs, you are right down to the basic meaning. It either works or it doesn't.'[2]

His quest for neutrality leads him to choose the characters with the least cultural baggage, to allow the content to emerge. So as not to be tied to a particular style, Weiner decided to design his own letterform, Margaret Seaworthy Gothic, as well as adapting already existing typefaces to his own needs, for example, by converting them into stencils.

The letterforms used for the Spui installation are Franklin Gothic Condensed, with edges that have been rounded during the casting process.

[1] Lawrence Weiner, 'From an Interview by Jonas Ekeberg', in Gerti Fietzek and Gregor Stemmrich (eds.), *Having Been Said: Writings & Interviews of Lawrence Weiner 1968–2003*, Hatje Cantz, Ostfildern Ruit, 2004, p. 332.

[2] Ibid.

Opposite: Views of the installation in position in the square.

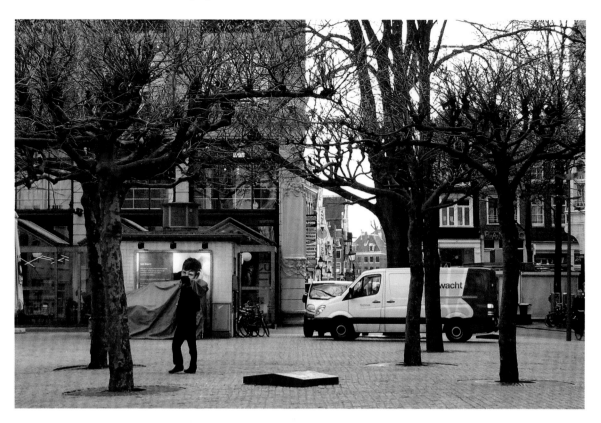

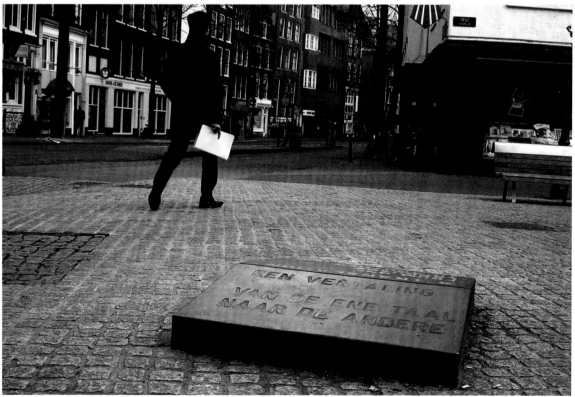

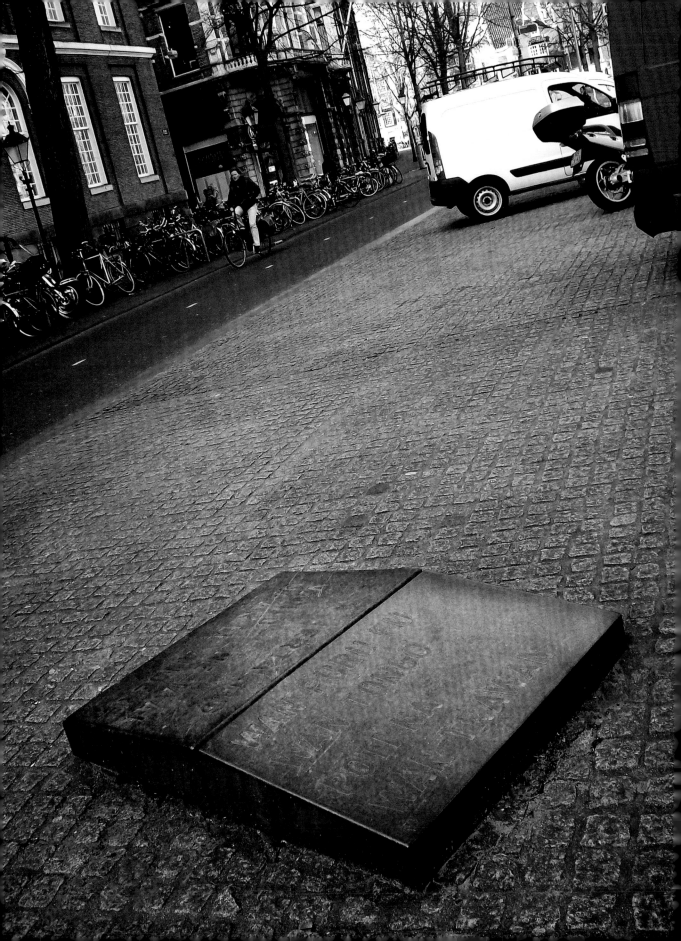

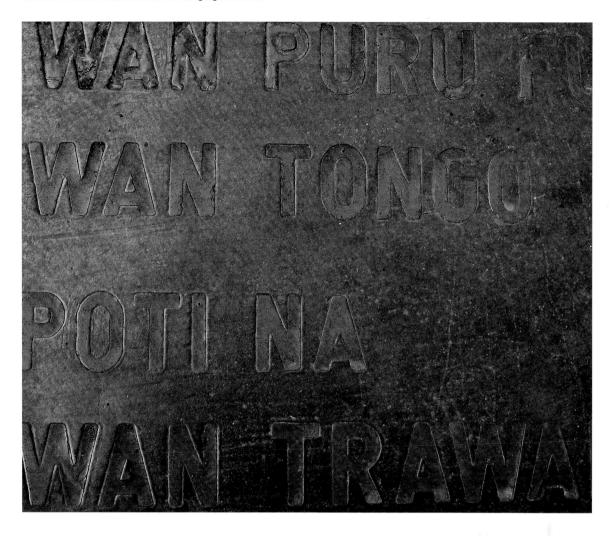

Opposite and above: The metal slabs with texts in different languages: Dutch (black) and Sranan (red).

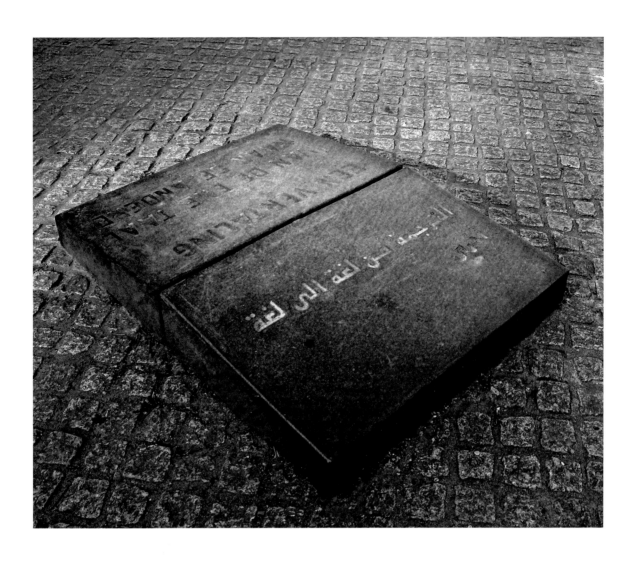

Above and opposite: The texts in Dutch (black) and Arabic (green).

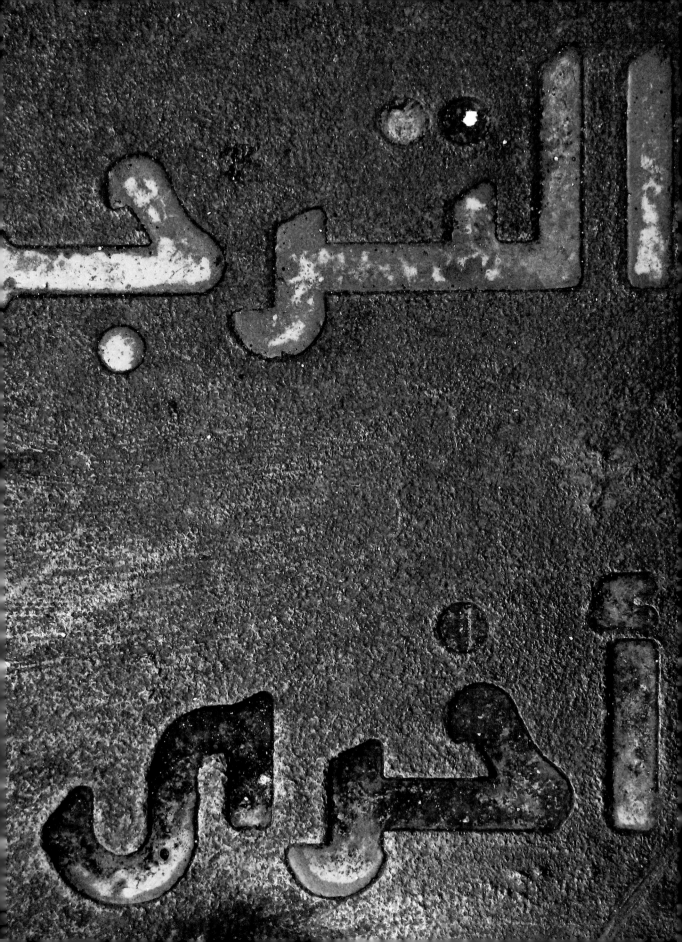

Word art adorns the pavements
trodden by thousands of New
Yorkers each day.

Lawrence Weiner
NYC Manhole Covers
Manhattan, New York City, USA

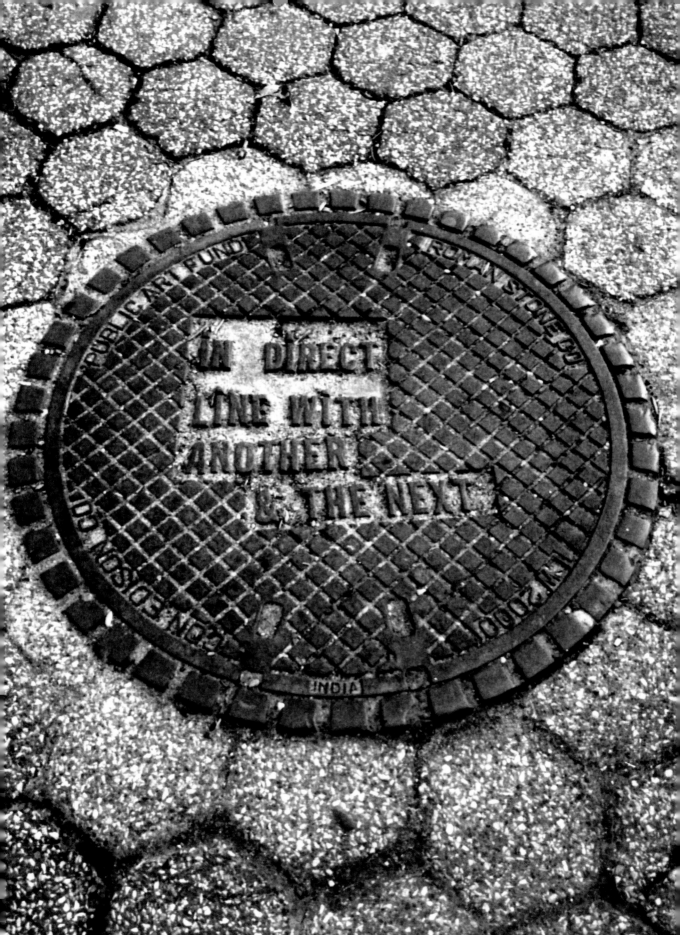

Designed by Lawrence Weiner for the Public Art Fund, *NYC Manhole Covers* consists of nineteen cast-iron manhole covers that were installed in New York City in November 2000. With the assistance of the Consolidated Edison Company of New York and the manhole-cover fabricator Roman Stone, Weiner's work involved the replacement of the usual covers with ones that bear the inscription 'iN DiRECT LiNE WiTH ANOTHER & THE NEXT'.

From the mid-1960s, after an earlier phase of experimentation in the field of painting, Weiner began to concentrate on the use of words as a means of expression. He uses phrases and short texts to present the artist's relations with the external world in the most objective way possible, avoiding the subjective view. With the new manhole covers, Weiner introduced a modification to pavements that are trodden every day by thousands of people in Manhattan. As he puts it: 'The content of the sculpture (essentially the meaning of the words) functions as, and is, an object within the landscape. In effect it is a component of the landscape. Space becomes place.'[1]

In the artist's statement that accompanied the work, the project was dedicated to the people of New York, who, unable to navigate their way by stars that are invisible in the over-illuminated city sky, can only look downwards. The artist pays tribute to the fact that pedestrians are obliged to keep their eyes on the ground to avoid obstructions and dirt and arrive safely at their destinations. Thus each manhole cover becomes a certainty, a declaration of anti-monumentality based on the same materials from which the city is made: iron and asphalt. The words refer to the grid plan of the city and also to its democratic rules. In New York, everyone queues to get onto the subway and waits until the traffic light turns green before crossing the road; whatever their social condition, in the street New Yorkers are always 'in direct line with another and the next'.

The letterform used for the text is Franklin Gothic Demi Compressed with the addition of a dot on the capital *I*. In Weiner's view, 'Typography presents the work. The choice is to find elegance without authority and without a dependence upon a historical meaning.'[2]

Franklin Gothic is one of the most frequently used letterforms in Weiner's work. Its use has become a distinctive and immediately recognizable feature of his production, particularly in its compressed or condensed versions, set against a neutrally coloured page or wall.

[1] Interview with Lawrence Weiner, 3 March 2008.
[2] Ibid.

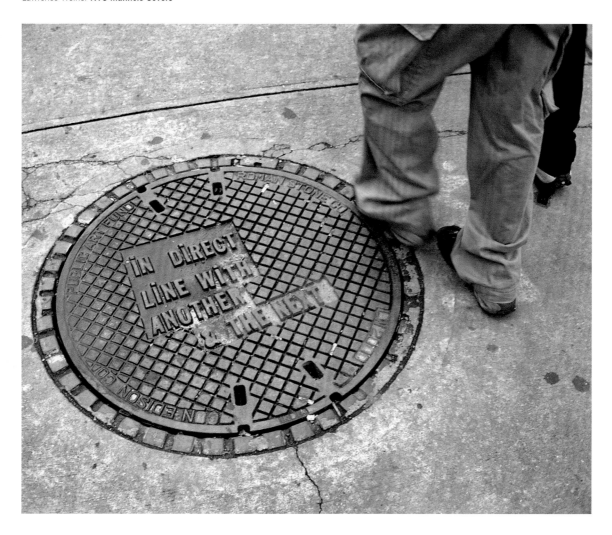

Above and overleaf: Nineteen
manhole covers were installed in
New York City by the Public Art
Fund in collaboration with the
Consolidated Edison Company
and Roman Stone.

277

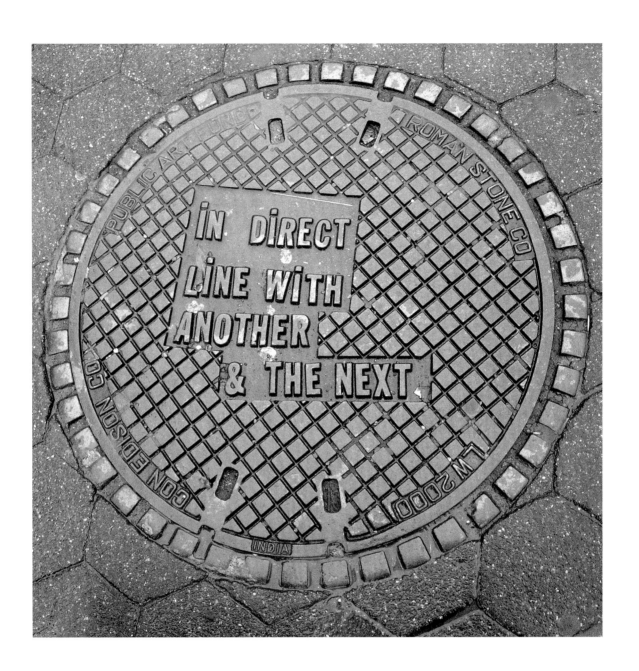

IN DIRECT LINE WITH ANOTHER & THE NEXT

Franklin Gothic Demi Compressed

A controversial spatial and
cultural connection between
two heritage sites draws upon
deep-rooted local history.

Gordon Young
& Why Not Associates
The Cursing Stone
and Reiver Pavement

Millennium Subway, Carlisle, Cumbria, UK

The *Cursing Stone and Reiver Pavement* installation was created in 2001 by Gordon Young in collaboration with Why Not Associates, who curated the typographical elements, and with Russell Coleman, who was in charge of the implementation. It is situated in the Millennium Subway, a pedestrian underpass that links Tullie House Museum with Carlisle Castle, and which is part of the northern English city of Carlisle's Millennium Project. One of the aims of the commission was to create a cultural connection between the two sites.

The museum, one of the major attractions for visitors to this region, explores the turbulent history of Carlisle, a town standing on the border between England and Scotland. The focal point of the installation is the 'Mother of all Curses', featuring the text of a curse cast in 1525 by the archbishop of Glasgow, Gavin Dunbar, on the Border Reiver families, who were guilty of raiding and pillaging Carlisle. Gordon Young himself is descended from one of these families.

The installation consists of two parts: a block of granite weighing 14 tonnes (15½ tons), and the paving stones on which it stands. The surface of the imposing monolithic stone is etched with an extract from the curse. It took twenty days to prepare and polish the stone until it was smooth and shiny, and only then was the text sandblasted onto its surface. The typeface used is Bembo Italic.

Some one hundred inscriptions on the paving stones of the 80-metre-long (87-yard) underpass record the names of the families against whom the curse was originally uttered. They include cattle thieves, blackmailers and other miscreants who, particularly from the late fourteenth until the seventeenth centuries, frequently came to sack these lands. Many of the names are still very common in the area. Composed in upper-case News Gothic, the names alternate in position and size.

Even before it was installed, this work created a storm of protest. A number of local churchmen accused it of being a 'a shrine for devil worship' and something that would bring bad luck to the inhabitants of the area, even going so far as to demand that it be exorcized, or else removed and destroyed. A male witch apparently telephoned Why Not Associates to ask whether there was sufficient room on the top of the stone to add an anti-curse.

Despite the objections, the stone is still in place. As Why Not Associates have pointed out, this incident underlines the strong impact a typographical installation can have on a community: 'We think the project proves that you can only create really powerful graphics if you have strong content.'[1]

[1] Why Not Associates, *Why Not Associates ?2,* Thames & Hudson, London, 2004, p. 132.

An original plan for the
installation.

I curse their head and all the hairs of their head;
I curse their face, their brain (innermost thoughts),
their mouth, their nose, their tongue, their teeth,
their forehead, their shoulders, their breast, their heart,
their stomach, their back, their womb, their arms,
their legs, their hands, their feet, and every part
of their body, from the top of their head to the soles
of their feet, before and behind, within and without.

I curse them going and I curse them riding;
I curse them standing and I curse them sitting;
I curse them eating and I curse them drinking;
I curse them rising and I curse them lying;
I curse them at home, I curse them away from home;
I curse them within the house, I curse them outside
of the house; I curse their wives, their children
and their servants who participate in their deeds.
I (bring ill wishes upon) their crops, their cattle,
their wool, their sheep, their horses, their swine,
their geese, their hens, and all their livestock.
I (bring ill wishes upon) their halls, their chambers,
their kitchens, their stanchions, their barns,
their cowsheds, their barnyards, their cabbage patches,
their plows, their harrows, and the goods and houses
that are necessary for their sustenance and welfare.

May all the malevolent wishes and curses ever known,
since the beginning of the world, to this hour, light on them.
May the malediction of God, that fell upon Lucifer
and all his fellows, that cast them from the high Heaven
to the deep hell, light upon them.

May the fire and the sword that stopped Adam
from the gates of Paradise stop them from the glory
of Heaven, until they forebear, and make amends.

May the evil that fell upon cursed Cain, when
he slew his brother Abel, needlessly, fall on them
for the needless slaughter that they commit daily.

May the malediction that fell upon all the world,
man and beast, and all that ever took life,
when all were drowned by the flood of Noah,
except Noah and his ark, fall upon them and drown
them, man and beast, and make this realm free
of them, for their wicked sins.

May the thunder and lightning which rained down
upon Sodom and Gomorrah and all the lands surrounding
them, and burned them for their vile sins, rain down
upon them and burn them for their open sins.
May the evil and confusion that fell on the Gigantis
for their oppression and pride in building the Tower
of Babylon, confound them and all their works,
for their open callous disregard and oppression.

May all the plagues that fell upon Pharoah
and his people of Egypt, their lands, crops and cattle,
fall upon them, their equipment, their places,
their lands, their crops and livestock.

May the waters of the Tweed and other waters
which they use, drown them, as the Red Sea drowned
King Pharoah and the people of Egypt, preserving
God's people of Israel.

May the earth open, split and cleave, and swallow
them straight to hell, as it swallowed cursed Dathan
and Abiron, who disobeyed Moses and the command
of God.

May the wild fire that reduced Thore and his followers
to two-hundred-fifty in number, and others from
14,000 to 7,000 at anys, usurping against Moses
and Aaron, servants of God, suddenly burn and
consume them daily, for opposing the commands
of God and Holy Church.

May the malediction that suddenly fell upon fair
Absolom, riding through the wood against his father,
King David, when the branches of a tree knocked him
from his horse and hanged him by the hair, fall upon
these untrue Scotsmen and hang them the same way,
that all the world may see.

May the malediction that fell upon Nebuchadnezzar's
lieutenant, Olifernus, making war and savagery upon
true Christian men; the malediction that fell upon Judas,
Pilate, Herod and the Jews that crucified Our Lord;
and all the plagues and troubles that fell on the city
of Jerusalem therefore, and upon Simon Magus
for his treachery, bloody Nero, Ditius Magcensius,
Olibrius, Julianus Apostita and the rest of the cruel
tyrants who slew and murdered Christ's holy servants,
fall upon them for their cruel tyranny and murder
of Christian people.

And may all the vengeance that ever was taken since
the world began, for open sins, and all the plagues
and pestilence that ever fell on man or beast,
fall on them for their openly evil ways, senseless
slaughter and shedding of innocent blood.

I sever and part them from the church of God,
and deliver them immediately to the devil of hell,
as the Apostle Paul delivered Corinth.
I bar the entrance of all places they come to,
for divine service and ministration of the sacraments
of holy church, except the sacrament of infant baptism,
only; and I forbid all churchmen to hear their confession
or to absolve them of their sins, until they are first
humbled / subjugated by this curse.

I forbid all Christian men or women to have
any company with them, eating, drinking, speaking,
praying, lying, going, standing, or in any other
deed-doing, under the pain of deadly sin.

I discharge all bonds, acts, contracts, oaths,
made to them by any persons, out of loyalty,
kindness, or personal duty, so long as they sustain
this cursing, by which no man will be bound to them,
and this will be binding on all men.

I take from them, and cast down all the good deeds
that ever they did, or shall do, until they rise from
this cursing.

I declare them excluded from all matins, masses,
evening prayers, funerals or other prayers, on book
or bead (rosary); of all pigrimages and alms deeds done,
or to be done in holy church or be Christian people,
while this curse is in effect.

And, finally, I condemn them perpetually to the deep pit
of hell, there to remain with Lucifer and all his fellows,
and their bodies to the gallows of Burrow moor,
first to be hanged, then ripped and torn by dogs, swine,
and other wild beasts, abominable to all the world.
And their candle (light of their life) goes from your sight,
as may their souls go from the face of God, and their
good reputation from the world, until they forebear
their open sins, aforesaid, and rise from this terrible
cursing and make satisfaction and penance.

**These pages: The complete text
of the 'Mother of All Curses',
cast in 1525 by the archbishop
of Glasgow, Gavin Dunbar.
Only the initial part has
been engraved on the stone.**

**Following pages: Details of the
inscriptions.**

MILBURN HEDLEY

TURNER
THOMSON

News Gothic Bold

DAVISON

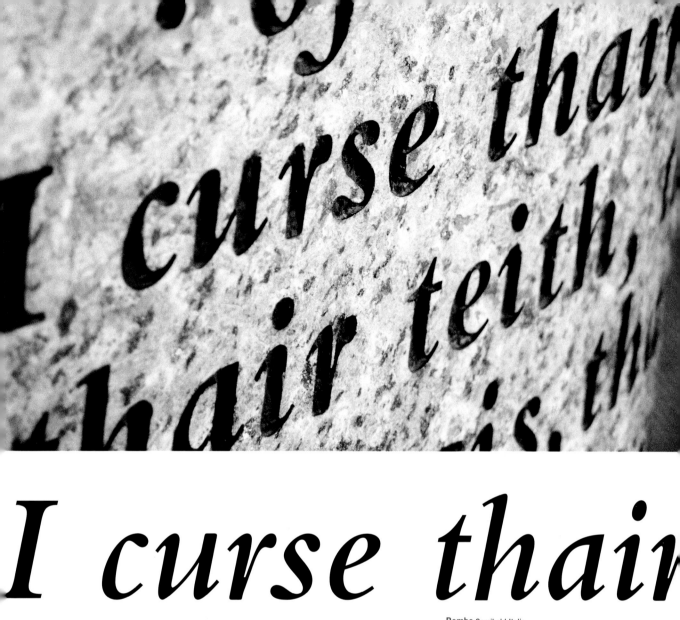

I curse thai

thair teith, t

ir leggis, th

Bembo Semibold Italic

Dynamic phrases in concentric rings
create a memorial architecture
in homage to a local celebrity.

Gordon Young
& Why Not Associates
The Eric Morecambe
Memorial Area

Marine Road Central,
Morecambe, Lancashire, UK

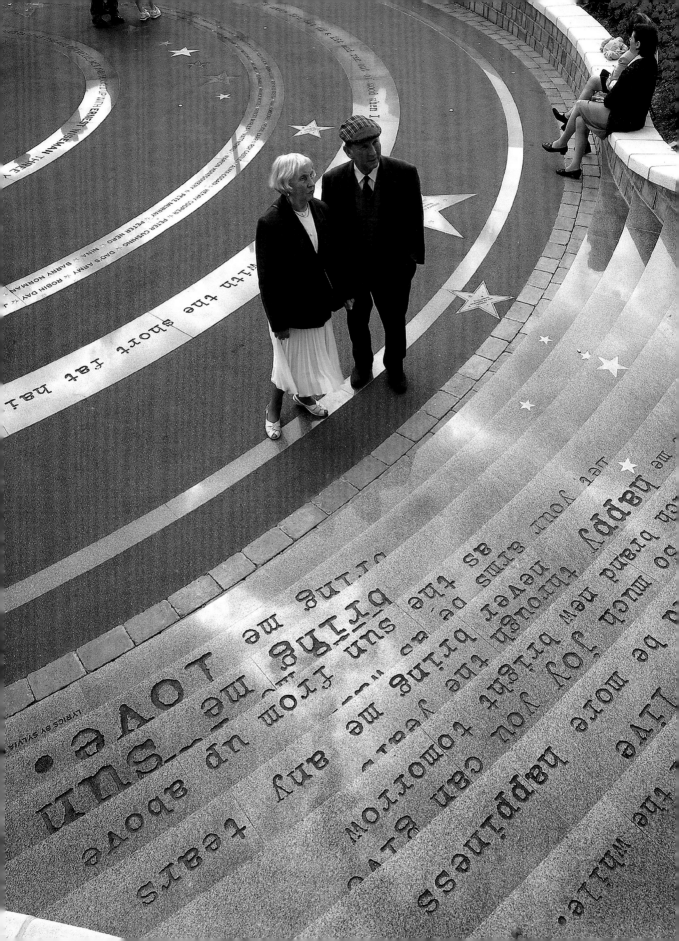

The Eric Morecambe Memorial Area, commissioned by Lancaster City Council, was created in 1999 by Gordon Young in collaboration with Why Not Associates, who designed the typography, and with Russell Coleman for the implementation. Like the installation *A Flock of Words* (see page 296), the Eric Morecambe Memorial Area was part of the Tern Project, initiated in 1994, which is a group of public art projects created for the promenade at Morecambe in Lancashire with the intention of giving a new image to the centre of the town and enhancing the surrounding landscape. One of the characteristics and attractions of the area, the annual passage of migratory birds, has been taken as the theme linking the artworks that comprise the project.

The Eric Morecambe Memorial Area is dedicated to the famous local comedian and enthusiastic ornithologist John Eric Bartholomew, who adopted the name of his hometown to become Eric Morecambe. The memorial consists of a circular space from which steps lead up to the statue by Graham Ibbeson showing the actor in one of his most characteristic poses, his birdwatching binoculars around his neck. Bronze seagulls by Shona Kinloch perch on rocks around the monument. The landscape architect Ann Kelly was in charge of harmonizing the context.

The paving stones around the memorial are inscribed with songs, jokes and catch-phrases associated with the 1970s comedian who, with Ernest Wiseman (Ernie Wise), could command UK television audiences of more than 28 million. Also recorded on the paving stones are the names of the celebrities who appeared on Eric and Ernie's shows. The texts are inscribed in a variety of sizes and materials, often emphasizing the circular space by following its curved lines. As design critic Laurel Harper has said, 'The site is both a kinetic and sensory experience for visitors, who are encouraged to walk up, over, and all around the memorial.'[1]

The polished granite steps leading to the statue are inscribed with some of the words from the optimistic *Morecambe & Wise* theme song, 'Bring Me Sunshine'. *Plazm* magazine has noted, 'Why Not Associates place a premium on sense of humour when approaching design problems.... By selecting a figure that melded with local culture and history, the designers were able to dispute the idea that only generals and princes could be the subject of statues, but that a man who made people laugh was worthy of commemoration.'[2] The smudged and fuzzy typeface used in the installation is Erik van Blokland's Trixie, recalling old-fashioned typewriters, and Tobias Frere-Jones's Interstate, a sans-serif typeface with large loops that were used for the signage. This installation has become one of the symbols of the town of Morecambe, and the memorial's fame was further increased when it was officially dedicated by Queen Elizabeth II.

[1] Laurel Harper, *Provocative Graphics: The Power of the Unexpected in Graphic Design*, Rockport Publishers, Gloucester (Massachusetts), 2001, p. 173

[2] *Plazm, 100 Habits of Successful Graphic Designers: Insider Secrets on Working Smart and Staying Creative*, Rockport Publishers, Gloucester (Massachusetts), 2003, p. 72.

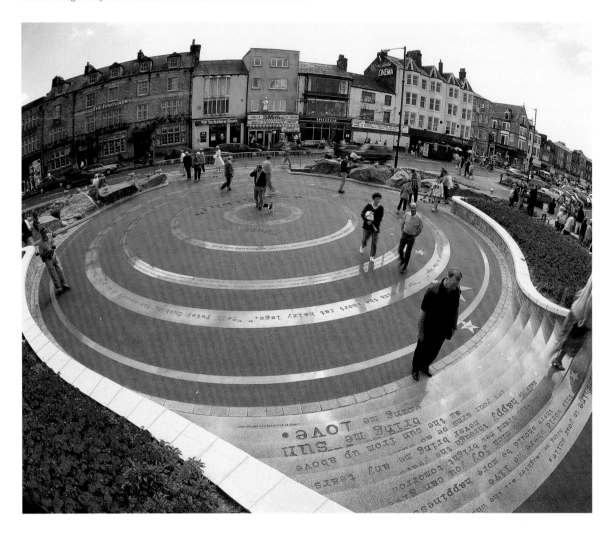

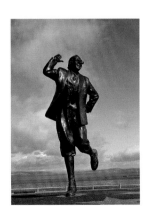

Above: A general view
of the installation.

Left: Graham Ibbeson's
statue of Eric Morecambe
at the top of the steps.

Following pages: Details of the
installation. Varying in size
and materials, the succession
of phrases creates a strong
kinetic effect.

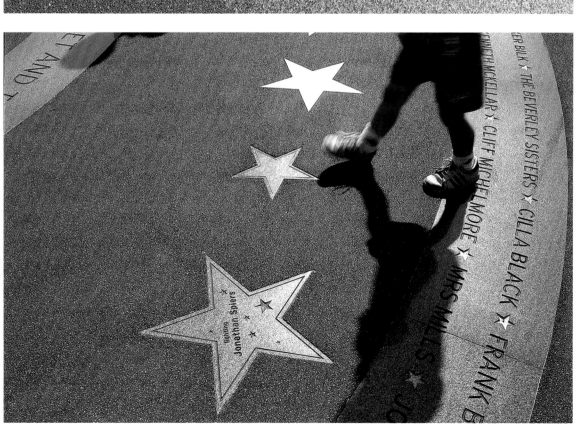

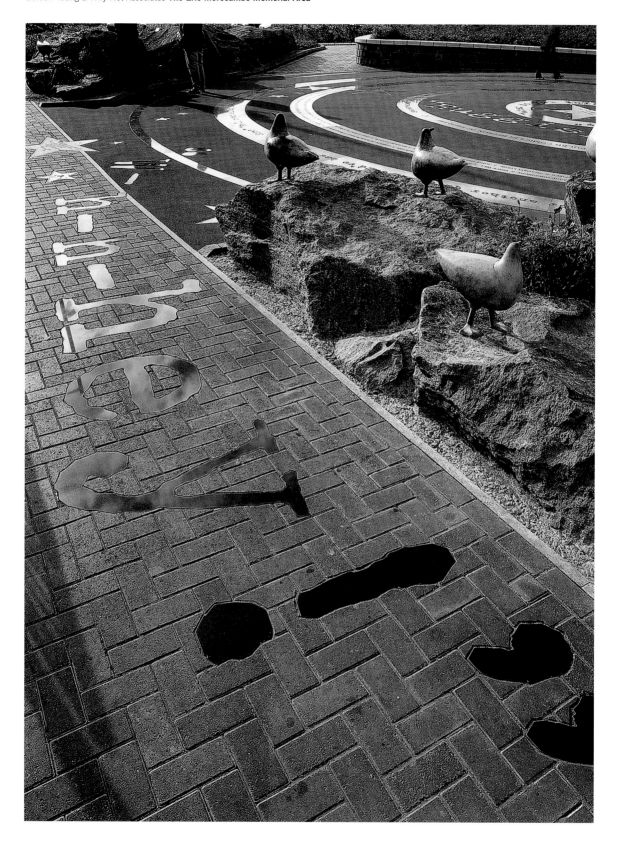

PATRICK MOORE ★ JOHN MILLS ★ MRS MILLS ★ CLIFF MICHELMORE ★ KENNETH McKELLAR ★ YEHUDI MENUHIN ★ FRANCIS MATTHEWS ★ MILLICENT MARTIN ★ KENNY BALL ★ MAGNUS MAGNUSSON ★ RICHARD BAKER ★ VERA LYNN ★ ...SPEL ★

...RICHARD BRIERS ★ FRANK BOUGH ★ CILLA BLACK ★ THE BEVERLEY SISTERS ★ ACKER BILK ★ THE BEATLES ★ SHIRLEY BASSEY ★ PETER BARKWORTH ★

...STARTED PERFORMING ON STAGE AT THE AGE OF TWELVE, MET AND TEAMED UP WITH E...

TIME ★ ERIC BARTHOLOMEW ★

Interstate Regular

Interstate Bold

"Rubbish!"

of the show so far?"

"All of life is based on timing."

What do

uggish!"

Trixie Plain

FORM 'MORECAMBE AND WISE'. THEIR COLLABORATION WITH SCRIPTWRITER EDDIE BRABEN MADE THEM THE MOST PO

A typographic collaboration
between artists and designers
celebrates the importance
of wildlife.

Gordon Young
& Why Not Associates
A Flock of Words

Central Drive, Marine Road Central,
Morecambe, Lancashire, UK

stare,
ruddok;
cok,
sparow,
nightingale,
swalow,

turtel,
pecok,
fesaunt,

AND THE COWARD KYTE;
THAT ORLOGE IS OF THORPES LYTE;
VENUS SONE;
THAT CLEPETH FORTH THE FRESSHE L
MORDRER OF THE FLYES SMAL
THAT MAKEN HONY OF F
WITH HIR HERTE
WITH HIS
SCO

unkinde;
ever

A Flock of Words was created in 2003 by Gordon Young in collaboration with Why Not Associates, who designed the typography, and Russell Coleman, who implemented the project. It formed part of the Tern Project (see also the Eric Morecambe Memorial, page 290), for which Young was appointed lead artist in 1992. The work celebrates the rich birdlife of Morecambe Bay, a vast expanse of sand on the north-west coast of England. The area sees Europe's greatest number of different migratory species.

The installation consists of a 300-metre-long (328-yard) typographical pathway that winds its way between the new train station and the seafront. Accompanying the visitor are poems, extracts, proverbs and lines from songs relating to the world of migrating birds, by authors including Shakespeare, Chaucer, Spike Milligan and local poet Laurence Binyon. A vertical note on the horizontal walkway is provided by a 9-metre-high (29½-foot) column, on which is a text in galvanized steel from the book of Genesis.

The collaboration between Gordon Young and Why Not Associates was close and intense, leading them to reflect on their respective roles in the project: 'We're involved in redefining where design stops and art starts,' said Young. 'It's shifting perceptions of what an artist can do and what a designer can do.'[1]

Careful planning was needed to accommodate the dimensions of the walkway, which is rather narrow – barely 2.55 metres (8½ feet) – compared with its length. Creating the letters, which were originally designed digitally, was also a complex process. Various techniques were used: some letters were laser-cut, some cut out with powerful jets of water and others chiselled out of the stone. The materials used were granite, steel, brass, bronze and glass, depending on where the lettering was to be sited, what effect this would have on colour, and the safety implications of each position.

The dimensions of *A Flock of Words* meant that the project took on an architectural aspect, and so the relationship between the visitor and the lettering needed to be studied with great care. In order to understand how a pedestrian would relate to the texts, whether reading them coming from the station or from the seafront, the designers worked with models and drawings, alternating small-scale versions with life-size mock-ups.

While the intention of the project was to inform, interest and educate visitors, according to Young it also led to more general reflections on the present state of art and design. This work made the statement that there can be a language common to artists and designers, that collaboration between them can be mutually profitable and that, luckily, there are individuals prepared to invest in experiments of this kind.

The typography for the project is based on the letterforms created by Eric Gill – here Why Not Associates have, not for the first time, chosen to celebrate the work of one of their favourite type designers. Gill had connections with the Morecambe area, having redesigned the interiors of the Midland Hotel, an Art Deco building designed by Oliver Hill in 1933 that stands on the seafront and is much admired by the local people.

[1] In Deborah Burnstone, 'A Flock of Words', *Eye*, no. 45, Autumn 2002.

Opposite: The installation process.

Following pages: Details of the pathway, and some of the words that celebrate the local birdlife.

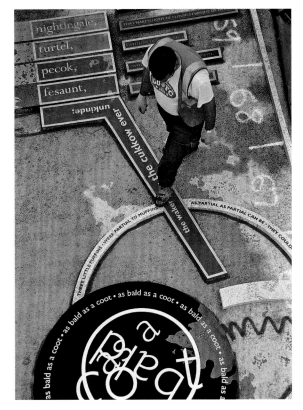

CAGE

BEWARE
AND BE
WARY
THERE'S NOTHING AS

SCARY
AS A
FURRY
CANARY

ROGER McGOUGH

A walkway for a sculpture
park commemorates
thousands of local patrons.

Gordon Young
& Why Not Associates
Walk of Art

Yorkshire Sculpture Park,
Wakefield, West Yorkshire, UK

Huddersfield Rd

Park Ln

Bretton
Country Park

Beaumont Dr

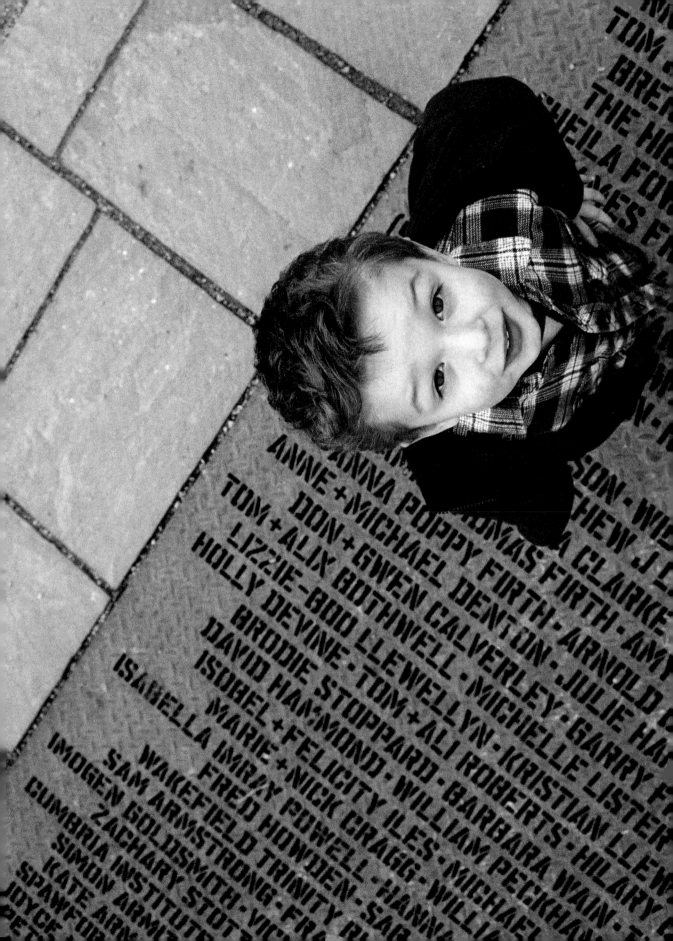

Walk of Art was designed in 2002 for the Yorkshire Sculpture Park by Gordon Young, in collaboration with Why Not Associates, who were responsible for the typography, and with Russell Coleman for the implementation. It forms a 110-metre-long (120-yard) typographical walkway linking the parking area to the new visitor centre designed by Feilden Clegg Bradley Architects. In addition to the visitor centre, the Yorkshire Sculpture Park has an extensive outdoor area and two covered galleries where modern and contemporary works by British and foreign artists are exhibited. *Walk of Art,* consisting of a very long list of names leading up to the entrance to the visitor centre, was a fundraising exercise. In exchange for a fixed minimum payment, the names of individuals, businesses, schools, groups or families were cut into the walkway.

This scheme proved to be remarkably successful, with 5,000 contributors to date. Their contributions had a tangible influence on the installation, determining not only which names would appear but also the overall length of the piece. The walkway now stands as a permanent record of the support and affection demonstrated by its donors. As a work, it is constantly evolving; every year, fundraising campaigns mean that the walkway becomes longer as new sections are added. The aim is to continue until there are 6,000 donors' names.

The names are cut into metal sheets that are finished with a non-slip surface. The original idea had been to inscribe the letters in granite, but the effect proved to be too funereal, which led Gordon Young to look for a material better suited to the forms of the new architecture surrounding it. The impact of the installation is the result of the texture generated by the endless rows of names filling the walkway. The names are all in capital letters, with each name separated by a small square. The whole composition is aligned along the centre of the walkway.

The letterform used is a slightly modified version of Water Tower, designed in 1999 by Cornel Windlin. It is a stencil typeface; the letters are cut out of the metal sheet. The thinner elements of the letterforms have been made thicker so that they are strong enough both to support the constant passage of visitors and to resist the effects of the deterioration of the metal. This material was chosen because as it rusts, it shows the signs of passing time. In this way both it and the stencil letterforms are well adapted to the modern architecture of the Yorkshire Sculpture Park.

The poet Simon Armitage composed a poem about the installation (see page 312), addressing the importance of our names, stating how they should only be revealed for worthwhile reasons: we should treasure them, therefore, and immortalize them in metal.

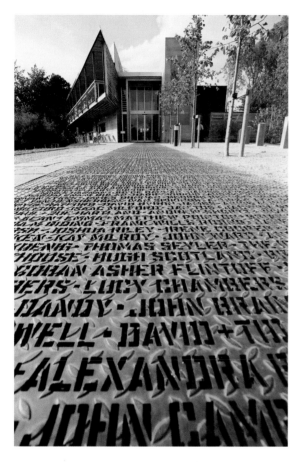

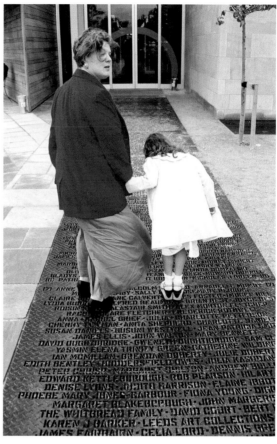

Above and following pages:
Some of the 5,000 names that
lead up to the visitor centre.

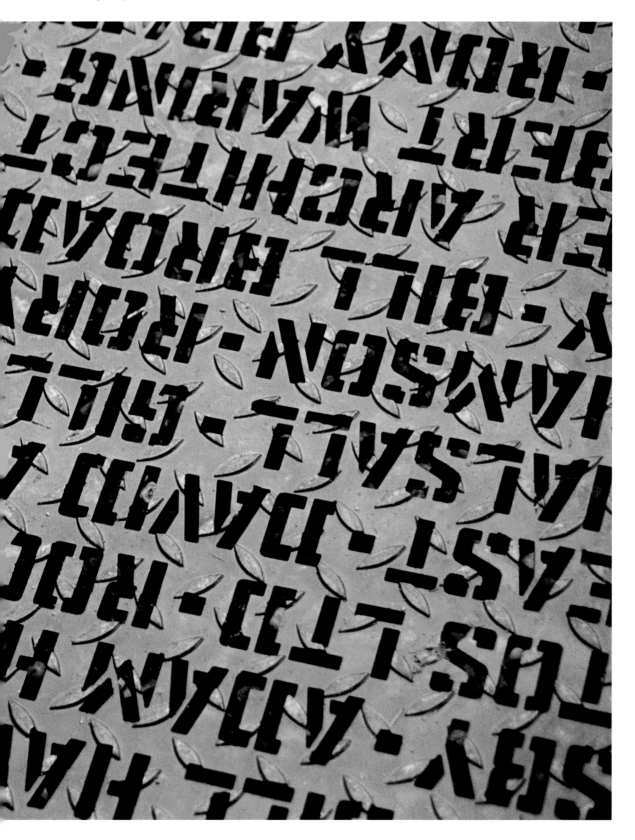

Making a Name

Simon Armitage

Here is a name – it is your name for life.
Loop it around your ears and toes – it works
like puppet strings, like radio control.
Try it for sound – slide it between your teeth.

Stitch that name into your socks and vest.
Sketch the shape of your name with a felt-tip.
Will it float or fly, or should it be screwed
to an office door, propped on a desk?

Once we were known by our quirks and kinks,
known by our lazy-eyes, our hair-lips.
Once we were named by the knack of our hands:
we were fletchers, bakers, coopers and smiths.

Don't sell your name to a man in a bar!
Don't leave your name in a purse on the beach!
Don't wait for a blue plaque – get yourself known
with glitter and glue, in wrought ironwork;

sign your autograph with a laser-pen
on the face of the moon. Here is your name
and a lifetime only to make it your own.
Then the mason takes it, sets in stone.

1 Names are separated
by a square glyph.

2 In the case of a couple,
the names are united by
a + sign.

3 Double last names
are linked by a hyphen.

REW FELTON · NANCY PAT

TON · TIM CRICK · CATERIN

ONNOR [1] · WENDY + MICHAE

· MABELLA PARSONS · OL

MARGINSON · BOB+ [2] NORA

AM TURNER · CONSTANCE

IAM COSSEY · JASPER CO

NSON [3] BREWIN · JENNIE

RT ASHWORTH · ALISON A

RIAM SWALLOW · JOSEPH

Water Tower Regular

MARION SHEPHERD · BRIA

Interviews

Esaú Acosta

Estudio SIC & Buj+Colón,
Monument to the Victims
of 11 March 2004,
p. 108

30 November 2011

**Why did you choose the written word in the Monument to the Victims of
11 March 2004? What is the relationship between words and space?**
From the beginning we thought that the most interesting reactions of the days after the
attack on Madrid's Atocha station were the countless expressions of affection and col-
lective support shown for the victims. This was crystallized in a spontaneous creation of
a collective catharsis in which the citizens left texts with questions, support, and so on.
A place for externalization of collective sentiments. Somehow this place built with the
word as a raw material should be kept forever.

How important is space in your project?
Space represents for us the true monument. We believe that a monument in the twenty-
first century should not be an object in the city but rather a space for reflection, more
immanent, and more ethereal. A place where there is light and silence. This was quite
a difficult concept to propose to the city of Madrid, since monuments are traditionally
conceived here more as sculptures than places where one can enter a space.

**Tell us about Isonorm: why did you choose it,
and how important is typography in your work?**
We chose Isonorm because it seemed clear, concise and neutral at the same time. It
is a typeface that is not too loud, that won't distract from the message. We think that
typography in architecture is an increasingly important element. It provides a human
dimension to space. In the case of the Monument to the Victims of 11 March 2004, the
transcription of the messages was totally integral. Even those that had spelling mistakes,
or were unorthodox, were left unchanged. This is our way to be faithful to the time when
the message was written, with the writer's emotions, feelings and mistakes. We avoid
passing any kind of rational 'varnish'.

**What is your relationship with the professional world of graphic
design and typography? And with the art world?**
We try and work with graphic designers and people who try to push the boundaries of
typography. Our proposal for the Omagh bombings memorial revolves around a similar
concept of the use of typography. We also try to apply it to other projects for companies
whose main concern is how to promote their brand.

Gustavo Aguerre

FA+, *Citat*,
p. 116

5 March 2008

**What kind of relationship is there between words and landscape
in *Citat*? How important is space in your project?**
There are not just some words in some street, as many people may think – no, it is
a tight concept and every element has a reason to be there. The cityscape and the
words – the quotations – in this work are extremely interrelated, to the point that the
street is a part of the work. The project is in Drottninggatan, in the centre of the city.
August Strindberg, the most important Swedish writer, lived the last years of his life on
this street; he had a large apartment (now museum) in a building at the top of the hill.

Every morning after breakfast, at the very same time, no matter the weather, he took a walk all the way to the water and back to then start work. It is not unlikely that some of these words came to him during his strolls…. The words in the street represent his thoughts embodied, solidified. The quotations have been chosen from theatre pieces, poems and letters. They were meant to give a picture of Strindberg's ideas and personality, mixing profound intellectual thought with banality, humour, political comments and…contradictions.

The texts, with their placement along the centre of the street, reconstruct a lane-dividing line, since the street has been closed to traffic. The installation uses materials currently found in the street: steel and asphalt. Also, Helvetica is the standard typeface used in all the surrounding traffic signs. As you can see, there is a great deal of interrelation between the text, the street and its history. It is what the entire concept is about.

Why did you choose to use the written word in your work?

On the occasion of the first Strindberg Festival in 1994, we were asked to visually 'interpret' the writer. We wanted to avoid the common exercise of simply playing on a visual depiction of the writer. That picture says nothing about the work. The text is the writer; therefore we chose his texts to represent him. Furthermore, we use words in our works because the written word it is a very powerful tool: if you are confronted with a word you cannot help but to read it; we have been taught to do exactly that.

Why did you choose the typeface Helvetica?
How important is typography in this work?

The typeface is extremely important: it is a language in itself; it's a part of the message. By choosing a typeface you are telling the people how to read the text: funny or serious, elegant or trendy, classic or punk, and so on. The typeface is the clothing of the message. In the case of *Citat* we chose Helvetica because it is the standard; it's integrated in the street language and it lacks futile decoration, making it simple and clear to read as you are walking up or down the street. The idea was to allow the passers-by to focus on the content of the text and not be disturbed by its form. Our work is not just a street decoration but an alternative to the invasive cacophony of advertising: 'Think. It's refreshing.'

In general, how do you choose a typeface?
Do you use some typefaces more often than others?

I am very careful in the use of typography; it has to be the right one both for text and titling. I choose the typeface depending on how much I want to show or hide of the content, how much I want you to be informed or dis-informed: you can dress a hobo in a tuxedo and it will take you a while to find out.

Do you find references from the past or contemporary history
of architecture, design and art in *Citat* and in your use of typography?

There are plenty of references, from the inscriptions on Roman sculptures to today's street signs. In art: Barbara Kruger, Jenny Holzer and many others. Fashions in typography come and go with accelerating speed, but the need for a clean type to transport a text, without visual interference or decorative pollution, will be always there. Helvetica is fifty years old and still going very strong. It's in the name, it's something classic, not a trend.

What is your relationship with the worlds of graphic design and architecture?

I design our publications and websites myself, and I have designed furniture too. I believe there exists a formal part in every aspect of design, but form without content

is empty. I do not believe design is art per se, and neither is fashion design. There are indeed design objects that are splendid and their beauty is a pleasure to contemplate, but art is that, plus something else. Design, for me, is just a tool to achieve a goal beyond form; the purpose of a Ferrari F1 is to win races and not just to look beautiful, even if it does. Architecture is always the container of whatever you do in a city. It is something you always have to confront. It is impossible to avoid: you have to face it, indoors or outdoors; you have to use it or fight against it. I am very fascinated by architecture (I started to study architecture but left it), but some architects are very dangerous people. They have the tendency to try to force or modify people to adapt to their creations, as if the people have to serve the building and not the other way around. I was born and raised in a big city, in Buenos Aires; the city context is in my nature and architecture is part of my natural surroundings. It's a language I am very used to dealing with.

In our work we make quite a lot of 'temporary architecture': we have to deal with the architecture surrounding us, integrating it into the piece if possible, or making the intervention a 'natural' (cultural) part of the architecture containing it.

Roberto Behar
& Rosario Marquardt

Roberto Behar & Rosario Marquardt / R & R Studios, *M*, p. 232

20 February 2012

What's the relationship between the *M* and its context?
How important is space in your project?
M celebrates Miami's Centennial and is conceived as a Monument of Multiple Meanings. Within the urban landscape it performs as three-dimensional graffiti, inviting interpretation and providing emotion in a landscape in motion. *M* stands as a landmark in an urban landscape still under construction and simultaneously performs as a place of encounters within the area and as an icon of the city at large.

And what kind of relationship is there between the letter and the passers-by?
The *M* is an exception within the anonymous fabric of the city; it is a 'placemaker', inviting personal ownership of the *M* as passers-by complete the letter into words and emotions of their choice. In a city as young as Miami, the *M* could be seen as an urban toy recalling common experiences of play and suggesting the idea of the city as home.

Why did you choose to use the written word in your work?
Letters, words and phases are a means for our projects to communicate with others and for cities to reveal their souls, in the process making the public realm personal and meaningful.

How did you choose the typeface? Was it custom designed or did it already exist?
Yes, the typeface was designed by us. Indeed, the transformation of letter into architecture or a two-dimensional graphic element into a three-dimensional event required the invention of the character. Formally, characters carry meaning, and we thought that Miami as a new city required a new letter type to project its identity.

**Do you find references from the past or contemporary history
of architecture, design and art in *M* and in your use of typography?**

There is not a specific project precedent but a multitude of references. Indeed, as Walter Benjamin mentioned, the modern city has seen an explosion and multiplication of the alphabet throughout landscapes. The *M* is an exaltation of this condition in poetic form.

What's the relationship between architecture, design and artistic research?

Artistic research is a fundamental part of our work; everyday life and the pursuit of happiness are key guiding principles of R & R Studios' production in all disciplines.

Catherine Griffiths

Wellington Writers Walk,
p. 132
29 November 2011

**What's the relationship between words and landscape in the
Wellington Writers Walk? How important is space in your project?**

The relationship is strong but not in a literal way – the works don't describe what is going on around them. Instead, you have the landscape as one element, the words and their meaning as another, then you put them together, and this juxtaposition results in a further meaning, another layer of meaning. So, Bill Manhire's text sculpture – 'I LIVE AT THE EDGE OF THE UNIVERSE, LIKE EVERYBODY ELSE' – seemed to fit perfectly in an existing space in the wharf, a small cut-out, where it is suspended over the water – it is not the edge, but gives the 'feeling' of being on the edge, as it cantilevers out in the air and over the water below. I wanted to create a sense of the environment, the landscape, the wider view, the detail, all these things that have to do with scale and space, when reading the texts…so that the reader experiences something that gives the written texts a new context; not simply words presented in a book, but words that could evoke feeling and emotion with a sense of place. And space. Some text sculptures are snug, others are uncomfortably exposed, another is perched, yet another floating but lined up with architectural forms, and so on. The text sculptures form part of the composition of the landscape.

Why did you choose to use written words in your work?

The Wellington Writers Walk project is based around the written word, honouring significant New Zealand writers who have strong associations with Wellington. In response to the commissioning committee's original brief, which was to 'design a series of A4-sized bronze plaques to be set into the ground on the civic square', I made the proposal that we celebrate the words of these writers in a way that would be worthy of the writers' and poets' ideas and writing. To me, it was obvious at this point that this would be a typographic response, using the very tool of these writers and poets – the written word – in a way that would push outside of the expected, beyond the original brief. A celebration of words and ideas.

The committee accepted my proposal, which dealt with scale and materials, looking at concrete as an urban vernacular material – one that was fresh in my mind as our new house took shape near the harbour. I loved the notion of becoming more sculptural with the literary form. There are two styles of text sculptures – one more traditional in its concept, the other more challenging and rigorous – and together they achieve an unexpected, yet balanced mix. I had anticipated choosing between the two styles, but figured, as the project developed, why choose one over the other? Let the words choose. The Writers Walk proposal discussed an idea much more sculptural and typographic than the committee had considered. The idea was seductive, and on reflection, probably

courted their passion for the written word. The motivation for me was celebrating writers and poets, words, language, their voices – how could this not be an opportunity to use the very tool I had, and push it for all it was worth? It was so clear to me. Suddenly, I'd leapt off the printed page and into the landscape – it was exhilarating.

Why did you choose Helvetica Compressed and Optima?
How important is typography in this work?
'Design had to be worthy of the writers' strong and beautiful words. My intimate knowledge of the particular characters of different typefaces allowed me to select fonts according to an intuitive response to the texts. The qualities of the selected fonts – Helvetica Extra Compressed and Optima – work to reinforce the content and sensibilities of the texts. The two typefaces are articulated differently. The texts set in Helvetica Extra Compressed were cast as individual letterforms [100 millimetres high × 35 millimetres deep (4 × 1 ⁵⁄₁₆ inch)] and then hand-set and fixed onto concrete panels. The letterforms sit proud, casting shadows that make apparent the curious forms of the negative spaces between letters. The texts set in Optima, with its slight flare tending towards a serif, were cast as integral parts of the concrete panels – imprinted 10 millimetres [⁵⁄₁₆ inch] deep, they allow shadows to fall and rainwater to pool. At a glance these panels resemble more traditional forms of 'public typography' – words carved into the stone surfaces of buildings or memorials. However, here the serif – developed from the exigencies of carving in stone – has been cast, straight-sided, into the plasticity of concrete. This is slightly strange, but the shift in material and mode of production might also be read as another level at which the Writers Walk reinvigorates and reinterprets the older tradition of inscribing the built environment.'[1]

[1] In Justine Clark, 'Writing by Types', *Artichoke*, 2003.

In general, how do you choose a typeface?
Do you use some typefaces more often than others?
Generally, I make my choice in response to the content – so my work is shaped by the content and its meaning. I don't have a particular bias for one over another, but then, I am quite fussy about the qualities of a typeface – I don't claim to be an expert, technically. Instead, my strength is that I respond to the visual aesthetic of a typeface, its form, and what happens to the 'voice' of the content, when it is set in one typeface over another. I probably use some of the classic typefaces more frequently than new ones – but, if there is a new one that convinces me, then I am happy to work with it. I am quite fussy. And not readily satisfied!

'I am unashamedly a user of classic typefaces – mostly, they seem to work for me. I am always searching for answers in new typefaces, and rarely am I satisfied – but, I am always looking. I recently purchased the perfect typeface for the cover of *STOPOVER*: Bryant Alt Light, designed in 2002 by Eric Olson of Process Type Foundry. The interlacing pattern formed will be reproduced as a very fine debossing in a dark grey and a Pacific blue (it turned out to be silver on the final book) on a black uncoated Italian paper. I am very excited about the proportions and feel of this typeface. It seems to sit well with Letter Gothic (designed in 1956 by Roger Roberson), which is the main text typeface in the book. Bell Gothic is a true favourite. I have tried to wean myself off it, really because I had exhausted it for over a decade, but recently it appeared again on two quite separate projects. I remember the day I discovered that it was designed by C. H. Griffith (in the 1930s) – and me being C. H. Griffiths (note the 's') made it all the more special! Other typefaces include Hermann Zapf's Palatino, and Optima. Years ago, I was required to work with Palatino as the main typeface for a university. It is a beautifully formed typeface, and by using it with care and sensitivity (inspired by Zapf), I was

[2] From an interview with Helen Walters, 2005.

able to transform the university's publications in a way that stood them apart as smart and intelligent. Gill Sans Light is another reliable favourite, and Clarendon, particularly the bold weight (1953, Hermann Eidenbenz). These are classics. Each project finds its own typeface. I am always looking. But I am hard to please.'[2]

I used Didot in 2007 for a book – that was a very nice experience – and, in 2008–09, Olsen's Maple for the TypeSHED11 work, with Courier New as the secondary typeface. Most recently, I discovered Paul Barnes's Dala Floda. When you arrive at my website, you land right in its beautiful, huge red forms!

Do you find references from the past or contemporary history of architecture, design and art in your work and in your use of typography?

Probably, at a push, you could say that my work is most closely connected to Modernist ideals. That's quite a hard question to answer so specifically. Perhaps by looking through my work, you could answer this question for me! My work is not so decorative nor so classic. It is about finding meaning and purpose, communicating clearly, simply and with feeling, in a way that might survive time.

What's your relationship with architecture? And with the world of artistic research?

I have a personal and quite private connection with architecture in terms of space and composition. I'm inspired by the Modernists, of course! I'm fascinated by Herzog & de Meuron's collaborative projects. Their book *Natural History* is exceptional. I tried to make an appointment with them in Basel, but they were too busy, sadly. Our house, which we had designed by New Zealand architect Nicholas Stevens, or any building or structure that speaks to me, I feel these things. It's kind of like typography. Domestic architecture in New Zealand is strong. Travelling overseas, I become aware of what is quite rare in New Zealand: extraordinary public buildings. Tadao Ando is someone I keep returning to again and again, nearly always by accident. While I'm not an architect, Ando's 'innate sensitivity to three-dimensional space' and clarity of logic are qualities that I feel are inextricably part of my make-up. His command of the texture of light and shade, materials and surface, sound and time, his embracing of human nature's imponderability – these are some of the things that form the language I engage with as a designer and typographer, whether in the landscape, in architecture, or in books.

[3] Kenneth Frampton (ed.), *Tadao Ando: Buildings, Projects, Writings*, New York, Rizzoli International, 1984, p. 139.

Three quotes of his: 'I became interested in trying to make shapes out of wood. Just as people have individual personalities and facial appearances, so woods all have their own characteristics.... I gained direct physical knowledge of the personalities of woods, their fragrances, and their textures. I came to understand the absolute balance between a form and the material it is made of.... I experienced the inner struggle inherent in the human act of applying will to give birth to a form. In addition, my flesh came to know that creating something – that is, expressing meaning through a physical object – is not easy.'[3]

[4] *The Japan Architect / JA #1: Tadao Ando*, January 1991, Tokyo, Shinkenchiku-sha.

'Perhaps it does not matter how pretty the details are, or how beautiful the finish is. What is important is the clarity of logic – that is, the clarity of logic behind a composition...the quality that one recognizes through reason, not perception. What is important is "transparency"...the "transparency" of a consistent logic.'[4]

[5] Kenneth Powell (ed.), *Tadao Ando: Buildings, Projects, Writings*, p. 139

'If you cannot sense the "depth" or philosophy of the designer when you experience a building, the architecture is merely an economic activity...[and] in that case, the architecture has little meaning for me.'[5]

Regarding artistic research: my research is the reading I do, the discussions and debates I am involved in, and looking around me – I'm not an academic, I'm a practitioner, with thoughts and ideas, wanting to make sense of things, make something meaningful.

the work many times. The decorative element will obscure the message, which is about local history, and with this intentional obscuring the message will not immediately yield up the words, but over many visits to the station people will slowly decipher the writing. In this way interest in the piece will be prolonged, hopefully for many visits.

Attila F. Kovács

House of Terror Museum,
p. 184
3 January 2012

What's the relationship between the black cornice, the words and its urban context? How important is space in your work?
The black cornice makes the building stand out from the others on the boulevard. It functions like a bookmark from the row of buildings on the boulevard; it is used to separate and leave a mark. The building is thus transformed to a statue-like object, with blind windows painted grey as the colour of the uniform of the secret police: the cornice represents a frame of a frozen object. This was a real place, where people were executed – hanged and tortured to death. The black cornice creates a virtual, dark space around one of Budapest's most feared buildings.

Why did you choose to use the written word in your work?
I used the written word because the propaganda the Communists and Fascists used were slogans, so words were always important as a visual symbol of the meanings, together with the political signs.

Which typeface did you use and who designed it? And why did you choose it?
I designed the typeface, following simple stencil designs of the 1950s. I like these simple letters. They had to be practical, easy to cut out from the passe-partout and have a characteristic shadow.

Do you find references from the past or contemporary history of architecture, design and art in your work and in your use of typography?
Not really. This is my invention, there is no other similar work. You can even read it from the sky. The negative symbolizes destructive power, but at the same time, light can go through and cut the letters out, showing what the black cornice means on the facade.

What's the relationship between your works and architecture, design and artistic research?
I can't separate these things, I believe in *Gesamtkunstwerk*, (total body of work), and the vision has to come from inside.

Anton Parsons

Invisible City,
p. 210
5 December 2011

How did you get involved in public art and why did you decide to put *Invisible City* in a public place?
This is public art and public art by nature should be universal. It should be understood by everyone, or understood by no one. I don't like the idea of there being one set of rules for one viewer and another set of rules for others. I don't like the idea that some people will 'get it' and others will miss the point entirely. So with a lot of my work I prefer to keep the

meaning hidden, or at least leave the job of 'understanding the art' with the viewer. With *Invisible City*, I wanted to break down some of the walls between public art and private art. There are rules to public art, particularly to art that is shown in spaces other than the public art gallery. For instance, it's perfectly acceptable to touch a sculpture in a park or plaza – it's not acceptable to touch it in a gallery or private home. *Invisible City* started out as a wooden Braille slab I had made for a dealer show at Hamish Mckay Gallery in Wellington, and it broke one of the first rules of private space art – the 'no touching' policy – where you only 'touch with your eyes'.

Of course the idea of touching Braille with your eyes is absurd. It's a form of communication that is meant to be touched to be understood. And the title of the work, by Peter Beatson, who is both a sociologist and a poet, comes from a poem written in memory of his guide dog, which is very much about a blind person's relationship with the city. It is this poem that was originally made out of wood, and then came to be fabricated in stainless steel for the final work.

It is appropriate that *Invisible City* came to be exhibited in Wellington, which is perhaps New Zealand's only real city. The heart of Wellington is quite compact and positioned between very steep hills on three sides, and the harbour on the fourth. Other New Zealand cities tend to sprawl out into the countryside. Wellington stays within a relatively small space and retains a very strong identity. It's also a capital city and is therefore quite planned; the architecture mirrors the organization of a seat of government and trade; it starts at the Parliament House and works outwards. It's also a very egalitarian city: people come from all over New Zealand to participate in their democracy and it has to make room for diversity – ethnic, economic and political. That's part of the reason why public art is so important, and why something that spoke for the blind was probably chosen.

Why did you choose to use the written word in your work?
How important are words in your sculpture?

The perverse thing is that in this work the Braille is indecipherable to the blind. A line of real Braille made from embossed paper is 10 millimetres [⁵⁄₁₆ inch] high and has a direct relationship to the finger. The stainless-steel letters (called cells) on *Invisible City* are scaled up, so now the Braille cell has a relationship to the hand. This upsizing meant that the work is not 'readable' for the blind. So, the blind can't read the poem, and sighted people can't read it either. There's no translation of the poem available alongside the work. As a result, an artwork called *Invisible City*, which uses the alphabet of the blind, is actually invisible in terms of meaning.

The writer of the poem, Peter Beatson, originally agreed with me that the words to *Invisible City* should stay hidden. Then, when the work was completed and installed in the street, he had second thoughts. And, yes, I could see his point of view: what was the point of contributing a poem that no one could read? But, for me at least, that was the whole point. It was the ambiguity that mattered. And this decision, to hide the meaning away from the public, is very true to the original poem. When you are blind, and making your way alone around a city, your other senses become more alert to make up for your loss of sight. Hearing, for instance, becomes very important. But Wellington, like Chicago, is a Windy City. And the wind sweeps away the sounds blind people rely on: the sounds of traffic, the buzz at a pedestrian crossing that tells you it's safe to walk, the chimes of the city's clocks that tell you you're early or late for an appointment. A line in the poem goes, 'betrayed by the wind / my sonic charts destroyed'. For a blind person finding his way around the city, to suddenly arrive in front of *Invisible City* – a pubic artwork, which no one can read, but is tactile, as it is visual for those people who have eyesight – is very ambiguous.

across the river and from the Millennium Bridge. The letters are below the tidal line, so they only appear at low tide. We made the sign of wood, so that over time it has turned a bright green from algal growth.

2. Painted in blue onto an existing galvanized metal screen fence on Great Guildford Street. The fence is around a playground along the street behind Tate Modern. The holes in the fencing are so big that you can only read the letters clearly when you look at the sign obliquely, so that it seems to disappear as you walk past it.

3. Painted in white onto a brick wall under the railway bridge in Southwark Street. This sign was later altered by the street artist Banksy to spell his name. It has been covered by another sign now and is lost.

4. Big letters in silvered mirror on a messy brick wall of a railway arch about 200 metres [218 yards] south of Southwark Street. The optical effect of the mirror reflecting the sky onto the old brickwork was very powerful. So all the signs were about making a spatial connection to the place, and making the signs interactive to movement, and seeing them differently from close up and far away.

How important was the choice of materials?

The specific size and the material are the idea of the project. The material concept is connecting to a romantic idea of the history and character of each place. For example, the big signs painted directly onto the walls refer to the Victorian tradition of painting advertising slogans on the blank sides of buildings. The signs in the pavements are simply manhole covers exchanged with existing manhole covers to sewers, electrics, etc., drawing attention to the fact that the services under the pavement in this part of the city are randomly placed and disorganized. The street signs on the corners of buildings are vitreous enamel, which is a traditional material for street signage that has now been replaced in most London streets by plastic signage.

Why did you choose Akzidenz Grotesk? How important is typography in this work?

We always use this type, because it's banal and with the minimum of style.

What's your relationship with graphic design? And with artistic research?

We sometimes use graphic designers, although we didn't on this project. Here the graphic part was an integral part of our design. We worked with an artist (Roy Voss) at first, to develop the concept. We tend to do this a lot. This question would require a very long list, as we are influenced by many artists.

Do you find references from the past or contemporary history of architecture, design and art in your work and in your use of typography?

The project refers to the past, but it's contemporary. This is because it doesn't try to recreate a past, but instead makes a new thing out of the past and the present that is rich and complex and ambiguous. It's post-modern. Perhaps the most important influence would be Robert Smithson, whose work was both contemporary and archaic.

Paula Scher

New Jersey
Performing Arts Center,
p. 224

26 November 2007

What's the relationship between NJPAC and its context? How did the context influence the project? And how did the project influence the context?

NJPAC is in a rough urban area that is becoming gentrified. Newark, New Jersey, still has factories and manufacturing. Not very far from NJPAC are auto and truck garages with painted lettering all over the buildings. The lettering on the NJPAC building was so precise and elegant that it raised the visual quality of the neighbourhood.

In this work you used the font Agency. Why did you choose this font?

I chose the font Agency because it has a condensed form. In all caps it could easily conform to the ins and outs of the building.

Can you find in this work and in your use of the character any specific reference to the past or contemporary history of design and art?

It was common practice in Victorian times to paint the sides of theatres with information about the performances and plays. You can see the faded lettering to this day on the sides of theatres in Covent Garden in London.

Pierre di Sciullo

National Dance Centre,
p. 246

21 February 2008

Why did you choose to use lettering in your work?

Because it was the best way to provide the essential information. This building housed government offices for twenty years, and it was now being transformed into a cultural space dedicated to dance. I didn't want to install an 'institutional sign' on an urban scale; that would have been a contradiction to the actual use of research and creation in the world of dance. I had to reconcile this with the industrial and commercial buildings around.

What kind of relationship is there between the word *danse* and its context? How important is space in your work?

Pantin is an industrial suburb: factories, warehouses, old industrial mills. The most recent residential buildings are built along the city's outer ring. Often, big signs are installed on these buildings. To install a similar sign was my way to play with the frame of reference; to place a sign with a word on the roof was like creating a link with the local industrial urban context.

How did you choose the lettering of the word *danse*?

The letters of the sign are placed on the ceiling (or the ground). The typeface used is a variation of Minimum; as if it had been subjected to a powerful force of gravity, as when an aircraft lands. The relationship with dance is evident. It's also a play on the motifs of the facade, the orthogonal cuts and the folds of the concrete. I particularly focused on the way the sign functions both by day and by night; the way in which the sign receives external light during the day and emits it at night.

What is your relationship with the world of architecture?
And with the world of art?

I have been working with architects for several years. It's exciting and frustrating at the same time. Most architects I meet are open to the plastic arts but their creation process is so complex that it is very difficult to avoid being a mere executor.

The attitude of the customer is crucial. At Pantin there were miraculous astral conjunctions. Graphic design has accepted me warmly and swiftly.

My ties with the art world are weak. I am, somehow, an artist who works unconventionally in this field: I voluntarily chose not to collaborate with galleries, thus not bartering with intellectual legitimacy. At the same time, as I work on projects commissioned by institutions, there is the appearance of formality. This makes me smile because it is in institutional contexts that I am often given the most freedom of expression. From my point of view, I'm an artist active in various fields, because I love to learn. Sometimes I find that my research does not progress fast enough because I lose myself in spontaneously pursuing the truth.

Do you find references from the past or contemporary history of architecture, design and art in the National Dance Centre and in your use of typography?

Good question! But to answer, even if partially, I am attaching a diagram (see below). It was originally sent as part of the bid for the project. My position is not static; nowadays I would give other interpretations. But this clarifies a few things.

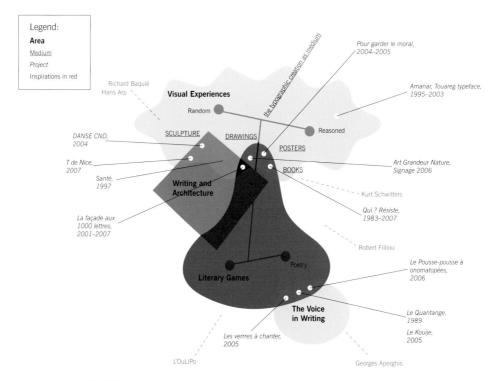

An attempt to summarize recent research, 2006.
By Pierre di Sciullo (adapted).

Lawrence Weiner

3 March 2008

What's the relationship between your work and its context?
How important is space in your project?
The content of the sculpture (essentially the meaning of the words) functions as, and is, an object within the landscape. In effect it is a component of the landscape. Space becomes place.

What's the relationship between the words on your works and passers-by?
As with all objects they represent meaning.

Why did you choose Franklin Gothic with the modified *I*?
How important is typography in this work?
Typography presents the work. The choice is to find elegance without authority and without a dependence upon a historical meaning.

What's the relationship between the words, the iron and the urban
context in the project *A Translation from One Language to Another*?
The use of iron was pragmatic. Originally it was stone but the stone was not strong enough within the use of the square as a market.

And what kind of relationship is there between the words and the passers-by?
They see it.

Which typeface did you use or modify in this work?
The original was shown in an art and project bulletin in 1969. That was lower-case Standard Royal Typewriter. The typeface at the Spui was Franklin Gothic Condensed with rounded edges due to the casting process.

Can you find in this work and in your use of the character any specific
reference to the past or contemporary history of design and art?
Gravestones.

What's your relation with graphic design and architecture?
I use graphic design and I live in architecture.

Why did you choose to name your font Margaret Seaworthy?
It seemed to be its name.

Addenda

Notes on the Project Authors

Ahn Sang-soo

Hangul Gate, p. 28

Ahn Sang-soo was born in 1952 in Chungju in South Korea. He qualified at Seoul's Hongik University, becoming a professor in 1991, and now works as a graphic and typographic designer, carrying out research and experiments relating to Hangul, the Korean alphabet, and is also a visual artist. Since 1988, he has been the art director of the magazine *Report*. He has won many prizes including, in 1988, a tribute from the Korean Language Academy for his contribution to the reinterpreting and encouraging of the Hangul alphabet, and he is frequently abroad to talk about his work and promote Korean design. Ahn can be credited with four Korean fonts. From 1997 to 2001, he was the vice-president of Icograda, the International Council of Graphic Design Associations, and is presently a member of the Alliance Graphique Internationale.

Ashton Raggatt McDougall

Marion Cultural Centre, p. 34

The architectural group Ashton Raggatt McDougall, also known as ARM, was established in 1986 in Melbourne, Australia, by Steve Ashton, Howard Raggatt and Ian McDougall. It specializes in architectural urban landscape and interior design. It came to prominence early on with its designs for public housing and community healthcare, going on to oversee projects such as the RMIT Storey Hall (1995), the National Museum of Australia in Canberra (2000), the Marion Cultural Centre (2001) and the Melbourne Docklands Masterplan (completion 2007). The group's highly varied and innovative work has been awarded numerous national and international prizes and has been exhibited at the Venice Biennale and the Royal College of Art in London.

Michael Bierut

Signage for the *New York Times* building, p. 216

Michael Bierut was born in 1957 in Cleveland, Ohio. In 1980 he graduated with a degree in graphic design from the University of Cincinnati's College of Design, Architecture, Art and Planning. After graduation, he worked for ten years for Vignelli Associates, ultimately as vice-president of graphic design. In 1990 he joined Pentagram in New York as a partner. The studio counts among its clients companies and institutions such as Disney, United Airlines, Motorola, Yale and Princeton Universities, Brooklyn Academy of Music and *New York* magazine. As a designer Bierut has created corporate identities, editorial designs, signage systems, environmental graphics and marketing strategies. He is co-editor of the anthology series *Looking Closer: Critical Writings on Graphic Design*, published by Allworth Press, and in 1998 he co-edited and designed the monograph *Tibor Kalman: Perverse Optimist*. He has received numerous awards and his work is exhibited in museums and permanent collections around the world. From 1988 to 1990 he was president of the New York Chapter of the American Institute of Graphic Arts (AIGA) and is now president emeritus of AIGA National, receiving the association's medal in 2006. In 2008 he received the Design Mind Award in the National Design Awards presented by the Cooper-Hewitt, National Design Museum, Smithsonian Institution. Bierut is a senior critic in graphic design at the Yale School of Art.

BBPR

Museum-Monument to the Deportee for Political and Racial Reasons, p. 42

The BBPR group of architects was established in Milan in 1932 by Gianluigi Banfi, Lodovico Barbiano di Belgiojoso, Enrico Peressutti and Ernesto Nathan Rogers. During the period of their collaboration, dating from their last years of study at the Politecnico in Milan, BBPR has undertaken regional planning, architectural design, staging and furniture design, seeking through its work to demonstrate the principles underlying modern architecture. United in their opposition to the political conformism of the Fascist regime, each one of them was caught up in the tragic events of the period. Rogers, in particular, was forced by the race laws to flee to Switzerland in 1938 (his mother was Jewish). Banfi and Belgiojoso, arrested in 1944 for their part in the Liberation, were imprisoned and then interned in concentration camps, from which Banfi never returned. After the war, BBPR maintained its political stance, carrying out a number of projects commemorating the victims of Nazi and Fascist violence, including the monument in the cemetery in Milan to those who suffered in the concentration camps, the Museum-Monument to the Deportee for Political and Racial Reasons in Carpi, and the Gusen memorial. The BBPR group has also initiated many design projects and important theoretical debates (with Rogers, who was the editor first of *Domus* and then *Casabella* magazines), combining this with significant amounts of academic teaching in Italian and foreign universities.

Joan Brossa

Bárcino, p. 54
Transitable Visual Poem, p. 62
Visual Poem for a Facade, p. 70

Poet, dramatist and artist Joan Brossa (1919–1998) was born in Barcelona. He began writing during the Spanish Civil War, in which he fought on the Republican side. Convinced that there are no dividing lines between the different artistic genres, his work embraced poetry, cinema, theatre, music, cabaret, magic and circus. Brossa's work shows influences from psychology, particularly Freud, and poetry, especially Mallarmé, whom Brossa regarded as a model of intellectual rigour and a precursor of the calligram. Other important encounters were with Joan Prats, Josep Vicenç Foix, the ADLAN group and Joan Miró, figures who introduced him to the world of the European avant-gardes, including Surrealism and Dadaism. Another significant moment was his meeting with the Brazilian poet João Cabral de Melo, who encouraged him to further his knowledge of Marxist thought, something that subsequently appears in his work. Among others he founded *Dau al Set*, a magazine essential for the Catalan artistic avant-garde at that time. In 1943, he produced his first 'object poem', a small sculpture consisting of a disparate selection of objects referring to the Surrealist idea of free association. He dedicated his last years to urban visual poetry, so endowing his works with a public dimension. He received many awards, including the National Prize for the Plastic Arts in 1992, the National Theatre Prize in 1998, the UNESCO Picasso Medal, an honorary degree from Universitat Autònoma de Barcelona in 1999 and he was made an honorary member of the Associació d'Escriptors en Llengua Catalana. His vast literary output, composed exclusively in Catalan, has been translated into many languages.

Paul Carter

Nearamnew, p. 76

Paul Carter was born in 1951 in Oxford in the UK and studied at Oxford University. He lives in Italy, Spain and, from 1980, in Australia, where he is presently professorial research fellow at the Faculty of Architecture, Building and Planning at the University of Melbourne. A scholar and prolific writer, he is the author of many books. He has also designed

numerous works of public art, many of which relate to the written or spoken word, as in the cases of *Named in the Margin* (1990, Hyde Park Barracks, Sydney), *The Calling to Come* (1995, Museum of Sidney), *Relay with Ruark Lewis* (Sidney 2000 Olympics) and *Nearamnew* (2003, Federation Square, Melbourne).

Caruso St John

Bankside Signage System, p. 94

Adam Caruso (b. 1962) and Peter St John (b. 1959) set up their architecture firm in London in 1990. They became known on the international scene in 1995 when they won the contract for the New Art Gallery in Walsall, and since then they have taken on a wide array of projects, both public and private, large and small, paying particular attention to the use of materials. In 2010 they opened a second firm in Zurich and two of their projects, the New Art Gallery in Walsall (2000) and the Brick House in London (2006), have been shortlisted for the Stirling Prize. Their clients include Tate Britain, the City of Lille, Bremer Landesbank and SBB (Swiss National Railways). Also involved in research, the two architects and many of their collaborators combine their professional work with teaching at schools of architecture.

Chermayeff & Geismar

9 West 57th Street, p. 102

Ivan Chermayeff (b. 1932) and Thomas Geismar (b. 1931) began their collaboration in 1958. Since then they have worked together in many different fields on well-known projects. They specialize in corporate identity, branding, editorial design, catalogues and exhibitions, animated graphics and art in architecture. The firm of Chermayeff & Geismar is based in New York but has carried out projects in Europe, Asia, Latin America and the Middle East as well as in the United States. Headed by the two founders, the firm has a third partner, the designer Sagi Haviv. Their work has received accolades from around the world.

Estudio SIC & Buj+Colón

Monument to the Victims of 11 March 2004, p. 108

Estudio SIC was established in Madrid in 2002 by the architects Esaú Acosta, Mauro Gil-Fournier Esquerra and Miguel Jaenicke Fontao, all graduates of the Escuela Técnica Superior de Arquitectura in Madrid. The group's work focuses on the dynamic relationship between architecture and landscape, multidisciplinary collaboration, public spaces, sustainability and urban identity.

Raquel Buj García and Pedro Colón de Carvajal Salís also studied at the Escuela Técnica Superior de Arquitectura in Madrid and are presently working towards the ETSAM's Doctorado de Proyectos Arquitectónicos. Since 2002, they have collaborated on projects in urban and landscape design, architecture and design.

FA+

Citat, p. 116

The FA+ group was created in 1992 in Stockholm as a result of the collaboration between the artists Ingrid Falk (b. 1960, Stockholm) and Gustavo Aguerre (b. 1953, Buenos Aires). The acronym FA+ stands for Falk and Aguerre's initials plus the various participants working on the projects. FA+ has carried out some forty projects in different countries, and has participated in curatorial and teaching activities as well as holding seminars in museums and universities. Gustavo Aguerre and Ingrid Falk have been awarded the Honorary Prize of the City of Stockholm.

Ian Hamilton Finlay

Little Sparta, p. 124

Ian Hamilton Finlay (1925–2006) was born in Nassau, Bahamas, to Scottish parents. An artist, poet and writer, he published his first book, *The Sea Bed and Other Stories*, in 1958. This was followed in 1961 by a collection of poems, *The Dancers Inherit the Party*. In the same year he founded the Wild Hawthorn Press, which published the work of several different artists before concentrating on Finlay's own work. From the outset, his work was characterized by its high quality and formal innovation. During the 1960s, he became interested in concrete poetry. In 1966, he moved with his family to a farmhouse at Stonypath in the hills to the south-west of Edinburgh. This was to become Little Sparta. Finlay's work has been exhibited in galleries all over the world and some fifty examples have been installed in public spaces. The recipient of numerous awards, he was also given two honorary doctorates and an honorary professorship by Scottish universities.

Catherine Griffiths

Wellington Writers Walk, p. 132

Catherine Griffiths was born in 1966. After graduating in 1986 in Visual Communication Design from the School of Design at Wellington Polytechnic, she worked first in London and then, from 1995, in Wellington, where she still works and has her studio. As well as writing about design, she concentrates on communication design, self-produced artists' books, corporate branding and design and typography in the landscape. In 2002, she was presented with the prestigious New Zealand Stringer Award for graphic design for her Wellington Writers Walk. In 2009, in conjunction with Simone Wolf of Typevents Italy, she organized TypeSHED11, the first typographical symposium to be held in New Zealand.

Rudolph de Harak

Digital clock, p. 144

Rudolph de Harak (1924–2002) was born in Culver City, California. He attended the School of Industrial Arts before working in a Los Angeles design studio and founding the Los Angeles Society for Contemporary Designers along with Saul Bass, Alvin Lustig and Lou Danziger. In New York he worked as art director for *Seventeen* and illustrator for *Esquire*. He was employed as image creator for the Kurt Versen Lighting Company for some twenty years. In the 1960s, he came to the public's attention for his timeline and typography display for the Egyptian Wing of the Metropolitan Museum of Art and for the John Street installation in Manhattan. Over the course of his career, he designed hundreds of posters, record sleeves and book covers, including around 350 covers for the McGraw-Hill paperback series. He also taught at Cooper Union and Yale University. In 1993, he was awarded a medal by AIGA in recognition of his career. He left New York in the late 1970s, moving with his wife to live in Maine in a house of their own design.

Robert Indiana

LOVE, p. 150

Robert Indiana (Robert Clark) was born in 1928 in New Castle, Indiana. He studied at Syracuse University and at the Munson-Williams-Proctor Institute in Utica, New York. From 1949 to 1953, he studied painting and graphics at the School of the Art Institute of Chicago, attending summer classes at the Skowhegan School of Painting and Sculpture in Maine and then one year at the University of Edinburgh. After a summer seminar at the University of London, he returned to the United States, settling in New York and becoming associated with the Pop Art movement. He began working as an artist and writing poetry, which led him to use writing

increasingly frequently in his art. His first works took their inspiration from the graphics of street signs, video poker and old commercial trademarks. He began gradually to concentrate less on painting and posters and more on what he called 'sculptural poems'. These were three-dimensional objects relating to letters, words and numbers. In 1964, he collaborated with Andy Warhol on the film *Eat* and, in 1976, he designed staging and costumes for the opera *The Mother of Us All*. The works of this very prolific artist can easily be recognized by their sign-like incisiveness, colours and contrasts. From 1978, despite his major successes in the world of art, he retired to live quietly at Vinalhaven in the Fox Islands, Maine.

Intégral Ruedi Baur

Urban Design for the Epidème Quarter, p. 156

Intégral Ruedi Baur Paris and Intégral Ruedi Baur Zurich are two partnerships founded by the graphic designer Ruedi Baur in, respectively, 1989 and 2002. They specialize in graphics, signage systems, visual identities, scenography and urban design. Baur was born in Paris in 1956 and trained as a graphic artist in Zurich. He worked for several museums and cultural institutions, first in Lyon and then in Paris, gradually moving into the field of architecture and urban design, with a particular interest in identity, scenography and signage systems. Since the 1990s he has held teaching posts at institutions in Europe, Canada and China. Baur is currently working on a number of experimental and research projects.

Ilya Kabakov

Antenna, **p. 162**

Ilya Kabakov was born in 1933 at Dnepropetrovsk (Ukraine, formerly in the Soviet Union). He studied at the VA Surikov Art Academy in Moscow and began his career in the 1950s illustrating children's books before joining a circle of conceptual artists working outside the Soviet art system. In 1987, two years after his first solo exhibition at the Dina Vierny Gallery in Paris, he moved for six months to Graz, Austria. In 1988, he began working with his wife, Emilia, whom he married in 1992. They now live and work together on Long Island in New York. All their work since has been collaborative, and has been exhibited in many important venues including the Museum of Modern Art (MoMA), the Hirshhorn Museum in Washington DC, the Stedelijk Museum in Amsterdam, Documenta IX, the Whitney Biennial in 1997 and the State Hermitage Museum in St Petersburg. They have also received many prizes and accolades including the Oscar Kokoschka Preis (Vienna, 2002) and the Chevalier des Arts et des Lettres (Paris, 1995). In 1993, Kabakov represented Russia at the 45th Venice Biennale with his installation *The Red Pavilion*. Today, he is considered to be the most important Russian artist of the late twentieth century. His installations express both the social and cultural environment of the Soviet Union and humankind's universal condition.

David Kindersley

British Library Gates, p. 76

David Kindersley (1915–1995) was born in Codicote, UK. He learned his trade from Eric Gill at Pigotts in Buckinghamshire where he was an apprentice stone-cutter between 1934 and 1936. He attained a high level of skill in inscribing stone. In 1945, he set up his own workshop at Barton, outside Cambridge, where, while remaining grateful for what he had learned from Gill, he developed his own individuality in thought and design, both in letterforms and in the layout of inscriptions. In 1967, he moved from Barton to Chesterton Tower and, ten years later, to Victoria Road, where the Cardozo Kindersley Workshop still is located. From 1976, he began working in collaboration with Lida Lopes Cardozo, a young Dutch letter-cutter, who was to become his wife. Kindersley's many inscriptions can be seen today in churches and other public places in the UK. He designed the typo-

graphical font Octavian for Monotype in 1961 and is the author of a number of works on lettering and letter-carving.

Richard Kindersley

Canning Town Underground, p. 170

Richard Kindersley studied at the Cambridge School of Art and in his father David's workshop. In 1970, he established his own workshop in London, concentrating on sculpture and lettering. He uses various materials for his incised work, chosen according to their significance to the site. As well as carving onto brick (for which he has won several prizes), he also designs lettering for architecture, inscriptions, memorials, sundials and printing. Among his best-known works are those for Tower Bridge and the M25 Bridge, St Paul's Cathedral, Westminster Abbey, the V&A Museum and Keele University. He has given many lectures on the relationship between lettering and architecture both in the past and today as it relates to his own work, and he has appeared on several television programmes.

René Knip

ABC on the Hoofdweg, **p. 176**

René Knip was born in 1963 in Hoorn in the Netherlands. In 1982, he worked for a period in France, where he learned French. After beginning a law degree at the University of Utrecht, he decided instead to attend art school. Following a study trip to England and Italy, in 1985 he enrolled at the Academy of Visual Arts St Joost in Breda, in the Netherlands. Here, one of his teachers, Chris Brand, an expert in type design and creator of the famous Albertina font, noticed Knip's passion for letters and numbers and offered to teach him privately. As a result of this meeting, Knip's interests moved away from the world of painting to that of graphics and, in particular, of lettering, leading him to transfer from the department of painting to that of graphic design in 1987. In 1989, he attended a four-month workshop at the National Academy in Amsterdam. Qualifying in 1990, he worked from 1992 to 1995 at the Studio Anthon Beeke, going on to establish the Atelier René Knip (A R K), where he combines an almost craft-like approach to materials with design and graphics. Often collaborating with artists and poets, he has designed many alphabets, using them in his graphic design projects and typographical installations, both for interiors and outside.

Attila F. Kovács

House of Terror Museum, p. 184

Attila F. Kovács was born in 1951 at Pécs in Hungary. He studied design and architecture at BME University in Budapest, then worked for more than ten years with István Szabó as a production designer for films and opera and spent two years working in Italy. From 1988, he executed numerous projects in cinema, theatre and opera. In 2000, he designed the installation at the House of Terror Museum, soon to become one of Budapest's most distinctive landmarks. One design, for the T&G restaurant, was shortlisted at the World Architectural Festival in Barcelona in 2008. In the later years of his career he has dedicated himself chiefly to works in the fields of architecture and interior design. His designs have appeared in major journals on architecture and design.

Barbara Kruger

Imperfect Utopia, **p. 252**

Barbara Kruger was born in 1945 in Newark. She studied visual arts at Syracuse University and design at Parsons The New School for Design in New York where she was profoundly influenced by the work of photogra-

pher Diane Arbus. Kruger started out by working for fashion magazines, encouraged in this by Marvin Israel, graphic designer and art director of *Harper's Bazaar*. Before long she became head designer of *Mademoiselle*. She then went on to work as graphic designer, art director and picture editor in the art departments of *House and Garden*, *Aperture* and other publications. Her work typically combines existing photographs with aggressive texts that challenge and shock the viewer. Her trademark is the use of a red frame around the black-and-white images covered in text in Futura Bold. Many of her texts deal with feminism, consumerism, autonomy and personal aspirations. Examples can be found not only in museums and galleries all over the world but also on posters, publicity, bus cards, in a public park and on a train station platform in Strasbourg, France. She has taught at the California Institute of Art, the School of the Art Institute of Chicago and the University of California, Berkeley. She lives in New York and Los Angeles.

Maya Lin

Vietnam Veterans Memorial, p. 192

Maya Lin was born in 1959 in Athens, Ohio. The daughter of two intellectuals who escaped from Mao's China, she gained a Master of Architecture degree at Yale University in 1986, and has since worked in New York City. In 1981, while she was still at university, she won the competition to design the Vietnam Veterans Memorial in Washington DC. Since then she has undertaken numerous public and architectural projects, earning much acclaim for her skill not only as an architect but also as a landscape designer and artist. She has designed several architectural memorials, often using art and sculpture to complete her projects, and has received many prizes and honours. She is a member of the American Academy of Arts and Letters, the American Academy of Arts and Sciences and in 2005 she was inducted into the National Women's Hall of Fame. Her work has been reviewed in publications such as *Time Magazine*, the *New York Times Magazine* and the *New Yorker*.

Karel Martens

Veenman printers, p. 200

Born in 1939, Karel Martens is a Dutch graphic designer and teacher. After taking a diploma at the Arnhem School of Art in 1961, he worked as a freelance graphic designer, specializing in typography. In addition to graphics for publishing, he has also designed stamps, phone cards, signs and numerous typographical facades. In 1998, with Wigger Bierma, he set up the Werkplaats Typografie, a two-year masters programme in typography. He has taught at the Arnhem School of Art, the Jan van Eyck Academie in Maastricht and he has been a critic in the graphic design department at Yale University.

Guy Nordenson

Imperfect Utopia, p. 252

Guy Nordenson and Associates is a structural engineering practice based in New York City, founded in 1997 by Guy Nordenson after twenty years of professional experience in San Francisco and New York, of which ten years were spent as director of Ove Arup & Partners New York (which he himself founded in 1987). From its inception, the studio has participated in many collaborations with leading architects.

Anton Parsons

Invisible City, p. 210

Anton Parsons was born in 1968 in Palmerston North, New Zealand. He gained a degree in sculpture in 1990 from the School of Fine Arts at the University of Canterbury, Christchurch. Parsons uses a wide range of materials in his work, including industrial, prefabricated and readymade objects, along with photography and installations. He often plays with exaggerations of scale and is particularly sensitive to the relationship between work and exhibition space. He exhibits his pieces in open spaces, galleries, exhibitions and institutions, working for both public and private commissions. He currently lives in Auckland, New Zealand.

Pentagram

Signage for the *New York Times* building, p. 216

New Jersey Performing Arts Center, p. 224

The basis of what was to become Pentagram was formed in 1962 when Alan Fletcher, Colin Forbes and Bob Gill set up a graphic design consultancy in London. In 1965, the members changed with the departure of Bob Gill and the arrival of the architect Theo Crosby, an event that meant the firm could begin to take on three-dimensional projects. The group was completed with the arrival of first Kenneth Grange and then Mervyn Kurlansky and, in 1972, Pentagram was established. Drawing on a wealth of collaborators, the firm is firmly avant-garde in its approach. Each designer can work independently, attaching his or her name to the project in question, or work together with others under the leadership of one person. New branches were added in New York in 1978, San Francisco in 1986, Austin in 1994 and Berlin in 2002. None of the original founders of Pentagram still work there today. Still admired for the quality of the work produced, the studio now has sixteen partners, covering the areas of architecture, interiors, products, identities, publications, posters, books, exhibitions, websites and digital installations.

Maarten de Reus

G.R.O.E.N., p. 238

Maarten de Reus was born in 1961 at Heerenveen in the Netherlands. He took his degree at the Academy for Visual Arts in Arnhem in 1986, where, from 1979 to 1985, he concentrated particularly on public art, producing various sculptures that investigated aspects of three-dimensionality. From 1989, he created numerous works of public art in the Netherlands, the UK and the US, and has taken part in exhibitions and conferences in many European cities. He divides his time between Amsterdam and England, teaching at the Rietveld Academy in Amsterdam, and is also a visiting lecturer at the Hochschule Für Bildende Künste in Hamburg.

Quennell Rothschild & Partners

Imperfect Utopia, p. 252

Quennell Rothschild & Partners are landscape architects and planners. Since 1968 they have been involved in the creation and restoration of parks, both public and private, and small and large. For more complex projects they often work alongside architects, artists and designers.

Roberto Behar & Rosario Marquardt / R & R Studios

M, p. 232

R & R Studios was established by two Argentinians, Roberto M. Behar, born in 1953 in Buenos Aires, and Rosario Marquardt, born in 1954 in Mar de la Plata. It is a multidisciplinary firm covering visual arts, exhibition, design, architecture and urban design. The pair's work has been featured in over 200 publications all over the world, and exhibited in many

museums and galleries in the US and elsewhere. They both studied at the Universidad Nacional de Rosario in Argentina, but Behar went on to the Institute for Architecture and Urban Studies in New York. He has been visiting professor at Harvard University, Cornell University and the University of Maryland, and is currently asspciate professor at the University of Miami. Marquardt has worked chiefly in the areas of art and painting. She studied puppet theatre and has staged two puppet plays of her own authorship, and is currently adjunct professor at the University of Miami School of Architecture.

Paula Scher

New Jersey Performing Arts Center, p. 224

Paula Scher was born in 1948 in Washington DC. She studied at the Tyler School of Art in Philadelphia and at the Corcoran College of Art and Design in Washington DC. She began her career as a graphic designer, designing record sleeves for CBS, and then working as an art director. A partner with Pentagram in New York since 1991 and president of the New York branch of AIGA from 1998 to 2000, Scher has specialized in projects for corporate identity, packaging, environmental graphics and graphics for publishing, working for a large number of clients. Her projects can be seen at MoMA and the Cooper-Hewitt National Design Museum in New York City, at the Library of Congress in Washington DC, at the Museum für Gestaltung in Zurich, at the Denver Art Museum, and at the Bibliothèque Nationale de France and the Centre Georges Pompidou in Paris. She has received many prizes including the Beacon Award for Integrated Corporate Design Strategy in 1996, the Chrysler Award for Innovation in Design in 2000 and the AIGA Medal in 2001. In 1998, she was enrolled in the International Art Directors Club Hall of Fame and, in 2001, she was awarded the title of Doctor Honoris Causa of Fine Arts by the Corcoran College of Art and Design. As well as working as a graphic artist, Scher has taught at the School of Visual Arts, Cooper Union, Yale University and the Tyler School of Art. She has written articles for a number of design magazines including the *AIGA Journal of Graphic Design*, *Print* and *Graphis*. In 2002, Princeton Architectural Press published her monograph, *Make It Bigger*.

Pierre di Sciullo

National Dance Centre, p. 246

Pierre di Sciullo was born in 1961 in Paris. He is a graphic designer, working across various platforms including books, posters, films, videos and exhibitions. In 1983, he founded *Qui ? Résiste*, an experimental publication written and designed by him and made up of text, images and graphics. He conducts research in the field of graphics and typography and has carried out commissions for institutions and cultural organizations. Since 1987 he has held teaching posts at various schools in France and abroad, and, since 1997, at the Ecole Supérieure des Arts Décoratifs in Strasbourg. He is the designer of numerous typographical characters including Minimum, Quantage, Basnoda, Sintétik and Gararond. In his work he uses graphics in space for signage, manifestos and writing on architecture, seeking to strengthen the relationship between word and typography. In 1995, he was awarded the Charles Nypels Prize for his work.

Smith-Miller+Hawkinson

Imperfect Utopia, p. 252

Henry Smith-Miller studied architecture at Princeton University and the University of Pennsylvania. He worked for seven years at Richard Meier Architects. Laurie Hawkinson studied fine art at the University of California, Berkley, then worked with Robert Venturi's firm of architects. He obtained a degree in architecture at Cooper Union. Smith-Miller+Hawkinson is a design studio specializing in architecture, urban design, installations, exhibitions and objects. Established in 1982

in New York City, it also has a branch in Los Angeles. Among its best-known buildings are the Shaye Residence in Los Angeles, the Plunge Landing complex at Telluride in Colorado, a house in Damascus, Pennsylvania, and Pardo House in East Hampton, New York.

Josep Maria Subirachs

Freize for the New Town Hall, p. 260

Josep Maria Subirachs was born in Barcelona in 1927. He studied at the Escola de Belles Arts in Barcelona and worked as an apprentice in the Enric Monjo studio, although his true master was Enrico Casanovas, from whom he inherited his Mediterranean style. In 1948, when he was just twenty-one, he mounted his first solo exhibition at the Casa del Llibre in Barcelona. He lived first in Paris and then in Belgium, adding to his professional training an in-depth knowledge of the visual arts of the twentieth century. In the 1960s and 1970s he was the best-known sculptor working in Barcelona, carrying out many commissions, both private and public. A tireless worker, he has produced many pieces that have been shown in exhibitions and brought him many accolades. Subirachs is a highly versatile artist, producing not only three-dimensional works but also paintings, drawings, graphic art (etching, drypoint, serigraphy and lithography), tapestry, book illustrations, medals and jewellery.

Lawrence Weiner

A Translation from One Language to Another, **p. 266**

NYC Manhole Covers, **p. 274**

Lawrence Weiner was born in 1942 in the Bronx in New York City. Once qualified, he began to produce a highly varied range of works as well as travelling throughout North America. Returning to New York, he exhibited at the Seth Siegelau Gallery in 1964 and 1965. His early works included experiments with 'shaped canvas', canvases cut into various non-traditional shapes and sometimes mounted together to form a single composition, going on to experiment with squares cut out of carpets and walls. He issued his famous Declaration of Intent in 1968, while the following year saw the publication of his first book, *Statements*, considered to be one of the most important books relating to conceptual art at that time. From the 1970s onwards, while his chief form of expression has been wall installations, he has also produced videos, films, books, audio cassettes, sculptures and installations. Weiner lives and works in New York.

Why Not Associates

The Cursing Stone and Reiver Pavement, p. 280

The Eric Morecambe Memorial Area, p. 288

A Flock of Words, **p. 296**

Walk of Art, **p. 306**

Why Not Associates is a London-based graphic design firm established in 1987 by Andy Altman, David Ellis and Howard Greenhalgh. Conceived from the outset as a multidisciplinary partnership between designers, it uses a variety of media, with projects in the fields of corporate identity, animation, editorial design, advertising, web design, signage systems, staging and environmental design. Its clients include international names such as Nike, First Direct Bank, Virgin Records, the BBC and cultural institutions including the Royal Academy of Arts, the Barbican Centre, the Centre Georges Pompidou and the Kobe Fashion Museum. Why Not Associates has also taken on urban art projects, creating sophisticated typographical works for the benefit of the public.

Gordon Young

The Cursing Stone and Reiver Pavement, p. 280

The Eric Morecambe Memorial Area, p. 288

A Flock of Words, p. 296

Walk of Art, p. 306

Gordon Young was born in Carlisle, UK. He works as a visual artist in the field of public art. While his output ranges from traditional sculpture to more innovative work, it is always carefully related to its surroundings. In order to carry out his projects, Young has successfully established strong and productive links with professionals from many different fields of expertise: architects, landscape architects, graphic designers, engineers, foresters, librarians and historians. His work, about which he has given several lectures and which has received many awards, has been described and reviewed in numerous books and journals.

Notes on Type

Agency Gothic
Morris Fuller Benton

Paula Scher, New Jersey Performing Arts Center, p. 224

Originally designed in 1932 by Morris Fuller Benton for American Type Founders (ATF), Agency Gothic is a font made up of narrow, square shapes, recalling the streamlined Art Deco designs of the period. Benton designed only the upper-case, reserving its use for headlines. In 1990 David Berlow of Font Bureau added the lowercase and the bold weight. Subsequently the font was developed to include ten additional weights of which were half compressed.

Akzidenz Grotesk

Caruso St John, Bankside Signage System, p. 94

Rudolph de Harak, digital clock, p. 144

This typeface, produced since 1896 by the German foundry Berthold, is a linear font that relates to early nineteenth-century models. Of unknown authorship, Akzidenz Grotesk is known under several names, including Standard in the US. The font achieved maximum diffusion in the 1950s, when the designers of the so-called 'Swiss school' chose its readability over the linear geometry of the fonts of the time. Akzidenz Grotesk was used as a model in 1957 by Max Miedinger to design Helvetica and by Adrian Frutiger for his Univers. Both of these typefaces went on to become two of the most famous of the century.

Bembo
Francesco Griffo

Gordon Young & Why Not Associates,
The Cursing Stone and Reiver Pavement, p. 280

Bembo is based on the characters engraved by Francesco Griffo to typeset Cardinal Pietro Bembo's *De Aetna*, published by Aldus Manutius's publishing house in 1496. This font, however, did not include italics, so when Monotype decided to produce it in 1929, the italics were adapted from Blado – Ludovico Arrighi's italics accompanying Poliphilus – and

a typeface by a Venetian engraver named Giovanni Antonio Tagliente, dating back to 1520.

Clarendon

Robert Indiana, *LOVE*, p. 150

Clarendon was cut by Benjamin Fox at London's Fann Street Foundry under the guidance of Robert Besley in 1845. In 1951 the Swiss designer Hermann Eidenbenz revised it for Haas foundry under the direction of Edouard Hoffmann. In 1962 a light weight was added. Clarendon is an Egyptian typeface (i.e. the thickness of the serifs is equal to that of the strokes) with some bracketing. Characterized by large strokes, flat serifs and button serif terminals, it is ideal for highlighting titles and signs. 'Egyptian' fonts were designed for the newly fledgling commercial advertising in order to draw the attention of the consumer. The metonym is derived from a craze for Egyptian artifacts in Europe and North America in the early nineteenth century, especially in the years following Napoleon's expedition to Egypt.

Franklin Gothic
Morris Fuller Benton

Lawrence Weiner,
A Translation from One Language to Another, p. 266

Lawrence Weiner, *NYC Manhole Covers*, p. 274

Franklin Gothic is a linear typeface designed by Morris Fuller Benton in 1904 for American Type Founders. Created to meet the new demands of print advertising in the early years of the twentieth century, Franklin Gothic's design recalls the great wooden typefaces – dark and compact – of the early nineteenth century. It also incorprates slight irregularities and asymmetries. Redesigned for ITC (International Typeface Corporation, founded in 1970 by Aaron Burns and Herb Lubalin), Franklin Gothic is still very popular.

Frutiger
Adrian Frutiger

Intégral Ruedi Baur,
Urban esign for the Epidème Quarter, p. 156

Frutiger, commercialized by Linotype in 1976, was originally designed a few years earlier by Adrian Frutiger for the signage at Paris-Charles de Gaulle Airport, also known as Roissy Airport. For this reason the font was originally known as Roissy. It is characterized by a good legibility from a distance, with pronounced ascenders and descenders and marked loops to distinguish the letters from each other. Frutiger is a descendant of Univers, but these pronounced characteristics – part of the Swiss tradition's neutral approach – are based on traditional Roman epigraphy.

Futura
Paul Renner

Smith-Miller+Hawkinson, Barbara Kruger, Quennell Rothschild,
Guy Nordenson, *Imperfect Utopia*, p. 252

Futura was designed by Paul Renner for the Bauer foundry in Germany. It was commercialized in 1927 but the first sketches date back to 1925, a period in which the Rationalist avant-garde aimed for a simplification of forms into their basic components. It seems that Renner, at the time a teacher in an art school in Frankfurt, took inspiration from an upper-case-only alphabet designed by Ferdinand Kramer, who had attended a

semester at the Bauhaus. Renner reinterpreted his work and added the lower case, which could not meet the same rigorous geometry of the upper-case due to matters of clarity and harmony of composition. For this reason, he reviewed the first version of the typeface, which was much more geometric (for example, r was a stem with a dot). The result was a typeface that is based on geometric models but, thanks to the optical corrections, also lends itself to composing texts of a considerable length. Presented in 1933 at the fifth Milan Triennale, it became one of the Italian Fascist regime's most widely used typefaces and served as a model for many others.

Gill Sans
Eric Gill

Gordon Young & Why Not Associates, *A Flock of Words*, p. 296

Gill Sans is a linear typeface, with very readable humanistic letterforms, designed in 1927 by Eric Gill. The story goes that Stanley Morison, then head of the Monotype Corporation, assigned Gill the task of cutting a new alphabet. The designer thus started working on Perpetua as well as on the lettering of a library sign. Morison was so impressed by his work that he decided to sell both fonts. Gill Sans resembled the font designed for the London Underground by Edward Johnston. After a lukewarm reception, Gill Sans became very popular. Its most characteristic letters are the g with its eye and loop, and the R's leg, which closely resembles that of Perpetua.

Helvetica
Max Miedinger

FA+, *Citat*, p. 116

Catherine Griffiths, Wellington Writers Walk, p. 132

Helvetica was created in 1957 when Edouard Hoffman, director of the Swiss Haas foundry in Münchenstein, commissioned Max Miedinger to redesign the popular Akzidenz Grotesk. Originally known as Neue Haas Grotesk, its name was changed to Helvetica after its acquisition by Stempel and Linotype. Helevtica's lower case is higher than Akzidenz and has a more uniform section. It is an even font that gives the page a uniform 'colour', and represents the overcoming of rationalist geometric typefaces. It quickly became the most popular font of its time and it stayed on top until the year 2000. It is also the symbol of 1960s Swiss graphic design.

Interstate
Tobias Frere-Jones

**Gordon Young & Why Not Associates,
the Eric Morecambe Memorial Area, p. 288**

Interstate is a sans serif typeface, designed by Tobias Frere-Jones in 1994, based on the alphabet used for Federal Highway Administration signs in the US. It features uniform stroke thickness, a g with an open loop, reduced-height ascenders and descenders, and lower-case leg terminals cut at a 30-degree angle. The particularly large x-height it makes it readable even at smaller point sizes.

Isonorm
International Standards Organization

**Estudio SIC & Buj+Colón,
Monument to the Victims of 11 March 2004, p. 108**

Designed in 1980 by the International Standards Organization (ISO), Isonorm is a simple and geometric typeface with rounded terminals. It is easily readable by the human eye and by mechanical readers.

Meta
Erik Spiekermann

Paul Carter, *Nearamnew*, p. 82

Meta is a sans serif typeface designed in 1985 by Erik Spiekermann. Originally designed for Deutsche Bundespost (and named PT55), it was subsequently distributed by Spiekermann himself through FontFont. Featuring a great legibility even in small point sizes, it was one of the most commonly used typefaces in the 1990s. The font's thickness varies only slightly, so that all strokes can be perfectly visible even at smaller point sizes. The vertical strokes of some letters are characterized by slightly curved teriminals.

Minimum
Pierre di Sciullo

Pierre di Sciullo, National Dance Centre, p. 246

This modular family comes from Minimum Écran, a display typeface drawn pixel by pixel by Pierre di Sciullo. Since 1988, he has designed many new versions, all with geometric bases, but in high definition. Often experimental, some of these versions can be found on sale, but others remain reserved for di Sciullo's exclusive use.

News Gothic
Morris Fuller Benton

**Gordon Young & Why Not Associates,
The Cursing Stone and Reiver Pavement, p. 280**

News Gothic is a font designed by Morris Fuller Benton in 1908 and marketed by ATF. Its forms, which resemble those of early nineteenth-century catalogue fonts, are also similar to Franklin Gothic. News Gothic can in fact be used as its light variant. A compact typeface, with an average x-height and small ascenders and descenders, it has the looped g typical of other linear grotesque fonts.

Nobel
Sjoerd Hendrik

Karel Martens, Veenman printers, p. 200

Nobel is a sans serif typeface designed by Sjoerd Hendrik de Roos and implemented by Dick Dooijes for the Amsterdam Type Foundry (Lettergieterij Amsterdam) in the early 1930s. Its design is based on simple geometric shapes, such as Futura and other simlar typefaces produced in those years. In the 1990s Nobel underwent a revival; it was redesigned by the Dutch Type Library (Andrea Fuchs and Fred Smeijers) and by Tobias Frere-Jones of Font Bureau, who affectionately calls it a 'Futura cooked in dirty pots and pans'. The light weight was added subsequently.

Optima
Hermann Zapf

Maya Lin, Vietnam Veterans Memorial, p. 192

Catherine Griffiths, Wellington Writers Walk, p. 132

Optima is a typeface designed in 1952–55 by Hermann Zapf and produced in 1958 by Monotype and Stempel. Its design is based on the stone inscriptions of ancient Greece and Italy, and on fifteenth-century Florentine epigraphy. Optima has a characteristic stroke thickness which thins out around the mid-points and thickens towards the terminals. These characteristics make it a unique font that, even lacking serifs, strongly recalls the classical world and the epigraphic tradition.

Perpetua
Eric Gill

Gordon Young & Why Not Associates, *A Flock of Words*, p. 296

Perpetua was designed between 1925 and 1928 by Eric Gill, who was commissioned by Stanley Morison of Monotype to cut a typeface that would recall his earlier engravings. Morison, fearing that the large-scale drawings could not be rendered in apt forms for the Monotype foundry molds, also commissioned a test typeface from Charles Malin, a Parisian punch-cutter. Perpetua is a serif typeface characterized by high readability, an elegance of design and shapes that recall those of tomb engravings of the seventeenth and eighteenth centuries. The font, launched in 1929, comes also with an italic variant, called Felicity, by Gill. It was featured in its entirety and appeared complete in the final edition of *The Fleuron*.

Sabon
Jan Tschichold

Intégral Ruedi Baur, Urban Design for the Epidème Quarter, p. 156

Sabon was designed by Jan Tschichold in 1960 after he was commissioned to create a typeface similar to Garamond. It is based precisely on Claude Garamond and his pupil Jacques Sabon's lines. It had to meet the needs of both manual and Monotype and Linotype mechanical composition. Midway through the design project, Sabon also had to be adapted for photocomposition. Composed of Round, Bold, Italic, and Small Caps, Sabon is a typeface designed to be used for large amounts of text.

Trixie
Erik van Blokland

Gordon Young & Why Not Associates, the Eric Morecambe Memorial Area, p. 288

Trixie is a character set designed by Erik van Blokland in 1991. Its letterforms recall those of dirty and worn typewriters. The typeface is in fact inspired by the typewriter of a friend of the designer, Beatrix Günther, hence the name. Trixie's family originally consisted of five versions, but two more were subsequently added: one with a coarse texture (Trixie Rough) and another more practical one (Trixie High Definition).

Univers
Adrian Frutiger

Intégral Ruedi Baur, Urban Design for the Epidème Quarter, p. 156

Joan Brossa, *Visual Poem for a Facade*, p. 70

Univers was designed by Adrian Frutiger in 1957 for French foundry Deberny & Peignot. Its major innovation lies in its many variations, planned from the beginning of the design phase: the Univers family is in fact made up of twenty-one weights, designed to be used in a large number of combinations. Each version is defined by two numbers. The first set defines the weight, while the second defines the level of compression. Odd numbers are assigned to regular weights while the even numbers designate italics. Univers was the first linear typeface designed specifically for photocomposition. In 1997 Frutiger redesigned the typeface for Linotype, further expanding the family.

Water Tower
Cornel Windlin

Gordon Young & Why Not Associates, *Walk of Art*, p. 306

Water Tower is a stencil font by Cornel Windlin initially designed in 1999 for the cover of a book on an eponymous sculpture by Rachel Whiteread. Available both in Regular and Capitals, its design is inspired by the standard cardboard stencil sets typically found in American art supply shops.

Notes on Type Designers

Morris Fuller Benton

Agency Gothic

Franklin Gothic

News Gothic

Morris Fuller Benton (1872–1948) was born in Milwaukee, Wisconsin. He was the son of Linn Boyd Benton, another famous type designer and inventor of the mechanical punch-cutter. After studying mechanical engineering, Morris Fuller Benton went to work at American Type Founders (ATF) for his father. From 1900 to 1937 he was the company's chief type designer. During his prolific career he designed over 200 typefaces, both original and expert reinterpretations of historical fonts. Among his most popular are: Franklin Gothic, News Gothic, Agency Gothic, Alternate Gothic and Broadway.

Eric van Blokland

Trixie

Erik van Blokland (1967) is a type designer from Gouda, the Netherlands. He studied graphic and typographic design at the Koninklijke Academie van Beeldende Kunsten in The Hague. Together with Just van Rossum, with whom he had previously worked for a year at MetaDesign, he founded LettError. The studio merges the pair's dual passions for typography and digital technologies. Van Blokland has designed many typefaces and achieved a certain fame with Beowulf; the font has deliberately blurry contours that vary slightly from letter to letter, making each one different.

Tobias Frere-Jones

Interstate

Tobias Frere-Jones was born in 1970 in New York City and trained at the Rhode Island School of Design. After graduating he worked for many years for the Font Bureau foundry, for which he designed a number of fonts (including Interstate and Poynter). He has been a lecturer in typeface design at the Yale University School of Art. In 1999 he left Font Bureau and has since collaborated with Jonathan Hoefler. The designer of more than 500 typefaces, in 2006 Frere-Jones became the first American to receive the Gerrit Noordzij Prize for his contribution to the world of typography and type education.

Adrian Frutiger

Frutiger

Univers

Adrian Frutiger was born in 1928 in Unterseen, near Interlaken, Switzerland. After graduating from the School of Applied Arts in Zurich he worked at the Deberny & Peignot foundry in Paris, where he designed some of the first fonts created specifically for photocomposition. After his success with Univers, he opened his own studio in 1961. As well as having designed typefaces such as Univers, Frutiger, Avenir, Glypha and Méridien, he has written books on typography and design, including the famous *Der Mensch und seine Zeichen* (Man and His Character). He has taught at the École Estienne and the École Nationale Supérieure des Arts Décoratifs in Paris, and won numerous awards including the Gutenberg Prize, the Type Directors Club Medal, the French Grand Prix National des Arts Graphiques and the Society of Typographic Aficionados Typography Award.

Eric Gill

Gill Sans

Perpetua

Eric Gill (1882–1940) worked as a sculptor, craftsman, stone engraver and type designer. After training with Edward Johnston (himself a student of William Morris), Gill wrote the appendix on stone inscriptions for his mentor's renowned manual, *Writing & Illuminating & Lettering*. His famous Gill Sans – the first sans serif font used systematically in a public project – is his sole linear font and an ideal evolution of Edward Johnston's Underground Sans. He wrote several essays, including 'An Essay on Typography' (1931), in which he discussed the forms of letters and sided in favour of unjustified text composition, stressing that greater uniformity of the space between words makes for better legibility. In addition to Gill Sans, he also designed Perpetua, Joanna and Pilgrim.

Francesco Griffo

Bembo

Francesco Griffo (1450–1518) was a punch-cutter from Bologna who worked in several Italian cities, in particular at Aldus Manutius's printing house in Venice. The many fonts he masterfully drew were reinterpreted in the twentieth century from prints, since none of the original punches survived. These fonts included Dante and Griffo (Roman and Italic), redesigned by Giovanni Mardersteig, and Monotype's Bembo (Roman) and Poliphilus. Griffo was also the first to draw italics for print, a project commissioned by Manutius in order to compress texts for more economical printing.

Max Miedinger

Helvetica

Max Miedinger (1910–1980) was a Swiss type and graphic designer. He began as an apprentice typesetter in his home town of Zurich, at the Kunstgewerbeschule, then worked as a typographer at the Globus advertising agency in Zurich and as a typeface sales representative for Haas in Münchenstein. From 1956 he worked as a freelancer in Zurich. His style was rigorous and his posters simple and often almost wholly typographical. Miedeinger designed several character sets, but achieved his fame thanks to Helvetica, a font commissioned by Edouard Hoffman, director of the Haas foundry, to commemorate the history of graphic design.

Paul Renner

Futura

Paul Renner (1878–1956) was born in Wernigerode, in Prussia, and received his training as an artist in the art academies of Berlin, Karlsruhe and Munich. He started working as a painter but, fascinated by graphic design, decided to attend the school of applied arts in Munich and took part in the Deutscher Werkbund. He worked as a teacher at Kunstschule Frankfurt and then as director of Munich's Graphische Berufsschule. In 1927 he designed Futura, and managed Germany's participation in the fifth Milan Triennale in 1933, but in the same year, with the advent of Nazism, he was removed from his position. In subsequent years, albeit in a form of internal exile, he still managed to work as a designer and writer. Among his books are *Typografie als Kunst* (Typography as Art; 1922), *Mechanisierte Grafik* (Mechanized Graphics; 1931) and *Die Kunst der Typografie* (The Art of Typography; 1940).

Sjoerd Hendrik de Roos

Nobel

Sjoerd Hendrik de Roos (1877–1962) was a Dutch typographer, designer and printer. Apprenticed as a lithographer before studying at the Rijksacademie voor Beeldende Kunsten in Amsterdam, he then went on to work for over thirty years at the Lettergieterij Amsterdam, for which he created several typefaces. Among his best are Hollandse Mediaeval, Nobel, Libra, Egmont and De Roos.

Erik Spiekermann

Meta

Erik Spiekermann (1947) is an information architect, type designer and author of many books and articles on typography. He studied English and art history at the Free University of Berlin and in 1973 moved to London to work as a graphic designer. In 1979 he founded MetaDesign, a graphic design company specializing in branding, corporate identity and signage systems, with offices in Berlin, Beijing, Düsseldorf, San Francisco and Zurich. In 1989, along with Neville Brody, he founded FontShop in Berlin. The digital foundry took advantage of the advent of the digital revolution in the world of typography. In 2001, Spiekermann left MetaDesign and is currently managing partner and creative director of Edenspiekermann, with offices in Amsterdam, Berlin, London and San Francisco. He has designed many fonts including Meta and Officina and has received recognition in both the academic and professional worlds.

Jan Tschichold

Sabon

Jan Tschichold (1902–1974) was born in Leipzig, where he trained as an artist and attended the Academy for Graphic Arts and Book Production. He began his career as an assistant designing advertising posters, before moving first to Berlin and in 1926 to Munich, having been invited by Paul Renner to teach in the academy there. With the advent of the Nazi regime in 1933 he was forced to quit his job and emigrate to Basel. From 1947 to 1949 he oversaw the great design reform of Penguin Books in London. Back in Basel, he continued to work as editorial designer and designed Sabon, his most famous typface. Besides working as a teacher, graphic artist and type designer, Tschichold has also authored many theoretical texts that have profoundly influenced the world of graphic design, including *Elementare Typographie* (Basic Typography; 1925) and *Die Neue Typographie* (The New Typography; 1928).

Cornel Windlin

Water Tower

Cornel Windlin (1964) is a Swiss designer and art director currently working in Berlin. He studied at the Schule für Gestaltung Luzern. In 1988 he moved to London where he worked with Neville Brody, and became art director of *The Face* magazine. In 1993 he returned to Switzerland and began working as a freelancer in Zurich. With Stephan Müller he founded Lineto, a digital foundry distributing its own fonts as well as those of a select group of designers. The creator of several corporate typefaces, he is also involved in editorial design.

Hermann Zapf

Optima

Hermann Zapf (b. 1918) was born in Nuremberg and initially worked as an apprentice photo editor at a printing house. Fascinated by the posthumous exhibition of Rudolf Koch, he decided to teach himself calligraphy by studying Edward Johnston's manual. In 1938 he sold his first typeface to Frankfurt's Stempel foundry and, after the Second World War, he became artistic director of the printing works. Among his fonts from this period are Palatino (based on the sixteenth-century letterforms of Giovanbattista Palatino) Melior and Optima. In 1954 he published the highly influential *Manuale Typographicum*. He left Stempel in 1956 but continues to work in the world of typography as a lecturer and consultant, devoting himself to calligraphy and drawing character sets such as Comenius and Marconi.

Bibliography

Books

Abrioux, Yves, *Ian Hamilton Finlay: A Visual Primer*, Reaktion Books, London, 1992

Baines, Phil and Catherine Dixon, *Signs: Lettering in the Environment*, Laurence King, London, 2003

Baroni, Daniele and Vitta Maurizio, *Storia del Design Grafico*, Longanesi, Milan, 2003

Bartram, Alan, *Lettering in Architecture*, Lund Humphries, London 1975

Baur, Ruedi, *Ruedi Baur, intégral et associés*, Lars Müller Publishers, Badon, 2001

Between Spaces: Smith-Miller + Hawkinson Architecture, Princeton Architectural Press, New York, 2000

Blackwell, Lewis, *Twentieth-Century Type*, Laurence King, London, 1992

Bordons, Glòria and Daniel Giralt-Miracle, *Itineraris brossians*, Fundació Joan Brossa i Ajuntament de Barcelona, Barcelona, 2006

Bringhurst, Robert, *The Elements of Typographic Style*, Hartley & Marks Publishers, Vancouver, 1992

Carter, Paul, *Mythform: The Making of Nearamnew*, Melbourne University Publishing / Miegunyah Press, Carlton (Victoria), 2005

Carter, Paul, *The Sound In-Between*, New Endeavour/University of New South Wales Press, Sydney, 1992

Cottom-Winslow, Margaret, *International Landscape Design: Architecture of Gardens, Parks, Playgrounds & Open Spaces*, PBC International, New York, 1991

Ducci, Teo (ed.), *In memoria della deportazione*, Mazzotta, Milan, 1997

Fietzek, Gerti and Gregor Stemmrich (eds.), *Having Been Said: Writings & Interviews of Lawrence Weiner 1968–2003*, Hatje Cantz, Ostfildern Ruit, 2004

Follis, John and Dave Hammer, *Architectural Signing and Graphics*, Whitney Library of Design, Watson-Gutpil Publications, 1979

Frampton, Kenneth (ed.), *Tadao Ando: Buildings, Projects, Writings*, New York, Rizzoli International, 1984

Gray, Nicolete, *Lettering on Buildings*, Architectural Press, London, 1960

Groys, Boris and Ilya Kabakov, *Die Kunst des Fliehens,* Hanser Verlag, Munich, 1991

Groys, Boris, David A. Ross and Iwona Blazwick, *Ilya Kabakov*, Phaidon, London, 1998

Harper, Laurel, *Provocative Graphics: The Power of the Unexpected in Graphic Design*, Rockport Publishers, Gloucester (Massachusetts), 2001

Harris, Roy, *L'origine della scrittura*, Stampa Alternativa & Graffiti, Rome, 1998

Herdeg, Walter (ed.), *Archigraphia: Architectural and Environmental Graphics*, Graphis, Zurich, 1978

Höger, Hans (introduction), *Intégral Ruedi Baur et associés: Identité de Lieux / Identity of Places*, Collection Design&Designer, no. 12, Paris, Pyramyd, 2004

Hyland, Angus and Emily King, *C/id: Visual Identity and Branding for the Arts*, Laurence King, London, 2006

Kabakov, Ilya, *Public Projects or the Spirit of a Place*, Charta, Milan, 2001

Kinneir, Jock, *Words and Buildings: The Art and Practice of Public Lettering*, The Architectural Press, London, 1980

Knip, René and Jan Middendorp, *A.R.K. Ten Years of Type Related Projects 1994–2004, ABC Ten Years of Custom Alphabets 1994–2004*, Atelier René Knip, Amsterdam, 2004

Leoni, Giovanni (ed.), *Trentacinque progetti per Fossoli*, Electa, Milan, 1990

Le Quernec, Alain (introduction), *Ahn Sang-soo: Graphiste*, Collection Design&Designer, no. 35, Pyramyd, Paris, 2005

Lussu, Giovanni, 'Caratteri Eminenti', in Marcello Baraghini and Daniele Turchi (eds.), *Farsi un Libro*, Biblioteca del Vascello, Stampa Alternativa, Rome, 1990

Maffioletti, Serena (ed.), *BBPR*, Serie di Architettura no. 32, Zanichelli, Bologna, 1994

Malvezzi, Piero and Giovanni Pirelli (eds.), *Lettere di condannati a morte della Resistenza europea*, Einaudi, Turin, 1995

Maymò, Jaume (ed.), *Joan Brossa: Poesia Tipografica*, Barcelona: Fundació Joan Brossa, Ajuntament de Barcelona, 2004

Montanari, Metella (ed.), *Architetture della memoria: Ideazione, progettazione, realizzazione del Museo monumento al deportato di Carpi*, Comune di Carpi, 2003

Mosley, James, *Radici della scrittura moderna*, Stampa Alternativa & Graffiti, Rome, 2001

Parmiggiani, Claudi, *Alfabeto in sogno: Dal carme figurato alla poesia concreta*, Mazzotta, Milan, 2002

Petrucci, Armando, *La scrittura: Ideologia e rappresentazione*, Piccola Biblioteca Einaudi, Turin, 1986

Pignotti, Lamberto and Stefania Stefanelli, *La scrittura verbo-visiva*, L'espresso, Milan, 1980

Plazm, *100 Habits of Successful Graphic Designers: Insider Secrets on Working Smart and Staying Creative*, Rockport Publishers, Gloucester (Massachusetts), 2003, p. 72

Pô, Guillaume (introduction), *Pierre di Sciullo: Graphiste / Typographe*, Collection Design&Designer, no. 8, Pyramyd, Paris, 2003

Polano, Sergio and Marco Mulazzani, *Guida all'architettura italiana del Novecento*, Electa, Milan, 1991

Polano, Sergio and Pierpaolo Vetta, *Abecedario: La Grafica del Novecento*, Electa, Milan, 2002

Pozzi, Giovanni, *La parola dipinta*, Adelphi, Milan, 1996

Poynor, Rick, *No More Rules: Graphic Design and Postmodernism*, Laurence King, London, 2003

Scher, Paula, *Make it Bigger*, Princeton Architectural Press, New York, 2002

Schippers, K. and René Knip, *Het ABC op de Hoofdweg*, Stadsdeel De Baarsjes, Amsterdam, 2002

Sheeler, Jessie, *Little Sparta: The Garden of Ian Hamilton Finlay*, Frances Lincoln, London, 2003

St John Wilson, Colin, *The Design and Construction of the British Library*, The British Library, London, 1998

Stonehouse, Roger and Gerhard Stromberg, *The Architecture of the British Library at St Pancras*, Taylor & Francis, London, 2004

The Japan Architect / JA #1: Tadao Ando, January 1991, Tokyo, Shinkenchiku-sha

Tubaro, Antonio & Ivana, *Lettering: Studi e ricerche sulla forma della scrittura e del carattere da stampa*, Idea Books, Milan, 1992

Various authors, *Graphic designers aux Etats-Unis*, vol. 2, Office du Livre, Fribourg, 1971

Various authors, *Lawrence Weiner*, Phaidon, London, 1998

Various authors, *Maya Lin*, American Academy in Rome, Electa, Milan, 1998

Various authors, *Works: Caruso St John Architects*, coll. *Arquitecturas de autor*, vol. 13, T6 Ediciones, Pamplona, 2000

Weilacher, Udo, *Between Landscape Architecture and Land Art*, Birkhäuser, Berlin, 1999

Weiner, Lawrence, *NYC Manhole Covers: Public Art Fund in Collaboration with Con Edison & Roman Stone*, Public Art Fund Publications, New York, 2001

Weinhardt, Carl J., *Robert Indiana*, Harry N. Abrams, New York, 1990

Why Not Associates, *Why Not Associates ?2*, Thames & Hudson, London, 2004

Articles

Argenti, Maria, 'Tipografia Veenman,' *Materia* 2000, no. 32, pp. 58–67

Behar, Roberto, 'R & R Studios: Entrance to the Miami Metro: The Biggest M in the World', *Casabella*, no. 654, 1998, pp. 42–45

Baines, Phil, 'Sculptured Letters and Public Poetry,' *Eye*, no. 37, Autumn 2000, pp. 38–49

Baroni, Daniele, 'Archigrafia: Il design grafico e la città', *Ottagono*, no. 70, September 1983, pp. 44–49

Basile, Giuseppe, 'The Difficulty of Being Simple', *Domus*, no. 802, 1998, pp. 64–67

Brossa, Joan, 'La poesia en present', *Anafil*, L'Alzina (collection), no. 16, Barcelona, 1987

Brossa, Joan, 'Projecte per un poema visual en tres temps', *Anafil*, L'Alzina (collection), no. 16, Barcelona, 1987

Brownjohn, Robert, 'Street Level', *Typographica*, no. 4, December 1961, Lund Humphries, pp. 30–60

Buj+Colon, 'Monumento a las víctimas de 11M', www.buj-colon.com/projects/monumento-11m--madrid

Burnstone, Deborah, 'A Flock of Words', *Eye*, no. 45, Autumn 2002

Cantor, Judy, 'Letter of Intent', *Miami New Times*, 9 May 1996

Carter, Paul, 'Auditing Acoustic Ecology,' *Soundscape*, Vol. 4, no. 2, Fall–Winter 2003, pp. 12–13

Chermayeff, Ivan, 'Quality is a Matter of Proportions', *Domus*, no. 802, March 1998, pp. 68–70

Clark, Justine, 'Writing by Types', *Artichoke*, April 2003

Ferrara, Cinzia and Fiore Alessandro, 'Why Not Associates, Tradition and British modernity', *Disegno Industriale*, no. 16, September–October 2005, pp. 68–71

Gonzalez, Julieta, 'Roberto Behar and Rosario Marquardt. Journey into the City', *ArtNextus*, no. 65, June 2007

Goodeve, Thyrza Nichols, 'The Art of Public Address,' *Art in America*, November 1997, pp. 93–99

Goodnough, Abby, 'A Century-Old City Still in the Process of Being Invented', *New York Times*, 21 December 2003

Heller, Steven, 'A Laboratory for Sign Language,' *New York Times*, 14 December 2003

Heller, Steven, 'Rudolph de Harak: 1992 AIGA Medal', www.aiga.org/medalist-rudolphdeharak

Hoare, Lottie, 'David Kindersley', *Independent*, 4 February 1995

Holmes, Russell, 'The Work Must Be Read', *Eye*, no. 29, Autumn 1998, pp. 36–45

Iannacci, Anthony, 'Il parco multi-funzionale: A park for the North Carolina Museum of Art,' *L'Arca*, no. 82, May 1994, pp. 70–73

'Imperfect Utopia: Un-Occupied Territory', *Assemblage*, no. 10, December 1989, pp. 19–45

L'Informatiu del Col·legi d'Aparelladors i Arquitectes Tècnics de Barcelona 30, Barcelona, 3, June 1993

Kinser Hohle, Maggie, 'The Eye of a Poet', *Theme Magazine*, no. 6, Summer 2006, pp. 44–51

Krasner, Michael, 'Thinking With Her Hands,' *Whole Earth*, Winter 2000

Lenza, Cettina, 'Scrittura e architettura', *Grafica*, no. 3, June 1987, pp. 39–51

Lootsma, Bart, 'Printing Press, Ede, Holland,' *Domus*, no. 807, September 1998, pp. 38–43

Metz, Tracy, 'René Knip: Ideas that Can't Wait,' *Graphis*, no. 333, May–June 2001, pp. 14–29

Marinelli, Annalisa, 'Costruire il nuovo: Scarto tra realtà e inaudito,' *Controspazio*, A. XXXII, no. 2, 2001, 64–69

Monaco, Silvia, 'Controlled Emotion', *Domus Techno*, no. 909, December 2007

Mosley, James, 'Giovan Francesco Cresci e la lettera barocca a Roma', *Progetto grafico*, no. 10, June 2007, pp. 61–96

Narea, Ximena, 'Facing the Physical and Cultural Space', *Heterogénesis*, www.heterogenesis.com/Heterogenesis-2/Textos/hsv/hnr27/Narea.eng.html

'New Building for Veenman Printers' *A + U*, no. 336, 1998, pp. 132–41

Pentagram, 'Sign of the Times', pentagram.com/en/new/2007/07/sign-of-the-times.php

Pickersgill, Sean, 'Marion', *Architecture Australia*, May–June 2002

Puglisi, Luigi Prestinenza, 'Poetica dell'essenza: Profile of Maya Lin,' *Costruire*, no. 191, 1999, 146–47

Rock, Michael, 'The Designer as Author', *Eye*, no. 20, Spring 1996

Reboli, Michele, 'Smith-Miller+Hawkinson: A Park for the New World', *Casabella* no. 654, 1998, pp. 34–41

Rocca, Alessandro, 'Caruso St John Architects,' *Lotus International*, no. 106, September 2000, pp. 121–23

Sierra, Lluís, 'Letras monumentales de Brossa evocarán el pasado de Barcelona ante la catedral', *La Vanguardia*, supplement *Ciudades*, Barcelona, 10 October 1993, p. 37

Skuptur Projekte, www.skulptur-projekte.de/information/ausstellung/?lang=en

Strano, Carmelo, 'Il museo-paesaggio: Imperfect Utopia', *L'Arca*, no. 117, July–August 1997, pp. 46–51

'Taking the Walk', *Leafsalon*, 2005, www.leafsalon.co.nz/archives/000785talking_the_walk.html

Teedon, Paul, 'Designing a Place Called Bankside: On Defining an Unknown Space in London', *European Planning Studies*, vol. 9, no. 4, 1 June 2001, pp. 459–81

Tombesi, Paolo, 'Sign language', *Domus*, no. 848, 2002, pp. 57–65

Tracy, Walter, 'Typography on Buildings', *Motif*, no. 4, Shenval Press, London, 1960, pp. 82–88

Turner, Elisa, 'Housing projects', *Miami Herald*, 6 May 2001

Vallès i Rovira, Isidre, 'L'obra pública de Joan Brossa: Els Poemes corporis', *Journal of Catalan Studies*, May 2001, www.uoc.edu/jocs/brossa/articles/valles.html

Vietnam Veterans Memorial, www.thewall-usa.com/information.asp

Walters, Helen, 'Life in Italics', *Print*, September–October 2006

Zapatka, Christian, 'La pace del Western Mall, recenti War Memorials a Washington', *Lotus*, no. 93, 1997, 64–76

Zevi, Adachiara (ed.), 'Maya Lin Verbal Sketches', *L'Architettura*, A. XLV, no. 521, 1999, pp. 180–82

Credits & Index

Photo Credits

Index

Page numbers in *italic* refer to illustrations

Acknowledgments

First of all I want to thank Professor Leonardo Sonnoli for passing on his love for the world of letters of the alphabet, of typography and of typographical installations. He has also taught me about critical method, and guided me in my formation as a graphic designer. Furthermore he has been the advisor of my graduate dissertation, from which this publication was born.

Thanks to Professor Carlo Vinti, attentive and patient co-advisor for my dissertation, and for having supported the creation of this book.

Many thanks also go to all the authors of the projects: for the interviews, for providing information and photographic material, and especially for creating the installations that spread love for letters and typography.

A special thanks goes to my family. To my mom, Mariagrazia, who helped me to proof the texts endless times, and who has encouraged and supported me all along. To my dad, Giulio, for his confidence in my abilities and his support for my decisions. To my sister, Francesca, for being close to me even thousands of miles away.

A warm thanks goes to all my friends who have supported me. In particular I would like to thank my precious friends, former classmates, and now workmates Monica Pastore, Anna Silvestri and Anna Dalla Via, for giving me constant encouragement, and for their caring and professional recommendations.

I also express my gratitude to SHS Publishing for their help and for giving me the opportunity to publish my first book as an author.

Anna Saccani

SHS Publishing would like to thank all the people that made this book possible, and in particular Emilio Macchia, Charlotte Bakken, Manuel Galli, Per Sandström, Helena Lagerholm, Catherine Heygate, Nina Byttebier, and Tom Grahsler.